# CHICAGO
# THEN & NOW

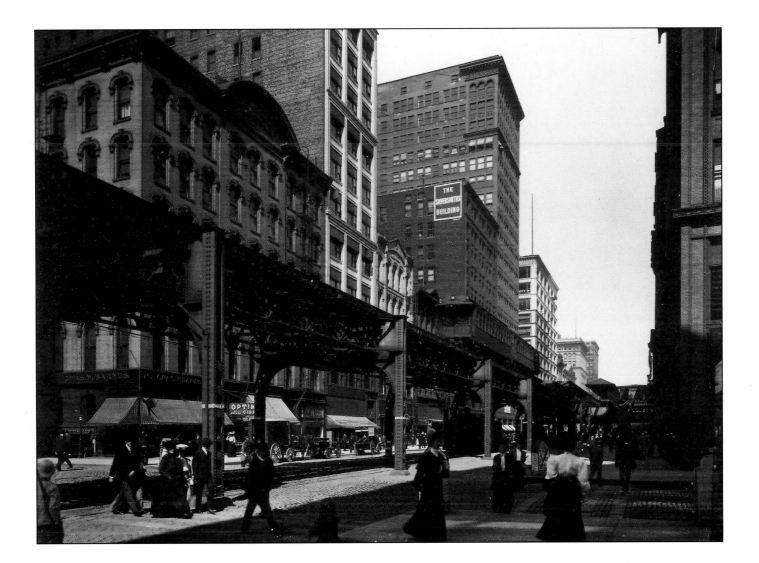

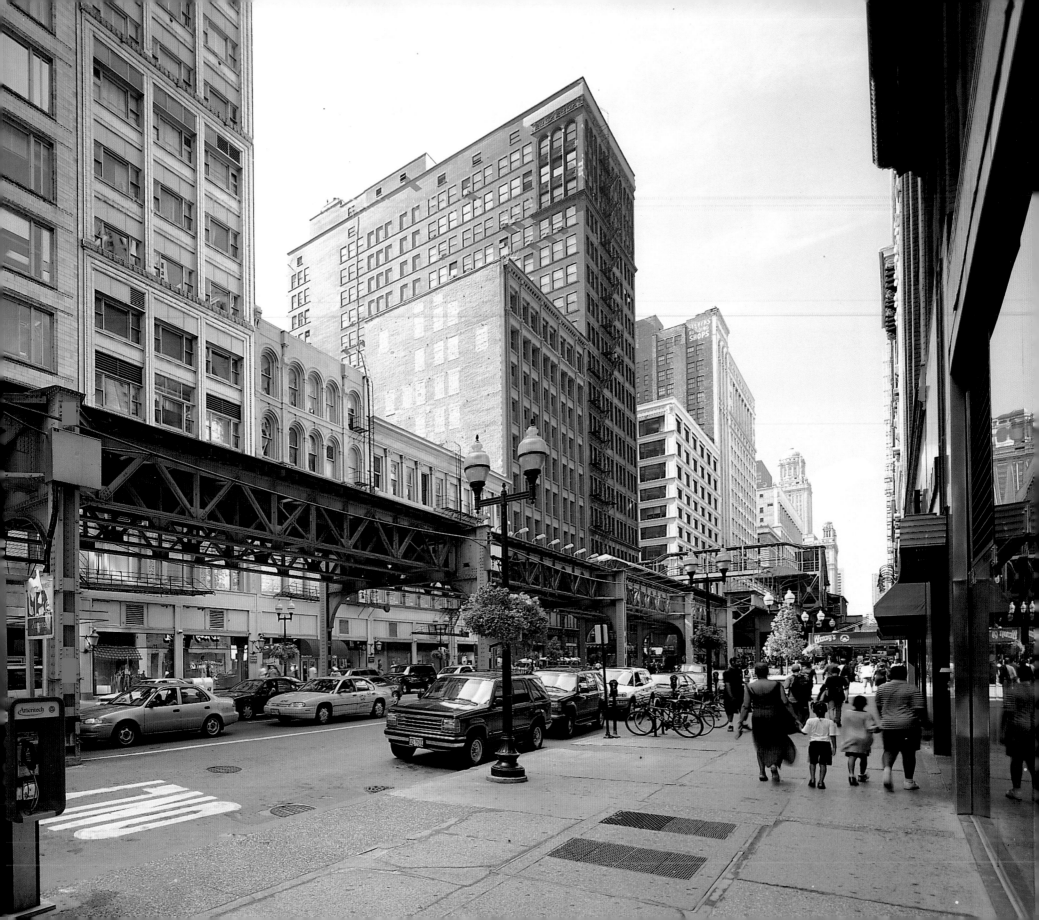

# CHICAGO
# THEN & NOW

## ELIZABETH McNULTY

THUNDER BAY
P·R·E·S·S

San Diego, California

**Thunder Bay Press**
An imprint of the Advantage Publishers Group
5880 Oberlin Drive, San Diego, CA 92121-4794
www.thunderbaybooks.com

Produced by PRC Publishing Ltd,
The Chrysalis Building, Bramley Road, London, W10 6SP, U.K.

A member of **Chrysalis** Books Group Ltd

All notations of errors or omissions should be addressed to Thunder Bay Press,
Editorial Department, at the above address. All other correspondence (author
inquiries, permissions) concerning the content of this book should be addressed to
PRC Publishing Ltd, The Chrysalis Building, Bramley Road, London, W10 6SP, U.K.

ISBN 1-57145-278-8

McNulty, Elizabeth, 1971-
    Chicago then & now / Elizabeth P. McNulty
        p. cm.
    Includes index.
    ISBN 1-57145-278-8
        1.  Chicago (Ill.)--Pictorial works. 2. Chicago (Ill.)--
    History--Pictorial works. I. Title: Chicago then and
    now. II. Title.

    F548.37 .M37 2000
    97.3'11--dc21                              00-033792

Printed in China

7 8 9 07 06 05 04 03

Acknowledgments:
Thanks to the staff of the Chicago Historical Society for all their help
negotiating the oustanding CHS photo collection. Thanks to Carrie Urbanic for
repeated hospitality, to Bobby Wong for a thorough edit, to Martin Howard and
Louise Daubeny at PRC for all their hard work, and to Simon Clay for
excellent photos under difficult circumstances.

Dedication:
For YDB, from Cassis to California, much love.

Picture credits:
The publisher wishes to thank the following for their kind permission
    to reproduce the photography for this book:

Front cover image courtesy of © Bettmann/CORBIS.

Front flap image (bottom), and pages 2, 7, 11, 13, 15, 17, 19, 21, 23, 25, 27, 29, 31, 33, 35, 37, 39, 41
    (both), 43, 45, 47, 49, 51, 55, 57, 59, 61, 63, 65, 67, 69, 73, 75, 77 , 79, 81, 83, 85, 87, 89, 91, 93, 95, 97,
    99, 101, 103, 105 , 107, 109, 111, 113, 115, 117, 119, 121, 123, 125, 127, 129, 131, 133, 135, 137, 139,
    141, 143 (both), and the back flap image (bottom) courtesy of Simon Clay.

Front flap image (top), pages 1, 6, 16, 18, 20, 24, 28, 30, 32, 36, 42, 44, 46 (main), 50, 52, 54, 56 (both), 58,
    60, 66, 68, 70, 72, 76, 80, 82, 88, 94, 96, 98, 100, 102, 104, 108, 110, 112, 118, 120 (inset), 128, 130, 134,
    136, 138, 140, 142, and the back flap image (top) courtesy of the Chicago Historical Society.
Image on page 8 courtesy of Chicago Aerial Surveying Company/Chicago Historical Society;
Image on pages 10, 12, 22, 34, 46 (inset), 74, 84 and 122 (both) courtesy of Barnes-Crosby/Chicago
    Historical Society;
Image on pages 26 and 92 courtesy of Kaufmann & Fabry/Chicago Historical Society;
Image on page 38 courtesy of Americo Grasso/Chicago Historical Society;
Image on page 40 courtesy of J. W. Taylor/Chicago Historical Society;
Image on page 48 courtesy of William T Barnum, from G1983.217/Chicago Historical Society;
Image on page 64 courtesy of Gordon Coster/Chicago Historical Society;
Image on page 78 (main) courtesy of S. L. Stein Publishing Company/Chicago Historical Society;
Image on page 78 (inset) courtesy of J. Carbutt/Chicago Historical Society;
Image on page 106 courtesy of C. R. Childs/Chicago Historical Society;
Image on pages 116, 124, 126 courtesy of Chicago Daily News/Chicago Historical Society;
Image on page 120 (main) courtesy of Essanay Film Studio Collection/Chicago Historical Society;
Image on page 132 courtesy of Richard Nickel/Chicago Historical Society.

Images on pages 9 and 71 appear courtesy of Corbis.

Image on page 62 appears courtesy of the Fourth Presbyterian Church. Special thanks to
    church archivist Bob Rasmussen and church administrator Mary Rhodes.

Back cover image courtesy of © Sandy Felsenthal/CORBIS.

Pages 1 and 2: Wabash Avenue (see pages 12 and 13).

# INTRODUCTION

"It is hopeless for the occasional visitor to try to keep up with Chicago—she outgrows his prophecies faster than he can make them," wrote Mark Twain in 1883, when Chicago was just fifty years old. In that half-century, the city had grown to be the second largest in the nation, billing itself as "Boss City of the Universe." Not bad for a swampy parcel of land along a sludgy river, but then, Chicago's official civic motto is "I Will!"

The first Europeans to reach the area, Jesuit Jacques Marquette and fur trader Louis Joliet arrived from the south in the fall of 1673. They paddled up the Mississippi into the Illinois and Des Plaines rivers, at which point they had to portage. They took a Native American trail, which led them to the south branch of the Chicago River, which in turn flowed northward into Lake Michigan. Joliet recognized the otherwise-dismal region's potential immediately: It would only be necessary to make a short canal to link the east-west Great Lakes system with that great north-south trade corridor, the Mississippi.

On a vast sweeping plain beside the "great water," the spongy area around the slow little river's mouth was called *che-cau-gou* by the Potawatomi Indians after the wild onion plants that grew there in abundance. The first permanent non-Native American resident of Chicago was Jean Baptiste Point du Sable, a black French fur trader, who built a cabin on the north bank of the river in about 1779. The region passed from French to American hands with the Louisiana Purchase of 1803 and was incorporated as the "Town of Chicago" (population 300) thirty years later.

With the development of the Illinois & Michigan canal in 1848, and the city's early simultaneous investment in railroads, Chicago became the leader in cattle, hog, lumber, and wheat industries, acting as a "golden funnel" to process and ship east the bounty of the prairie. Opportunities were plentiful, and by the mid-1850s, immigrants poured in at a rate of 100,000 a year. Chicago's secure location made it the Union's preeminent supply hub during the Civil War, and postwar Chicago seemed unstoppably prosperous.

Then, on October 8, 1871, the Great Chicago Fire raged through the town, laying waste to nearly four square miles of the city. With more than $200 million in damage and one-third the city's population homeless, Chicago's future lay in tatters, or so her detractors and rivals thought. "Chicago shall rise again!" crowed the local newspaper, and with "all gone but energy" Chicagoans went to work. Within two years, the entire city was rebuilt; within twelve, the city hosted twelve million guests at the World's Columbian Exposition, earning the nickname "The Windy City" for her boastfulness. The Great Fire united the citizenry as never before. By the late 1800s, Chicago had a population of over a million, placing her squarely behind a great city of the east. When a New Yorker deprecatingly referred to "the Second City," Chicago took up the moniker with pride.

The other positive to emerge from the Great Fire was the attraction of the nation's foremost architects. Chicago was wide open, a blank slate with no traditions but big ambitions. The resulting advances in skyscraper technology have led critics to hail Chicago as the "world capital of modern architecture." From the 1890s forward, Chicago's skyline sprouted a thicket of tall buildings, first masonry, then steel-framed, and is today home to three of the tallest buildings in the world. It was in Chicago that Louis Sullivan pioneered "functionalism" creating what is known today as the soaring Chicago School. Sullivan's student, Frank Lloyd Wright, revolutionized residential architecture. Instead of soaring, Wright's Prairie School designs take their inspiration from the horizontal planes of the Midwest and hug the earth.

Throughout, the "City of Big Shoulders" has had a reputation for toughness. "It is inhabited by savages," Rudyard Kipling wrote in 1889. Site of some of America's most notorious labor unrest (the Haymarket Affair, the Pullman Strike), Chicago became infamous for immigrant, and not to mention sanitation, abuse in Upton Sinclair's meat-packing exposé *The Jungle*. Political corruption was rampant, as was pollution. In the twenties, Chicago was that "toddlin' town," a hangout for the nation's most nefarious crooks and gangsters (Dillinger, Moran, Capone). Then, with the post-World War II influx of African Americans, the city developed a rep as among the most segregated of northern cities. Chicago is still fighting to right these wrongs, and signs—such as the election of the city's first black mayor in 1983—suggest the situation is improving.

Chicago today is a diverse and dynamic city, melding her status as international capital of commerce with down-home Midwestern good nature. Boston, Philadelphia, and New York owe big debts to European tradition, but Chicago, with her broad, spacious streets so perfectly rectilinear, and her gigantic, rule-breaking architecture, is one hundred percent American. Chicago is America's immigrant city, a patchwork of neighborhoods creating a great American quilt. Home to the largest Polish population outside of Warsaw, Chicago also contains tight-knit communities of Mexican, Russian, Irish, Italian, Chinese, Vietnamese, Czech, Croatian, Lithuanian, Ukrainian, Armenian, Assyrian, and Indian immigrants (just to name a few!). With a vast surfeit of attractions—the Art Institute, Field Museum, Shedd Aquarium, the Magnificent Mile, "duh" Bulls (Bears, Cubs, etc), world-famous comedy (Second City), and world-famous theater (Steppenwolf, Goodman), not to forget the blues—"Sweet home Chicago" is an American city second to none.

*Chicago Then and Now* pairs archival, black-and-white photos from the nineteenth and early twentieth century with full-color views from today to tell a story of the city's history. Historic photos may not exist for every street or neighborhood; likewise, historic streets or neighborhoods in a boomtown like Chicago may themselves no longer exist. Pairs have been selected based on symmetry (or lack of it), historic importance, and popular interest.

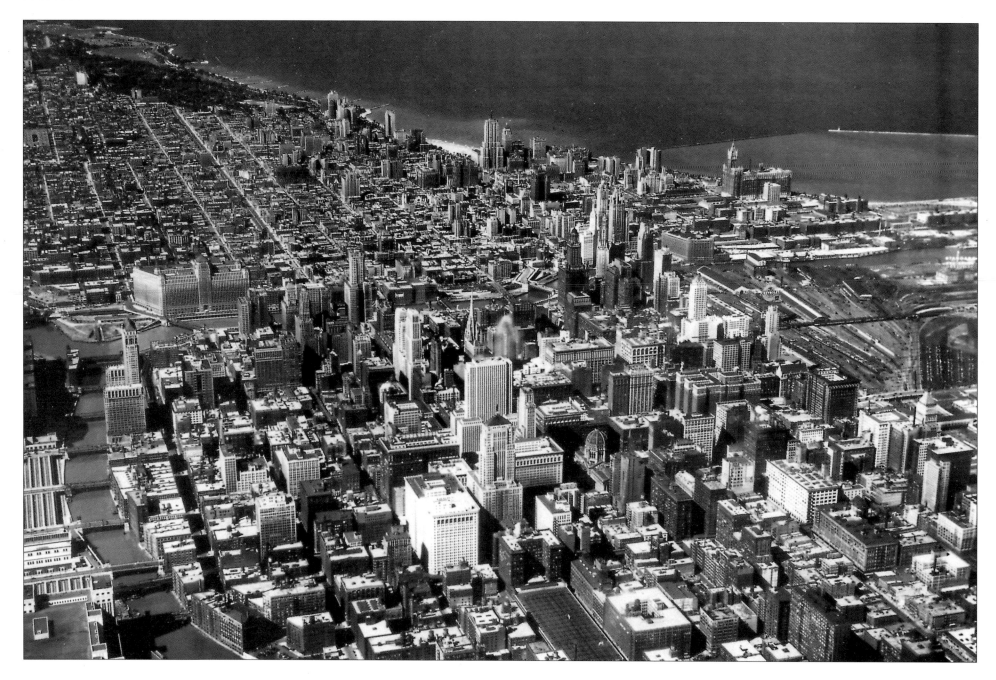

View toward the north-northeast, 1936. By the 1930s, Chicago was already taking shape as the home of America's boldest architecture. Some recently completed gems of the era include: the throne-like Civic Opera Building (1929) at left along the south branch of the Chicago River; the hulking Merchandise Mart (1930) on the river's east branch, with 4.1 million square feet, still today the world's largest commercial building; and, at center, Chicago's most famous art deco building, the Chicago Board of Trade (1930) topped with the pyramid.

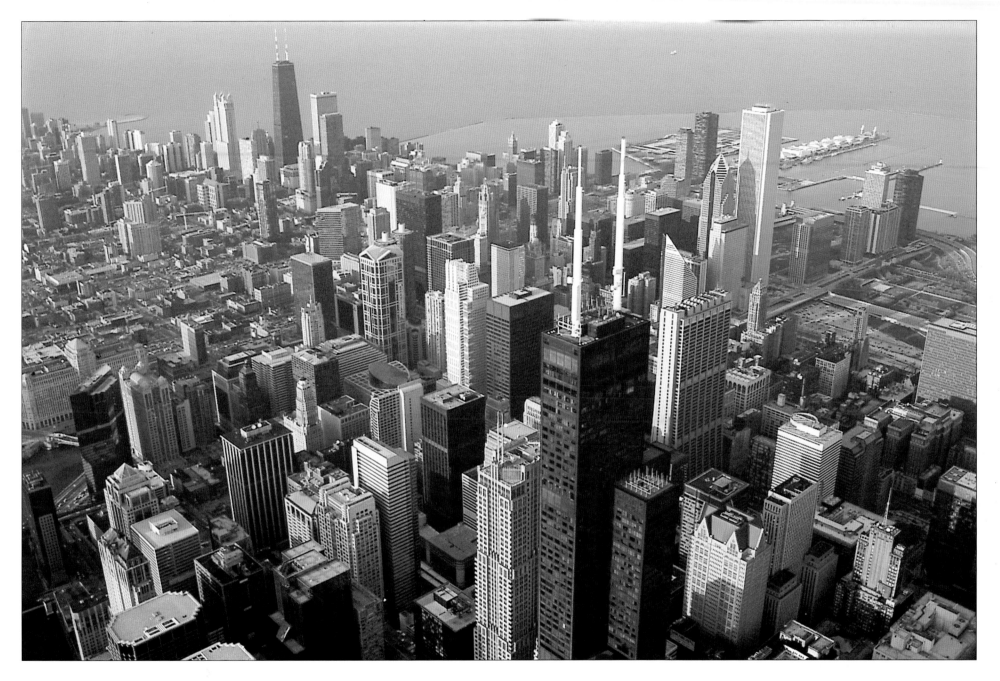

Today, skyscrapers crowd the view—Chicago boasts ten of the one hundred tallest buildings in the world. This view hovers over the Sears Tower (1974, 110 stories), the world's tallest building until 1996. The antennae seen here were replaced with taller models in 2000 to reclaim the tallest "height to tip of spire" title. At right stands Chicago's second tallest building, the sleekly rectilinear Amoco Building (1974, 82 stories), and at top right, the third of Chicago's big three, the 100-story John Hancock (1969).

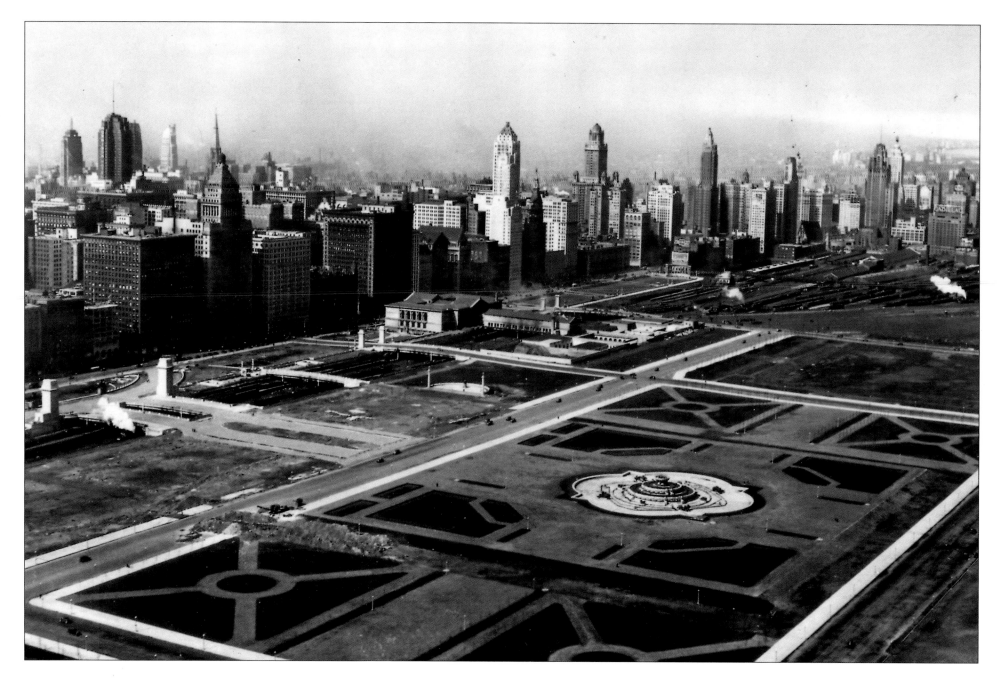

Part of Daniel Burnham's grand Chicago Plan was realized downtown in the construction of Grant Park. Seen here in 1929, the new park was built on 220 acres of lakefront landfill in a formal French style designed by the Olmsted Brothers. At center is one of Chicago's most cherished landmarks, Buckingham Fountain. Modeled on the Bassin de Latone at Versailles, only twice the size, the pink marble fountain was installed in 1927. The Art Institute (1892) faces Michigan Avenue whose skyscrapers dominate the skyline.

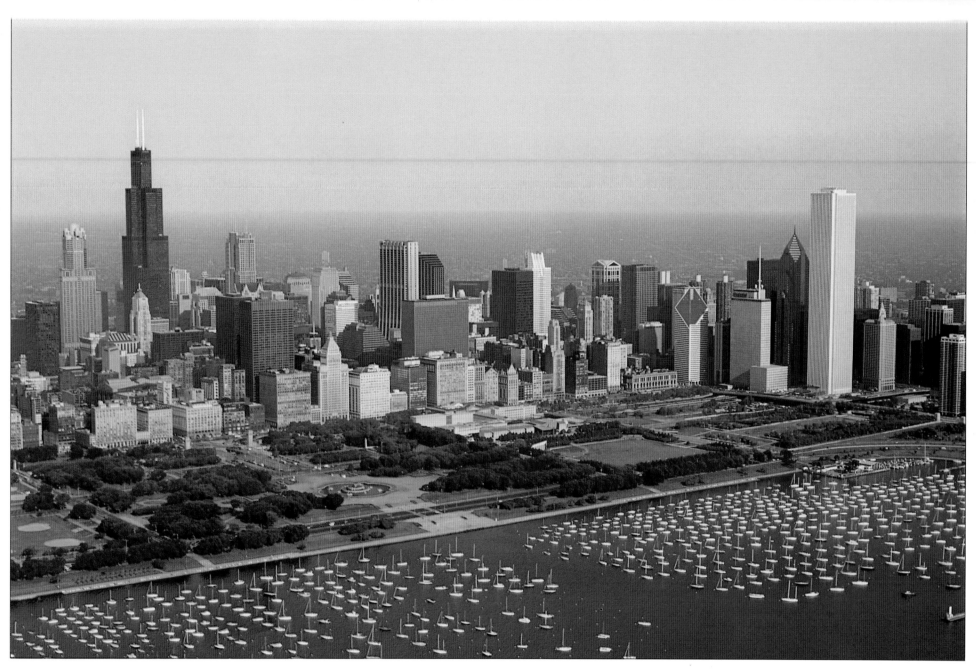

Today, Grant Park presents a lush green carpet along the city's lakeshore, and Buckingham Fountain gushes throughout the summer with a colored light display at night. To avoid the ban on "permanent structures" in the park, the Petrillo Music Shell, which hosts a variety of free concerts, can be disassembled (but the city never does so). The row of tall buildings facing the Art Museum on this stretch of South Michigan is wonderfully preserved, but twentieth-century skyscrapers now dominate the skyline. The city's two tallest buildings, the Sears Tower (*left*) and the Amoco Building (*right*) frame the view, and in the foreground, hundreds of boats rest at anchor in Chicago Harbor.

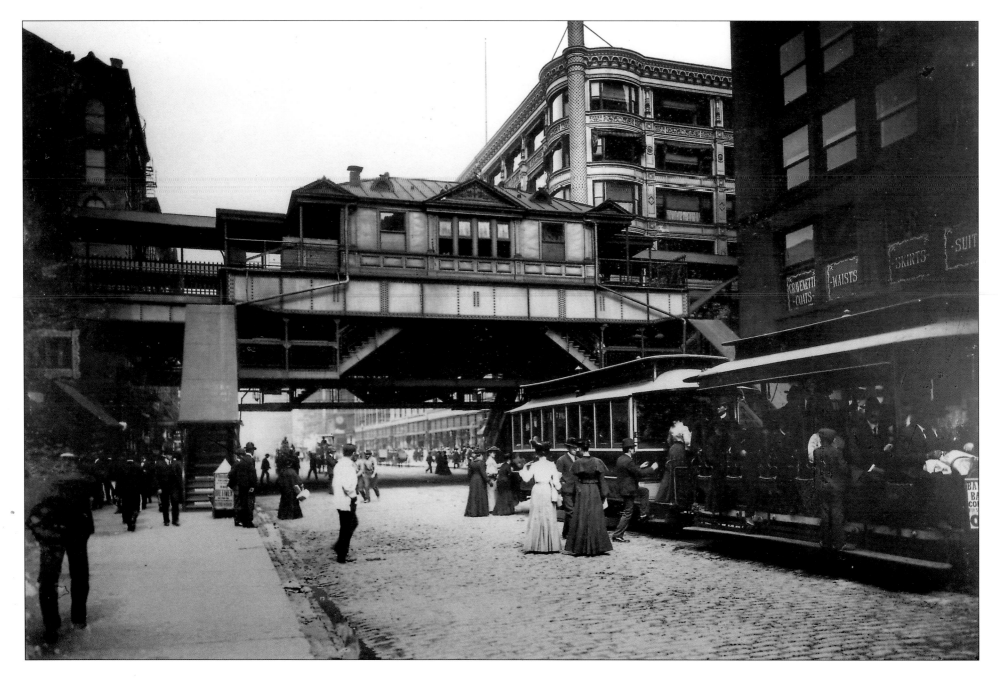

The nickname for downtown, the "Loop" refers to the rough circle of elevated rail (the "el"), completed in 1897, bounded by Wabash, Van Buren, Wells, and Lake streets, what Chicago novelist Nelson Algren called the city's "rusty iron heart." The "el" revolutionized turn-of-the-century commuting, with service to the south, and later west, side in almost half the time of streetcars.

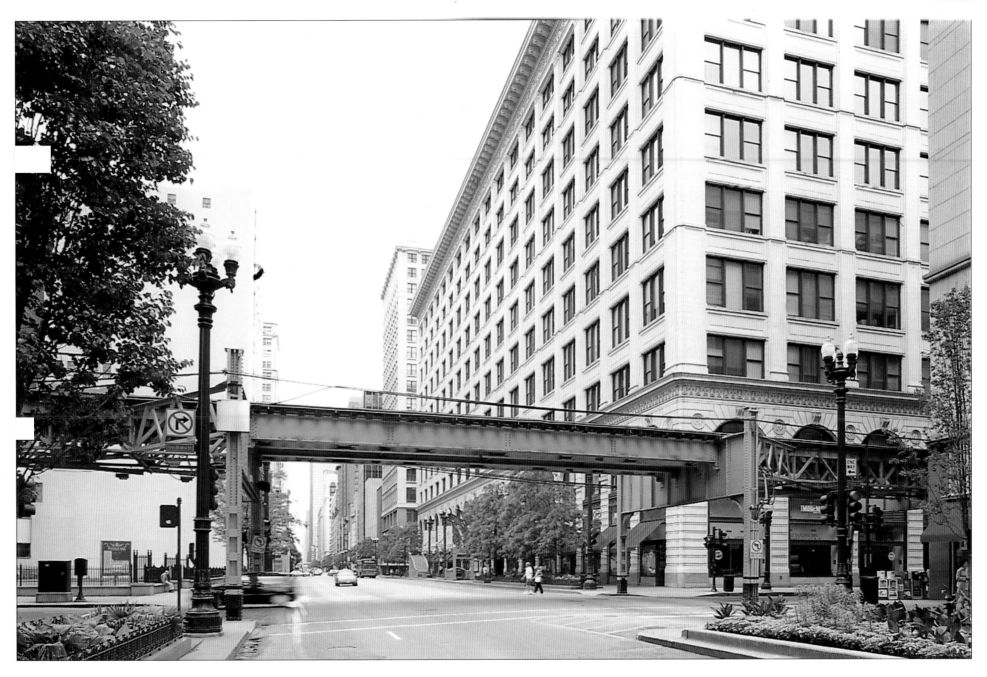

"El" stations were typically built quickly with lightweight, inexpensive materials such as wood and sheet metal, but they proved durable. Although this station was later removed, several originals are preserved today such as the Quincy Street Station. Looking north up State Street, the Rothschild Store with the eagle-topped column in the archival photo has been replaced by another building (1912, Holabird & Roche), later Goldblatt's, and now owned by DePaul University.

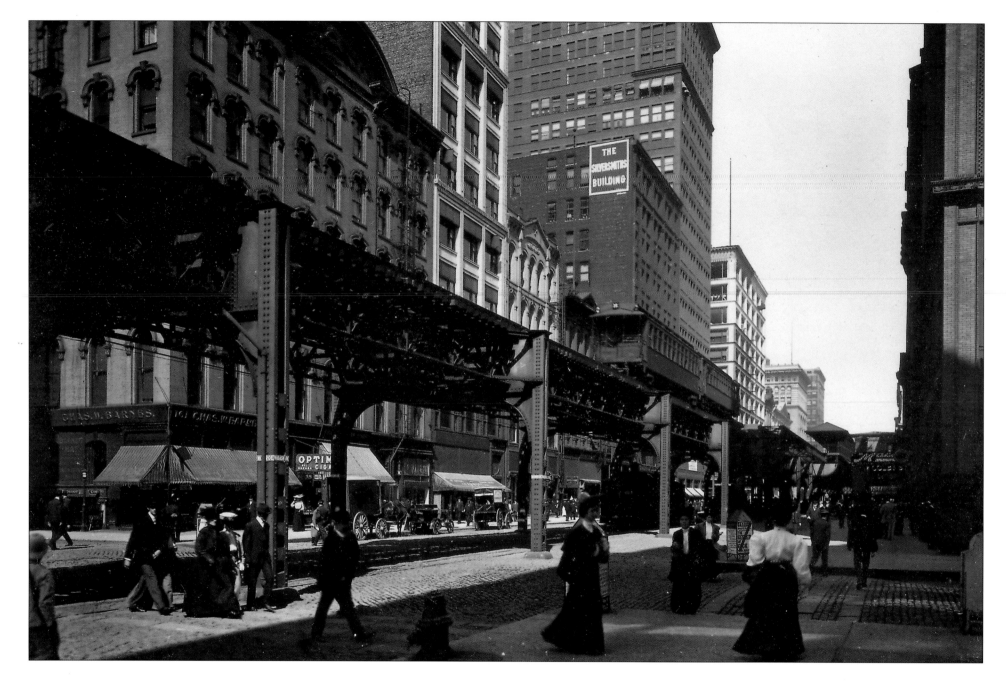

This view north from Monroe Street, circa 1905, shows how the "el" bisected city streets horizontally, but also vertically: the "el" was eye level with second-story windows. During an initial run in 1892 on what would become the Loop, one reporter noted that passengers witnessed "bits of domestic life usually hidden from the gaze of passing crowds." Although merchants initially resisted the "el," they soon discovered that the trains brought hordes of people into the area as never before, and property values near the "el" skyrocketed.

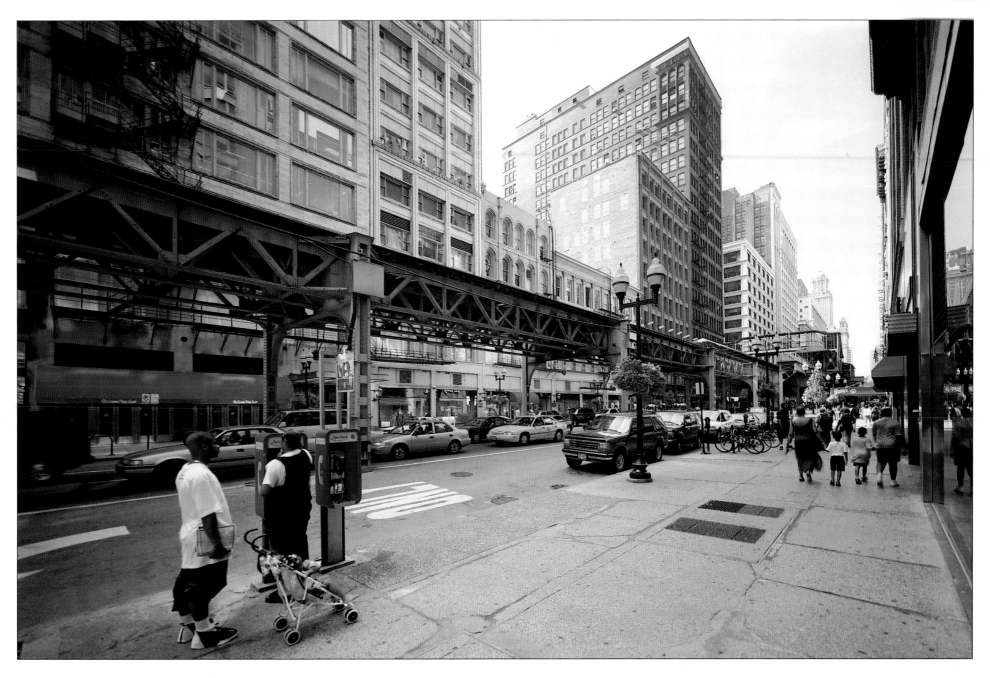

Today, cars and paving have replaced horsecarts and cobblestones, but Wabash has retained its commercial aspect. The three buildings preserved here, the Atwater (1877), and the Haskell and Barker buildings (1875), are considered the best examples of what the Loop looked like prior to the skyscraper boom of the 1890s. The white-painted iron facade of the Haskell was installed during alterations by Louis Sullivan in 1896. The old Silversmiths Building (1897) still stands, as does Mandel Brothers (1900), at the corner of Madison, where old Jewelers Row begins.

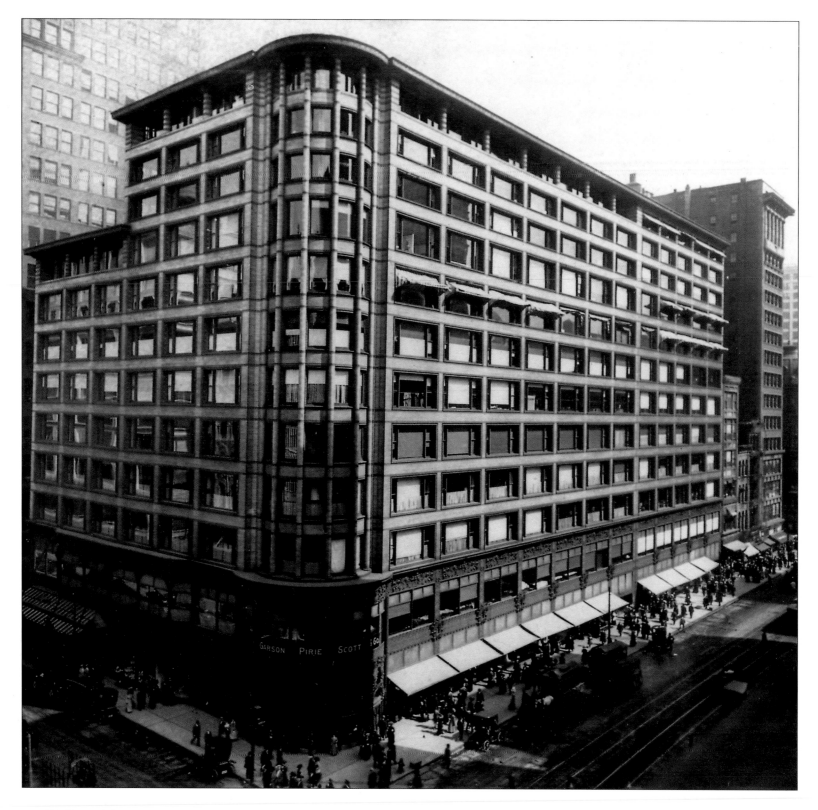

*Left:* Southeast corner of State and Madison, "the busiest corner in the world," circa 1912. Louis Sullivan's last major commission in Chicago, the Carson Pirie Scott store was originally the Schlesinger & Mayer store, but it was sold almost before completion in 1904. One of the first large department stores erected with entirely fireproof steel-frame construction, it became a model for architects around the world of skyscraper technology adapted for retail use, and an example of the seamless melding of beautiful form with everyday function.

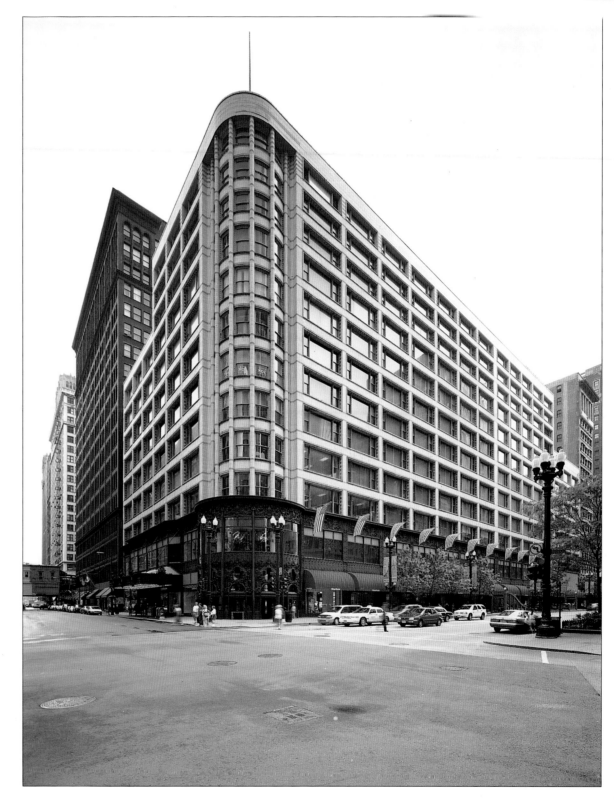

*Right:* Today, Carson's is a Chicago staple, and the building is widely regarded as a masterpiece of the Chicago School. With its rounded corner entrance, and the leafy cast-iron framing of the wide-paned windows, Sullivan united geometric and botanical motifs to create, in one critic's words, "a metaphor of the natural landscape," displaying Sullivan's genius for architectural ornament. The building was restored in 1979 and continues to be an anchor of State Street's "Retail Row."

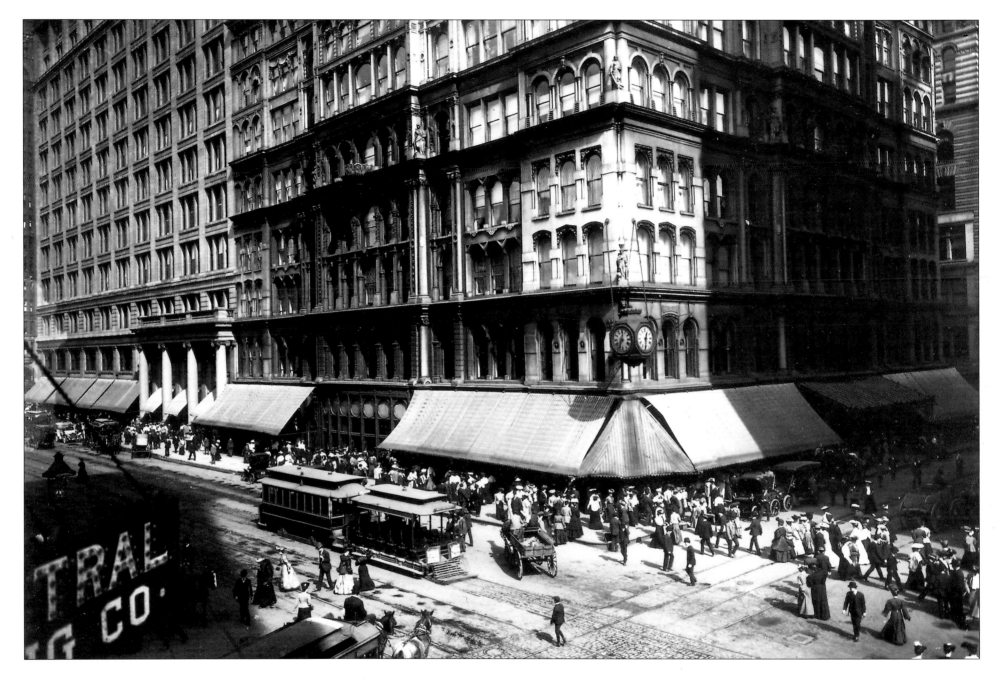

When asked about his business philosophy, retail entrepreneur Marshall Field quipped simply, "Give the lady what she wants." Since 1853, the store has been doing just that. First located on Lake Street, Field's moved to the new axis of business on State in the 1860s. After the Great Fire of 1871 destroyed the original building, the store grew piecemeal until it occupied the entire block. Burnham & Co. designed the present structure over the years 1892 to 1907.

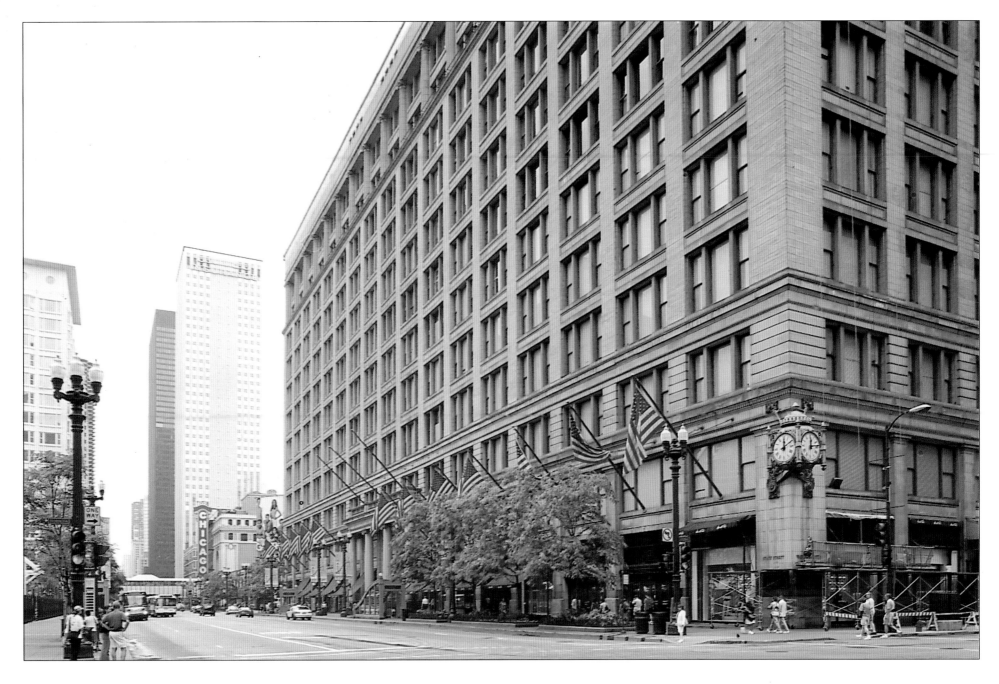

Upon its completion in 1907, a national magazine observed that Marshall Field's was "more than a store. It was an exposition, a school of courtesy, a museum of modern commerce." Today, with over 450 departments and 73 acres of merchandise, Field's is the "grande dame" of State Street. The corner clock is one of the Loop's most famous landmarks, and inside, the store features skylit atriums, one crowned with a shimmering glass mosaic dome by Tiffany.

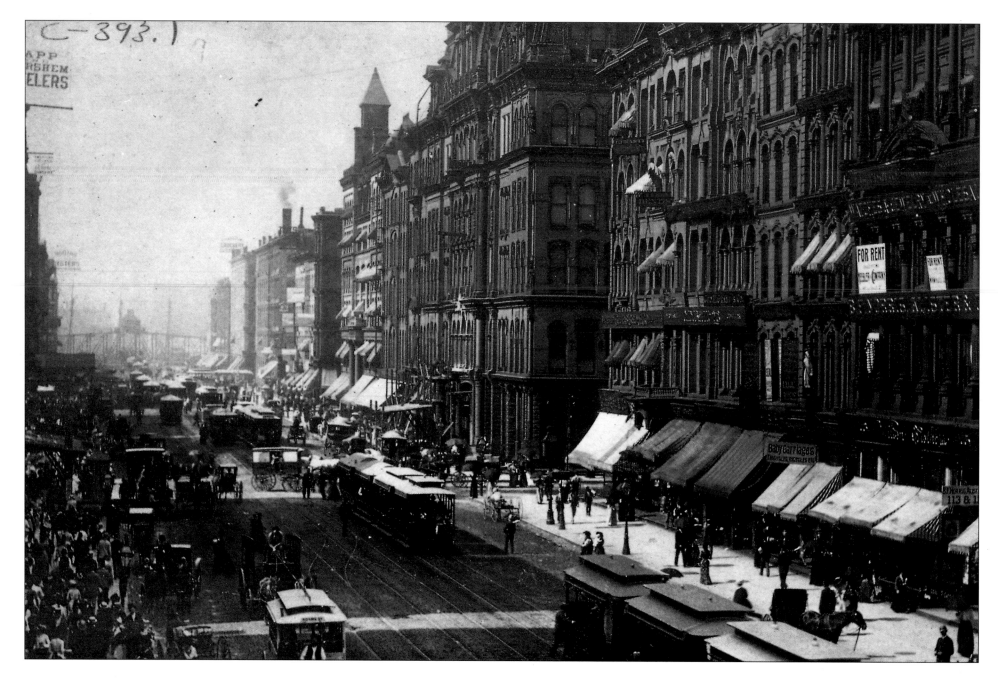

Until the 1860s, State Street was a cramped, muddy path lined with increasingly derelict balloon-frame shacks. Then successful retailer and would-be hotelier Potter Palmer invested in some land; within a few years the street was widened, paved (with wooden blocks at least), and Marshall Field's had taken up residence. By the 1890s when this photo was taken, besides Field's and Carson's, there were several other major retailers—the Boston Store, Mandel Brothers, Siegel Cooper—each with an enormous flagship on State.

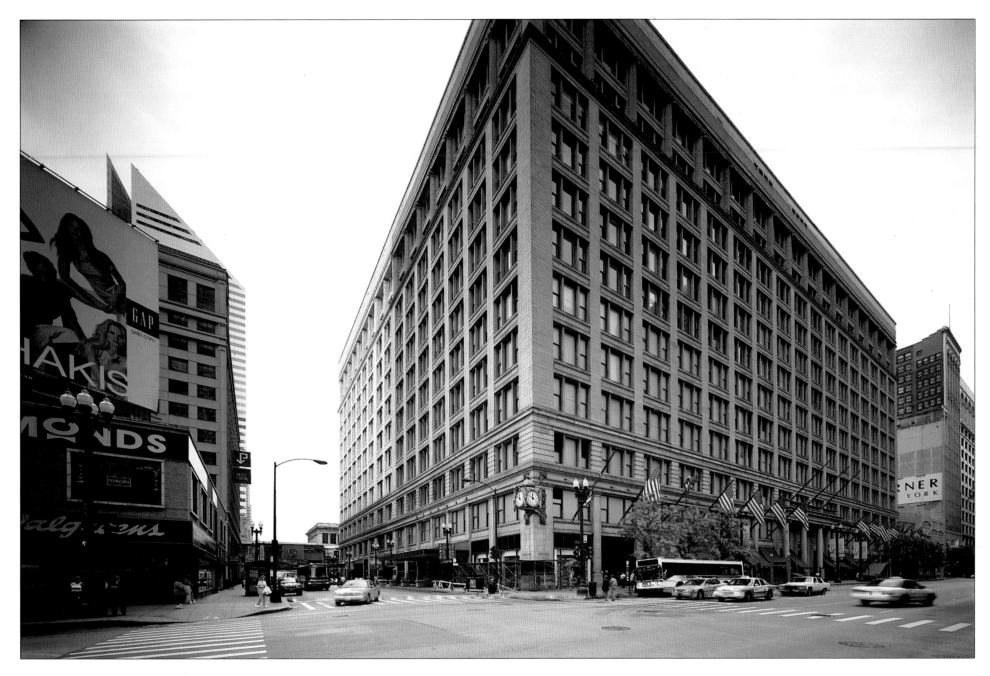

For most of the twentieth century, State Street was "That Great Street," home to an exciting retail district, second only to New York's Fifth Avenue. After the opening of the Michigan Avenue Bridge in 1920, however, business began slowly to migrate east and north. In an attempt to lure back pedestrians, the city closed State to cars in 1978, but this produced the opposite of the intended effect and has recently been revoked. Today, State Street still boasts its twin anchors, Field's and Carson's, and is poised to undergo a renaissance in the real-estate boom.

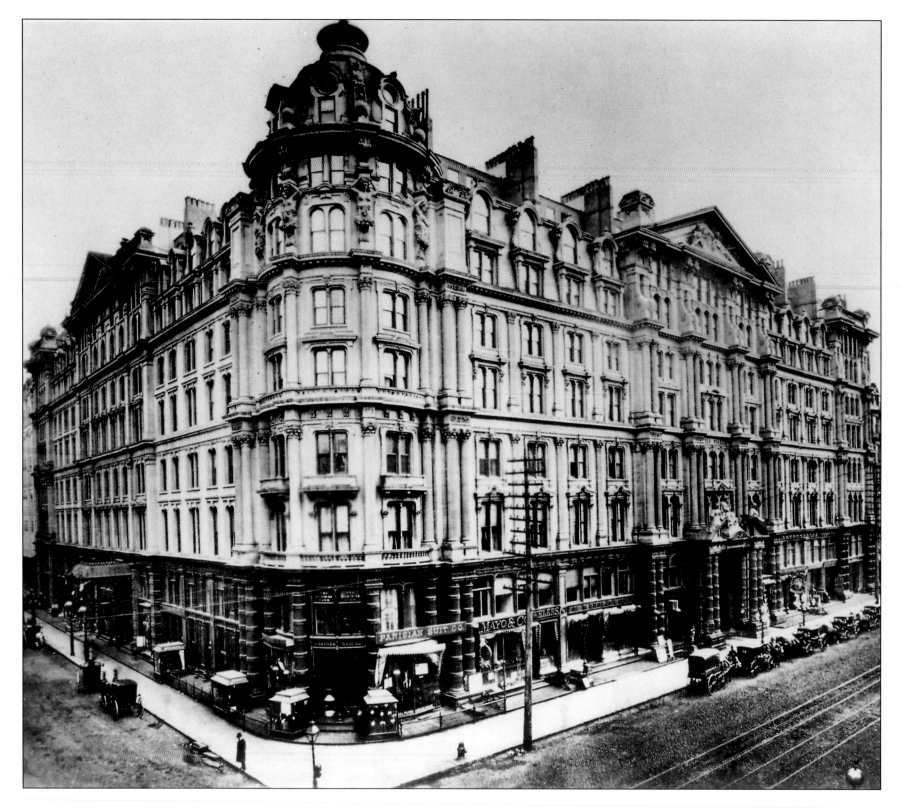

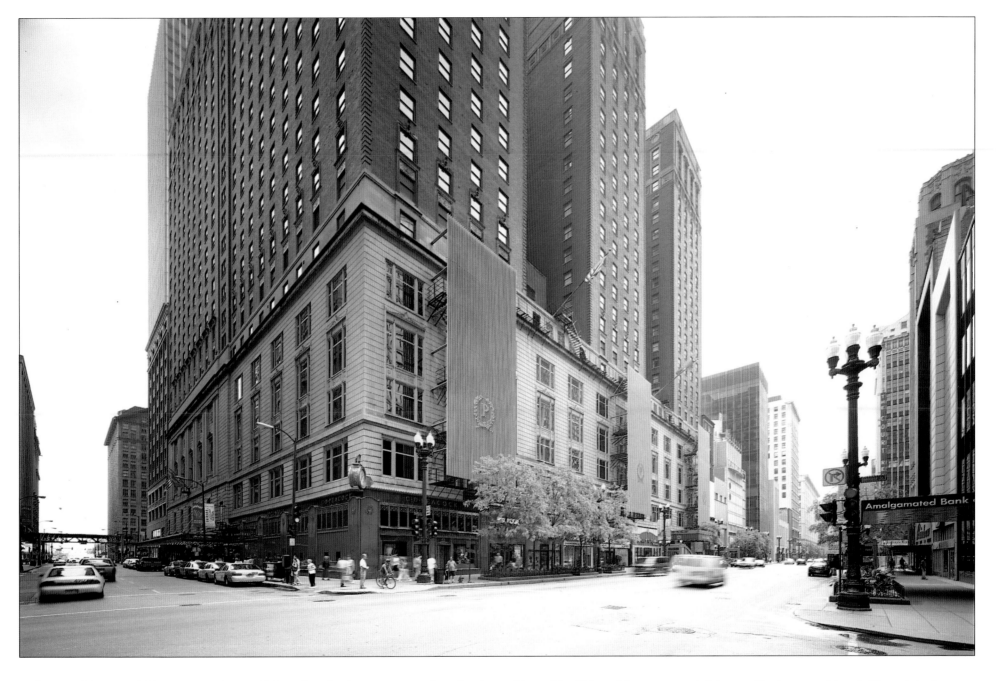

*Left:* In 1867, successful businessman Potter Palmer bought three-quarters of a mile of property on the ramshackle edge of town, State Street. Within two years, he had single-handedly transformed the area: convincing the city council to widen the street, inducing Marshall Field's to relocate from their premier Lake Street location, and replacing the tumbledown shacks at the corner of State and Monroe with the elegant Palmer House Hotel.

*Above:* The Palmer House seen at left is actually the second hotel. The original, which cost the then-outrageous sum of $300,000 to outfit, opened to great fanfare only thirteen days before the Great Fire of 1871. Potter Palmer rushed to rebuild, and in just a few years the grand rococo palace of the archival photo was completed. It was considered the grandest hotel of the day. Today, the Palmer House, a Hilton, is in its third incarnation, an elegant 1927 building by Holabird & Roche.

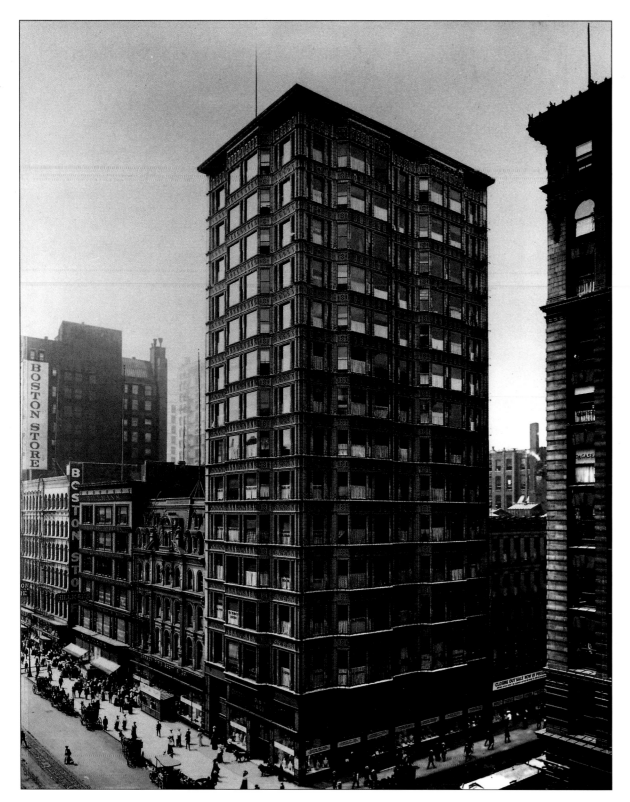

32 North State at West Washington, circa 1900. Advances in elevator technology combined with the explosive demand for office space in post-Fire Chicago to create the city's earliest skyscrapers. Burnham & Root were contracted to design this building, but after the foundations were laid, John Root died and his original plans were lost. Charles Atwood, another Burnham partner, took over, creating what is considered to be the best evidence for the Chicago School's role as the precursor of modern architecture.

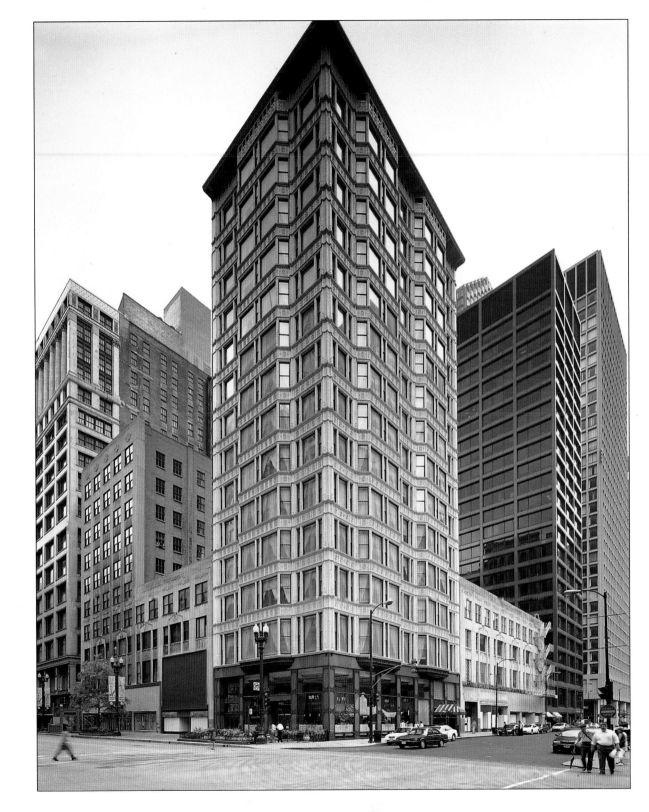

Today, over one hundred years after its construction, the Reliance (1895) is still considered the most elegant example of the Chicago style, complete with the first full example of the "Chicago window": a wide fixed pane with narrow movable sash windows flanking it. Structurally, with its then-radical wind-bracing techniques, the Reliance has more in common with the Amoco Building (1974) than its chronological peers. In 1996, the City of Chicago completed a full restoration of this gem. Its neighbor the Boston Store, now the State-Madison Building, is also preserved.

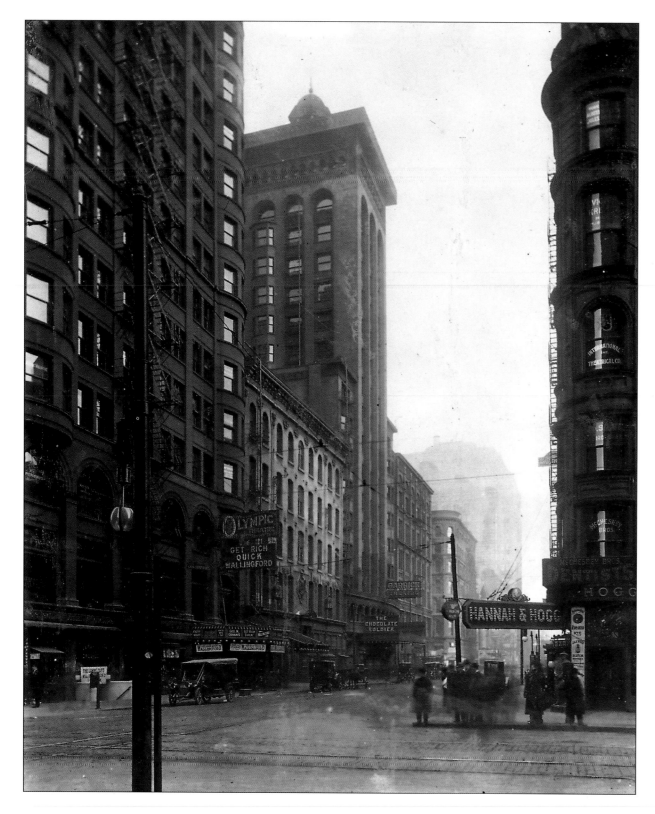

Randolph Street east from Clark, 1910s. From the 1880s until the Eisenhower era, Randolph near State, constituted Chicago's glittering theater district. The Olympic and the Garrick were two of the most important. Housing the Garrick, the tall building with the delicate arches and cupola is the seventeen-story Schiller Building, designed by Adler & Sullivan in 1892. At the corner of Dearborn stands the rounded, Italianate-style Delaware Building. Down the block was the Roof Theater, located in the city's then-tallest building, the twenty-one-story Masonic Temple (1892, Burnham & Root).

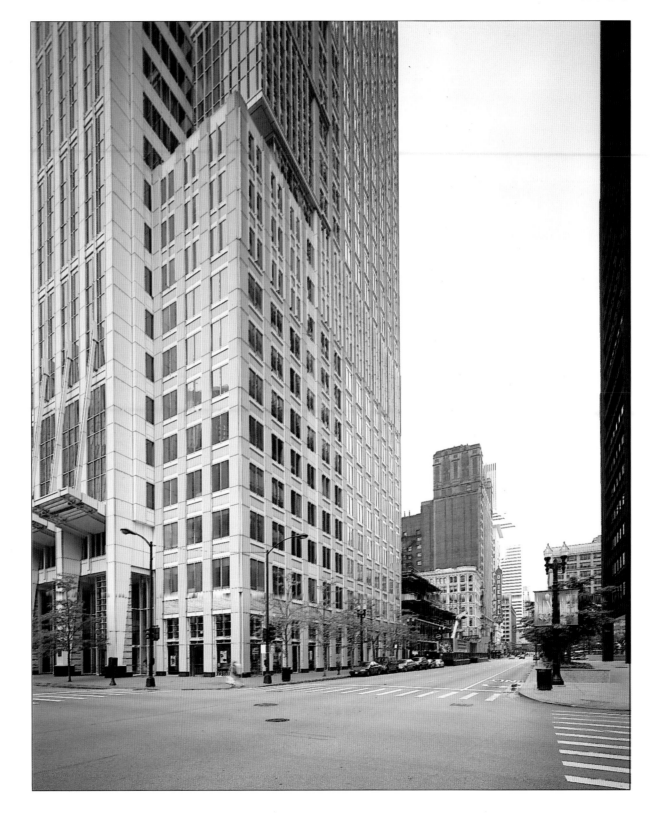

Today, Randolph is radically changed. In place of the Olympic, there is the Chicago Title & Trust Center (1992). The Schiller-Garrick was torn down in 1961 to make way for a parking structure, the Garrick Garage, which ironically incorporates some of the terra-cotta tiles from Adler & Sullivan's masterpiece. The Masonic Temple was demolished when the owners could not afford the property taxes, a fate not uncommon in Depression-era Chicago. The Delaware is now the Loop's oldest building, and the Oriental Theatre (1926) just beyond it is one of the last vestiges of the old neighborhood.

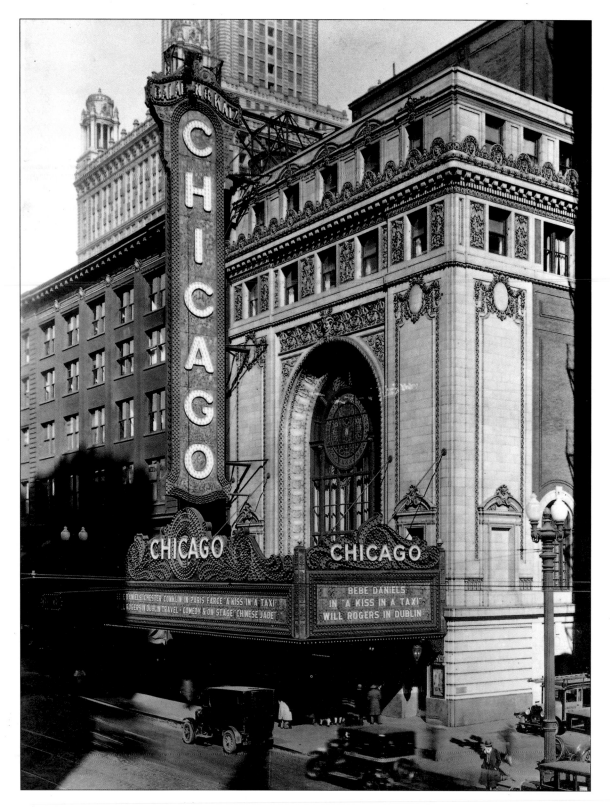

In the early 1920s, theater developers Balaban & Katz commissioned Rapp & Rapp to design two movie venues, the Tivoli (at 63rd and Cottage Grove, now demolished) and the palatial Chicago Theater. They would also later design another Chicago landmark—the Uptown Theater. The success of these models was so great that Rapp & Rapp went on to become "architects in residence" for the entire Paramount/Publix chain.

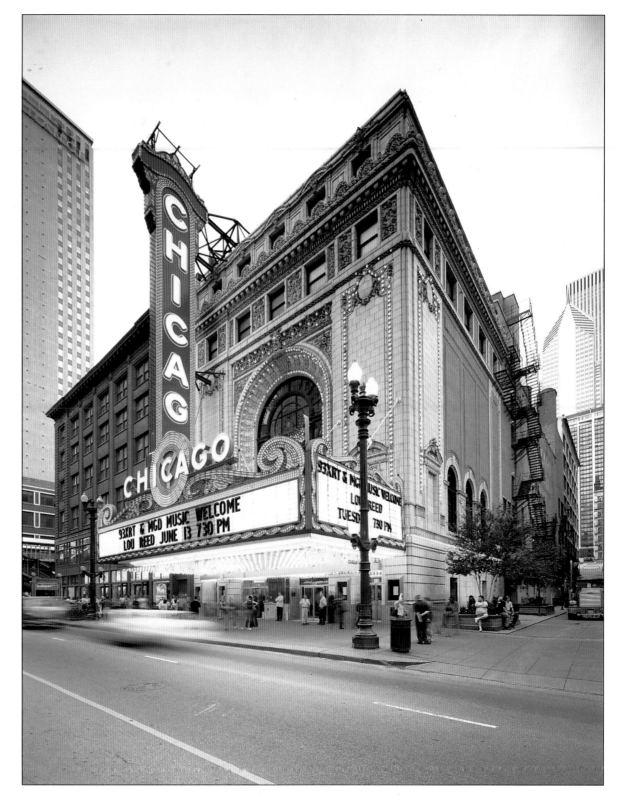

This Beaux-Arts style Classical Revival building was one of the first such buildings in the nation and is the oldest surviving in Chicago. The white terra-cotta triumphal arch behind the marquee opens into a series of lavish, Versailles-inspired spaces. The upright sign and marquee alone serve as an unofficial emblem of the city. The Chicago Theater was refurbished once for the 1933 World's Fair, but it would wait another fifty years before the lavish Baroque interior was restored in 1986. Instead of movies, the theater now features live concerts and performances.

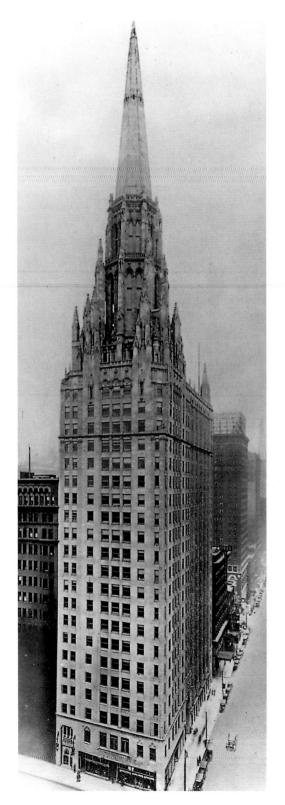

The First Methodist Episcopal Church, 77 West Washington. Built in 1923, and designed by skyscraper kings Holabird & Roche, the Chicago Temple is, in fact, a twenty-one-story office tower, crowned by a soaring, neo-Gothic, eight-story steeple, the only church spire in the Loop. At street level, stained-glass windows depict church history.

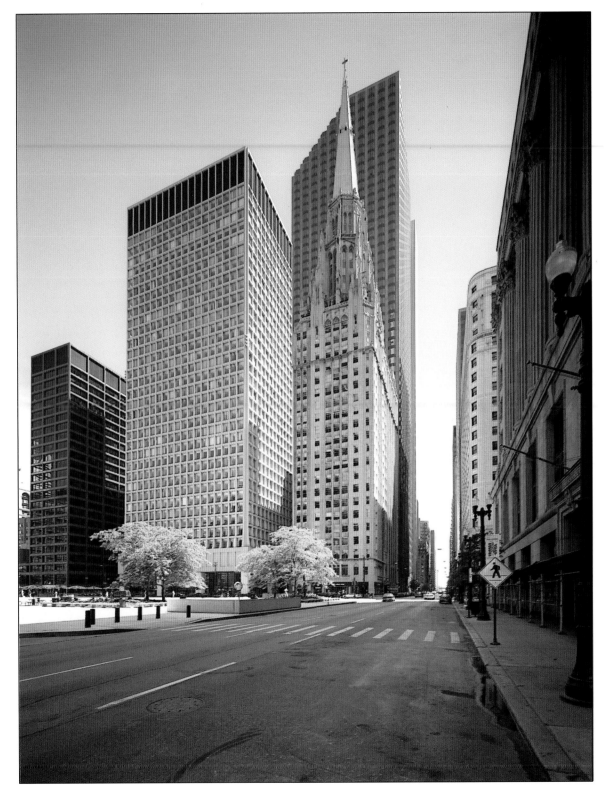

Today, the Methodist Episcopal Church still occupies the ground-floor sanctuary and maintains a chapel in the spire. At 568 feet, the Chicago Temple ranks as the world's tallest church, according to the Guinness Book of Records. Tall buildings now surround the church. From left: 33 North Dearborn (1967), 69 West Washington (1965), and Three First National Plaza (1981), all three by Skidmore, Owings, & Merrill.

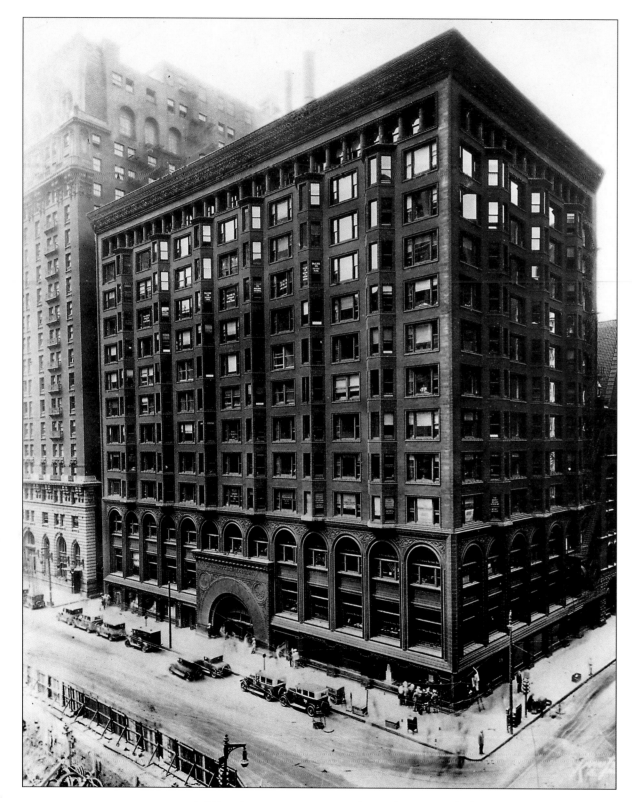

Southwest corner Washington and LaSalle. Founded in 1882, the Chicago Stock Exchange was the second largest in the United States. In 1894, they commissioned Adler & Sullivan to design this thirteen-story building. Skyscraper construction was always tricky on Chicago's marshy ground, and here the architects resorted to caisson foundations, among the first such used in Chicago, to help prevent damage to the newspaper presses of the neighboring Herald Building at right (demolished 1936).

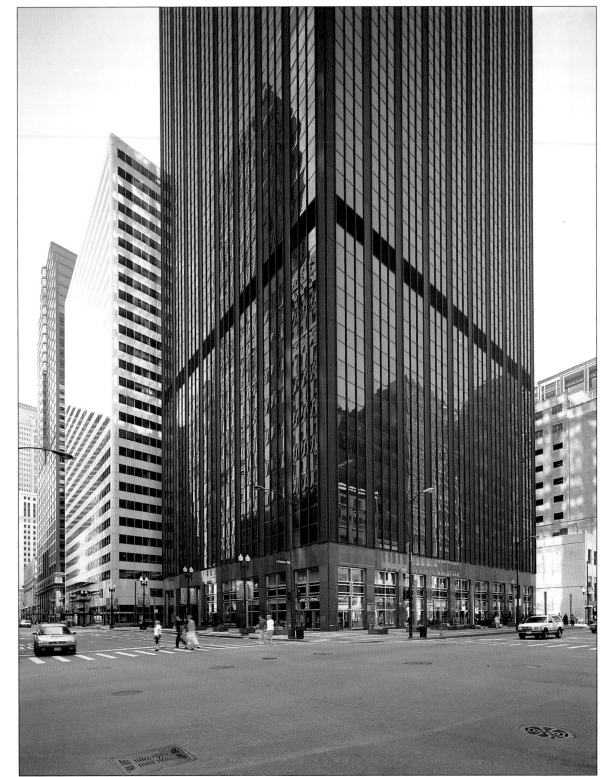

The archival photo was taken in 1928, two years before the Exchange moved out. The building then sat during the Depression, with no investor willing to take on the tax burden. Despite the best efforts of the city landmarks commission, Adler & Sullivan's Stock Exchange was torn down in 1972. Today, the interior trading room, with Sullivan's gorgeous stenciling and stained glass, is preserved at the Art Institute, as is the graceful entrance arch, called by one critic the "Wailing Wall of Chicago's preservation movement."

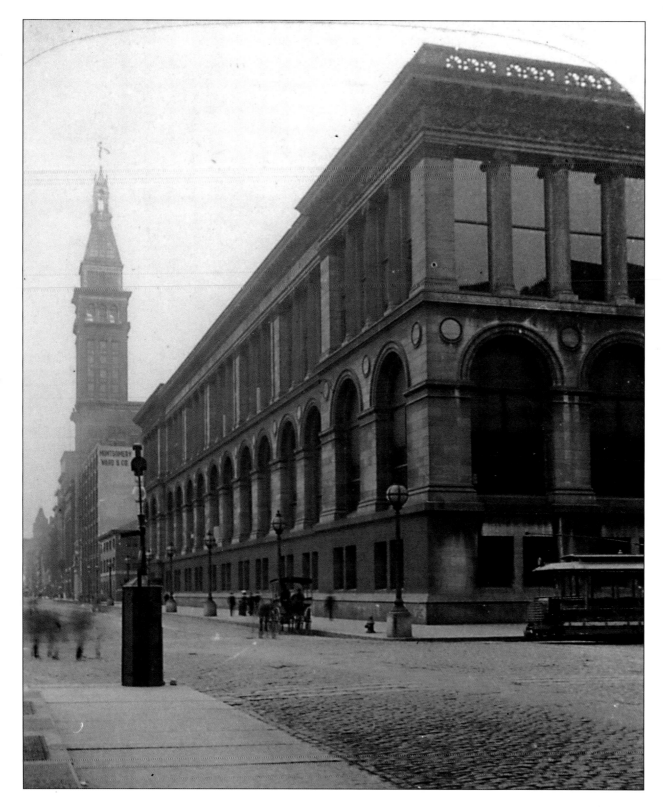

Michigan Avenue south from Randolph, circa 1900. In the wake of the devastation caused by the Great Fire of 1871, sympathetic Britons sent over 8,000 books, many signed by famous authors. The books were stored until a suitable location was secured. Boston architects Shepley, Rutan & Coolidge, who were then designing the Art Institute, were commissioned to design the building, and in 1897, the grand Renaissance palazzo-style Chicago Public Library opened. The Montgomery Ward Tower Building (1899) stands in the background, topped by the gilded female weathervane sculpture *Progress Lighting the Way for Commerce.*

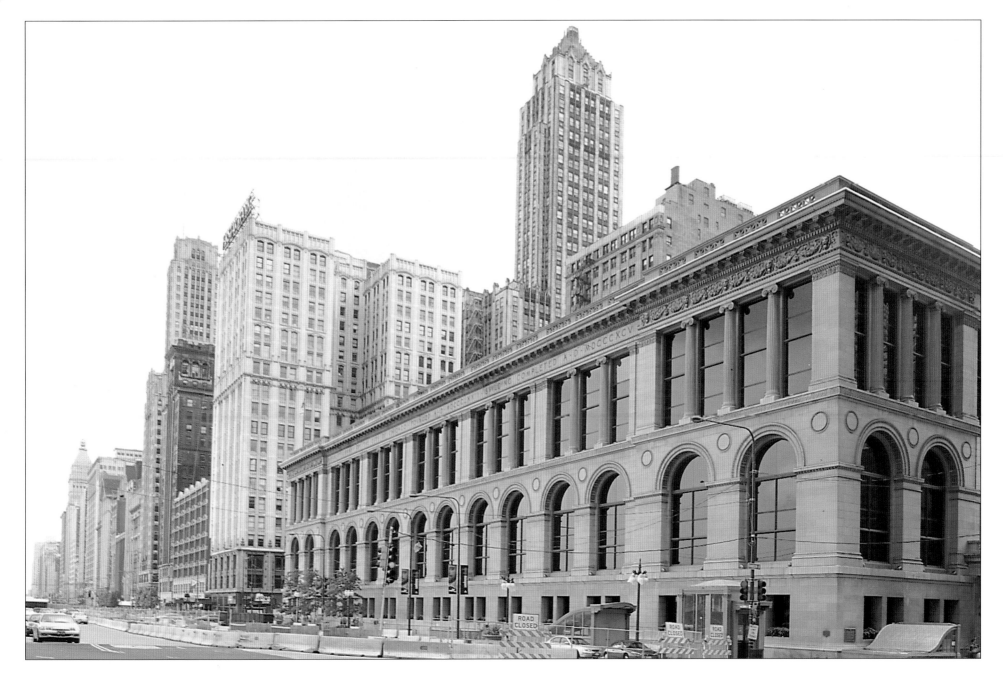

The Public Library was renovated and modernized in 1977, and, with the construction of the new Harold Washington Library in 1991, became officially known as the Chicago Cultural Center. No expense was spared on construction of the original library, from the granite exterior to the rare marble and beautiful mosaic interior. The building endures as an emblem of Chicago in the 1890s, when the city sought to attain the status of a cultural, as well as commercial, powerhouse. The Tower Building still stands, although its eponymous ten-story tower was removed in 1947.

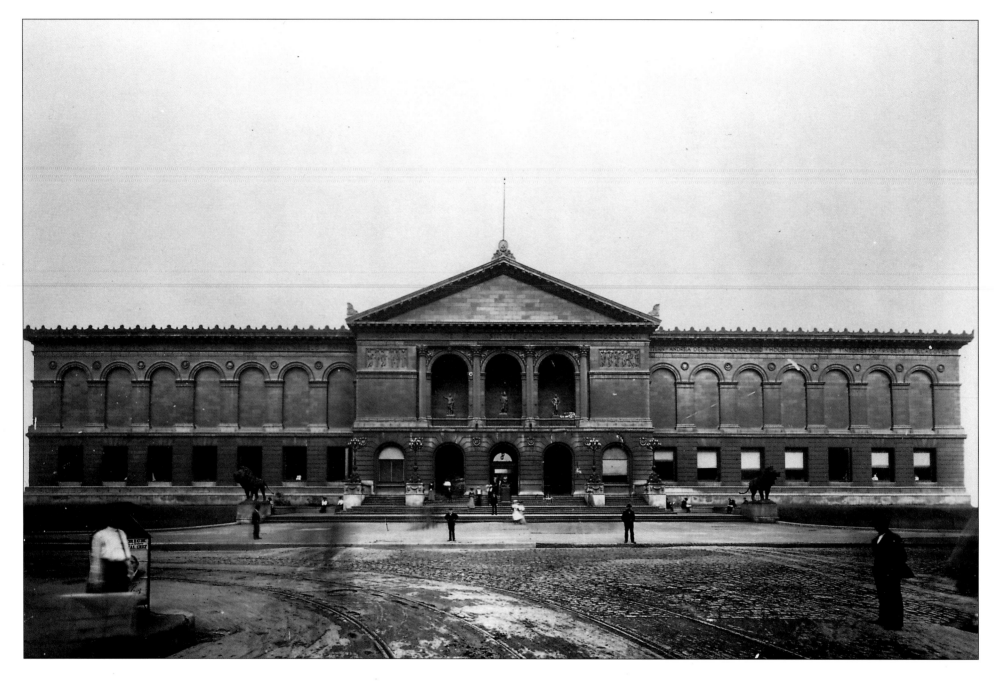

Incorporated in 1879, the Art Institute blossomed during the preparations for the 1893 World's Fair. The previous museum had outgrown its quarters on the west side of Michigan Avenue, and the city's foremost philanthropists decided to secure Chicago's cultural standing with a grand new building. Since Chicago's premier firm, Burnham & Co., was busy designing the buildings for the Fair, the Boston firm of Shepley, Rutan, & Coolidge was engaged to design this traditional Classical-Renaissance style museum in 1892.

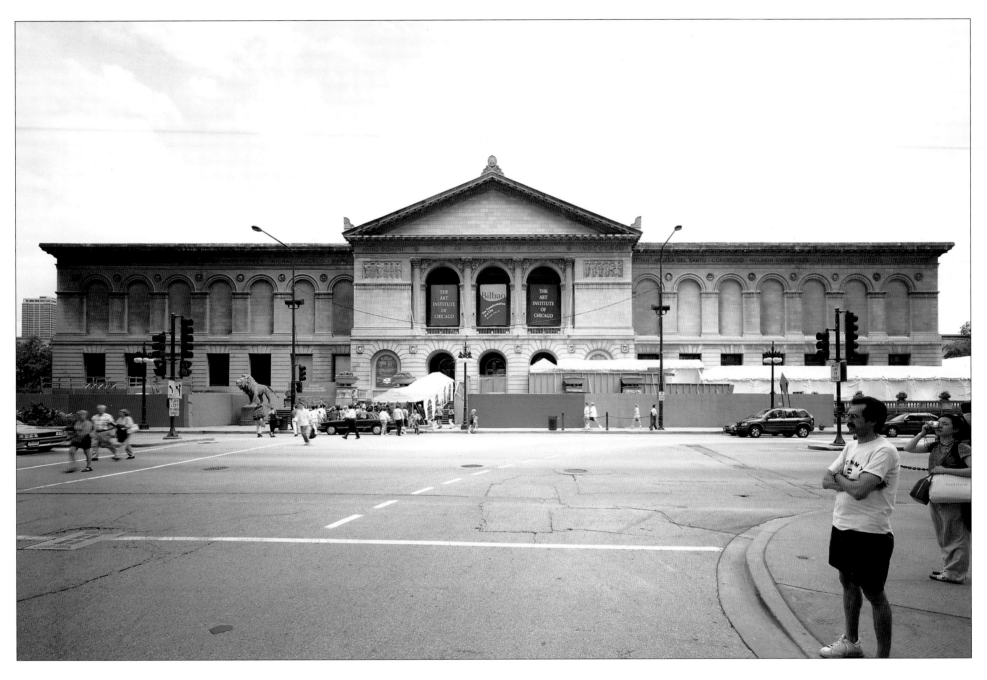

No fewer than seven additions/major alterations have been performed to the Art Institute, and even now, it is undergoing renovation. Unveiled in 1894, the bronze lions flanking the Michigan Avenue entrance are the work of Edward Kemeys. (One has been removed for cleaning). Chicago donors took a risk in the 1880s, investing in then-radical French artists, and today the Institute boasts a world-renowned Impressionist collection. Highlights include Monet's *Haystack* series and Seurat's *A Sunday on La Grande Jatte—1884*, the inspiration for Sondheim's musical *Sunday in the Park with George*.

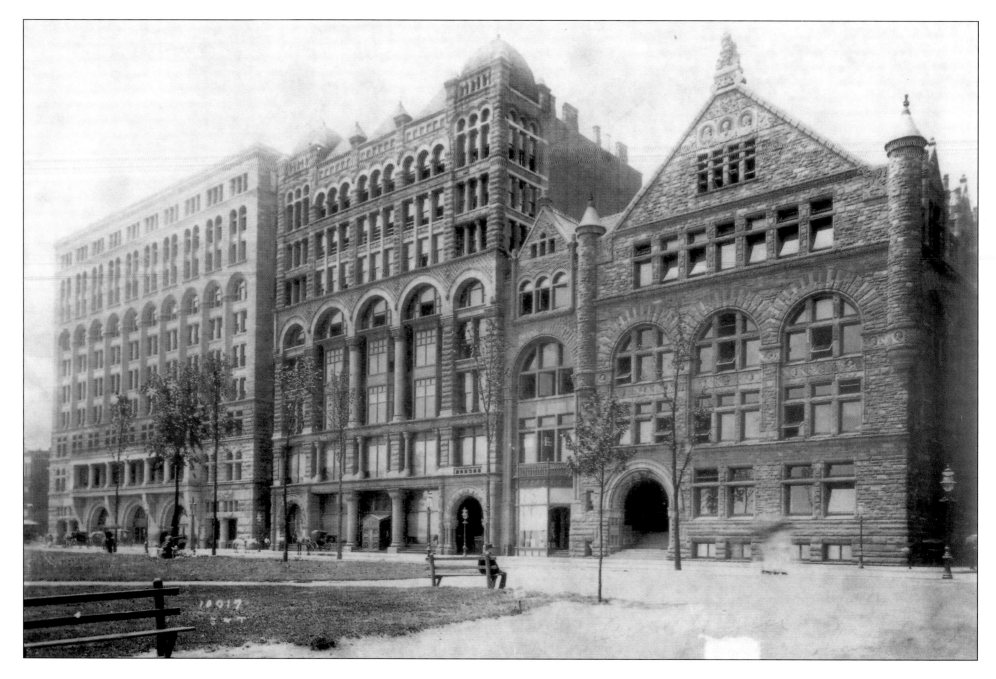

South Michigan Avenue circa 1890 featured several fine examples of the prevailing Romanesque style. The Auditorium Building stands at left, a theater-hotel-office complex that established Adler & Sullivan as the forerunners of modern architecture. When completed in 1889, the Auditorium's eight-story tower on its south face, rising above the ten-story building, was the highest point in the city. At center, designed in 1885 with abundant windows to light carriage showrooms, the Studebaker Building was reborn in 1889 as the Fine Arts Building. At right, the original, Burnham & Root-designed Art Institute.

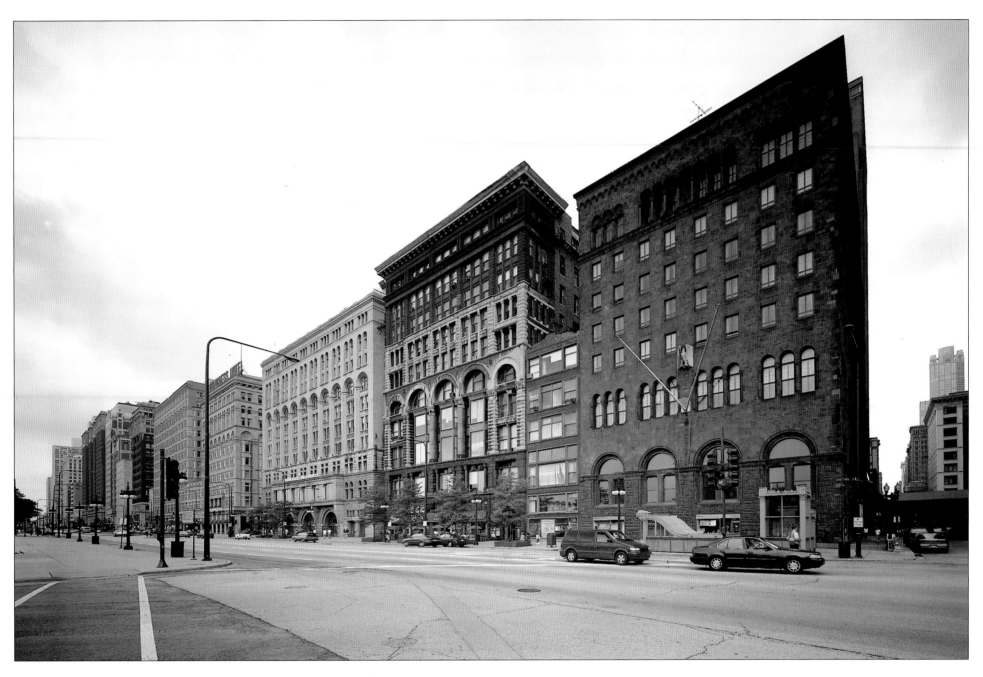

Today, Roosevelt University occupies the Auditorium complex, having purchased it in 1946 and converted the hotel and office space into classrooms. The theater is still operational and famed for its superlative acoustics and sightlines. Home to the Chicago literary movement of the 1920s, the Fine Arts Building (*center*) today contains an art-film house on the first floor and numerous music and dance studios above. When the new Art Institute was built in the 1890s, the private Chicago Club purchased the old building at right; however, during renovations in 1929, the original structure collapsed. The new Chicago Club was inspired by its predecessor.

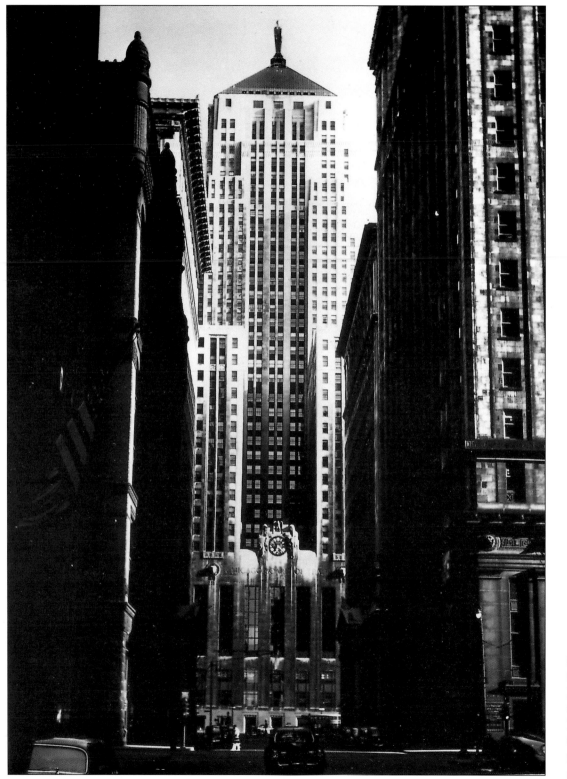

South LaSalle Street is to Chicago what Wall Street is to New York. Overlooking this canyon is the art deco Chicago Board of Trade Building (1930), designed by Holabird & Root with a pyramid roof topped by a thirty-foot statue of Ceres, the Roman goddess of grain. Founded in 1848, the Chicago Board of Trade originally promoted Chicago commerce in general, but changes in the grain market following the Civil War led to a new focus. By 1875, the city boasted a grain trade of $200 million and grain futures of $2 billion.

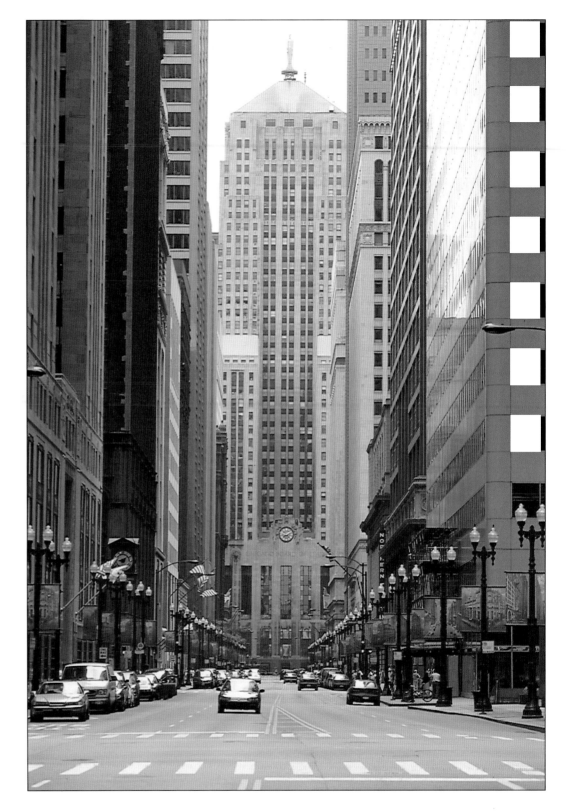

Today, the LaSalle Street canyon is refreshingly unchanged—at left, the Rookery and the Continental Bank, and at right, the Federal Reserve and the 208 S. LaSalle Building. The Board of Trade Building seen here is almost twice as large as the original thanks to a dramatic 1980 addition to its southern face. The Chicago Board of Trade is today the oldest and largest futures exchange in the world, trading agricultural products, as well as treasury notes, municipal bonds, and metals, in its hectic, signature "open outcry" system.

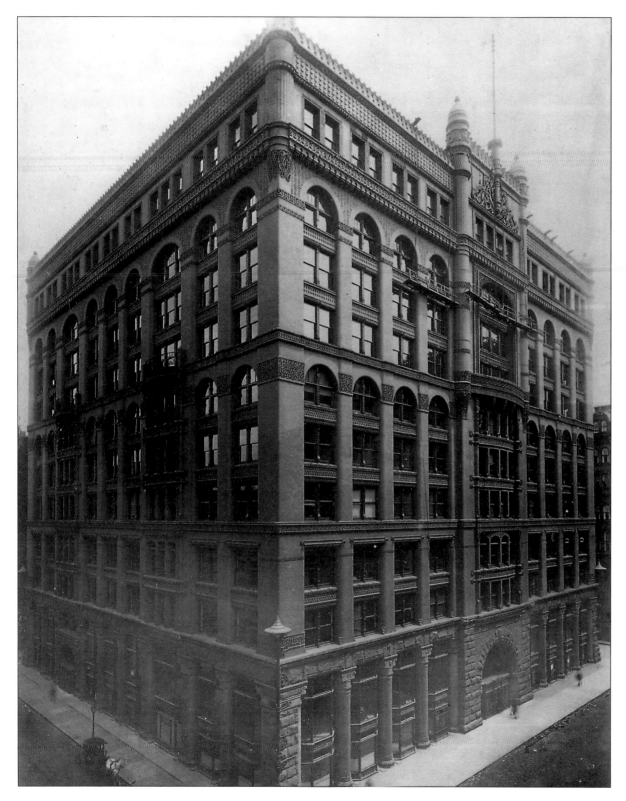

After the Great Fire of 1871, a dilapidated structure on the corner of LaSalle and Adams housed a temporary City Hall. Whether named for the pigeons or the roosting politicians, the building became known as the Rookery. When Burnham & Root were contracted to design a new structure for the block, the name stuck. Completed in 1888, the Rookery, with its Romanesque arches, was considered "a thing of light" and "the most modern of office buildings."

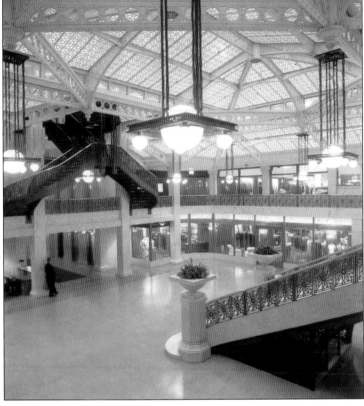

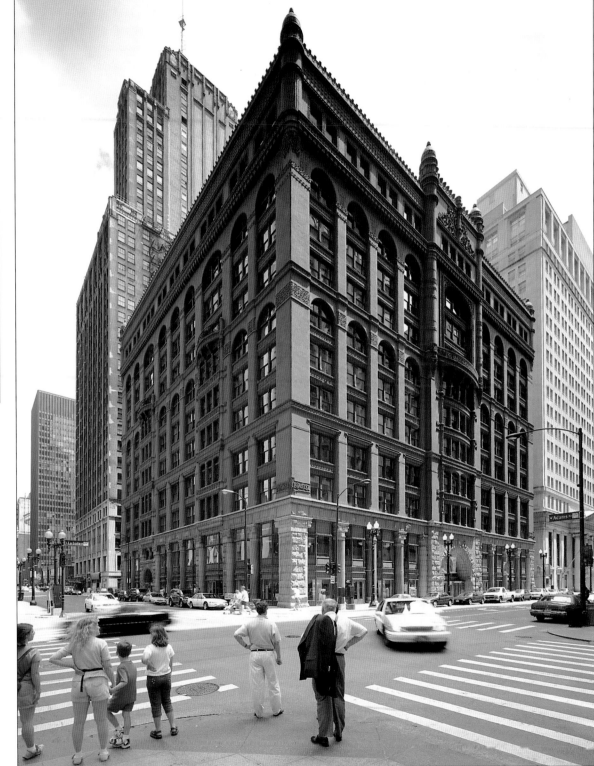

Immensely successful architects Burnham & Root designed over two dozen commercial buildings in the 1880s and 1890s; of them, only the Rookery remains. One of the "final monuments of the art of masonry architecture" in Chicago before the iron-skeleton revolution, the Rookery was completely revitalized in the early 1990s, and many historic features, such as the skylit lobby (*inset*), designed by Frank Lloyd Wright in 1905, were restored.

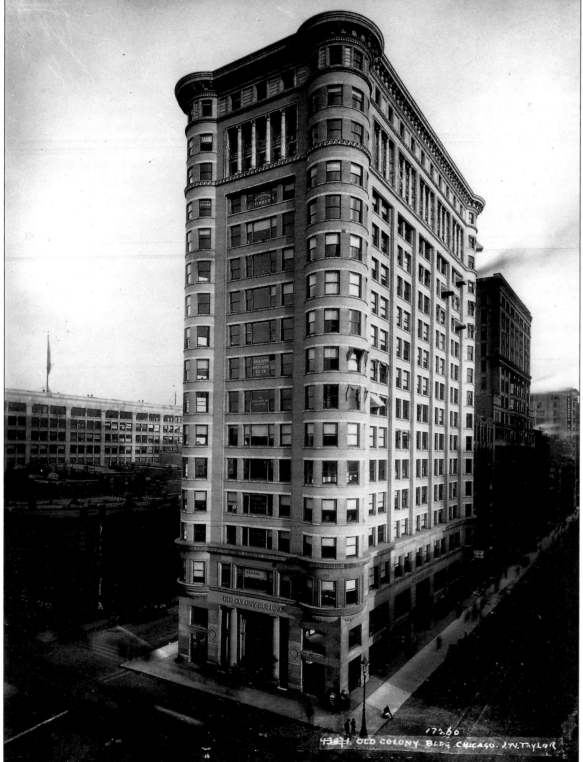

Dearborn Street at Van Buren, circa 1895. Designed by Holabird & Roche in 1894, the seventeen-story Old Colony Building was one of several Chicago School skyscrapers with gracefully rounded corner bays, designed to maximize desirable corner office space. Behind the Old Colony stands the Manhattan Building by William Le Baron Jenney. Upon completion in 1891, it was the first tall building to use skeleton construction throughout, the first sixteen-story building in the U.S., and briefly the world's tallest building.

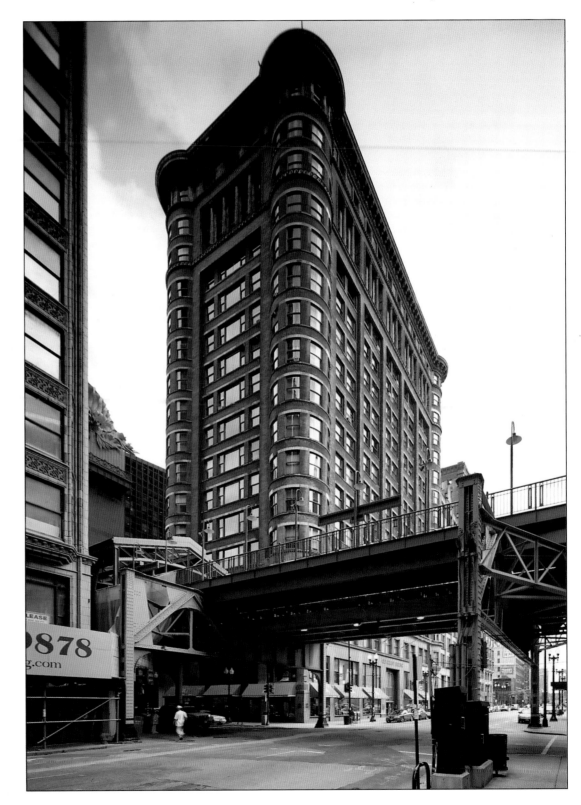

Today, the Old Colony and the Manhattan are separated by the 1899 Plymouth Building, designed by a student of Adler & Sullivan. The "el" tracks were built in 1897, obscuring the graceful, column-framed entrance of the Old Colony, which is now the sole surviving round-cornered building. The gargantuan Harold Washington Library (only the British Library is bigger) is visible at left. Completed in 1991, this ten-story, neo-Classical structure references several masterpieces of Chicago architecture.

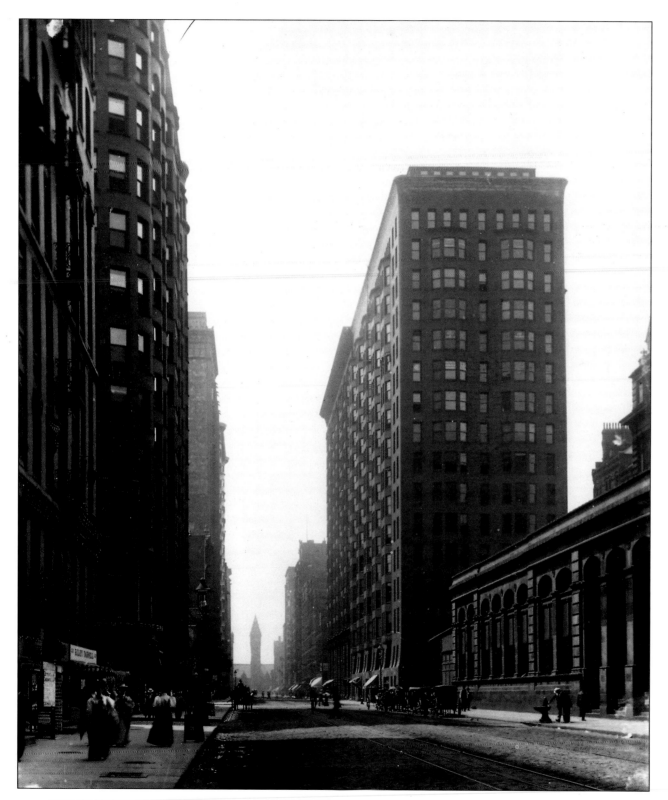

View south from Adams Street, circa 1895. At right, the Monadnock "Building" (actually two buildings). Burnham & Root designed the northernmost building in 1891. A brick tower, 66 feet wide, 200 feet long, and 200 feet high, the masonry-construction Monadnock has walls six feet thick at street level and was remarkable for its lack of exterior ornament. The southern addition by Holabird & Roche is a steel frame clad in terra cotta. In the distance is the Dearborn Street Station.

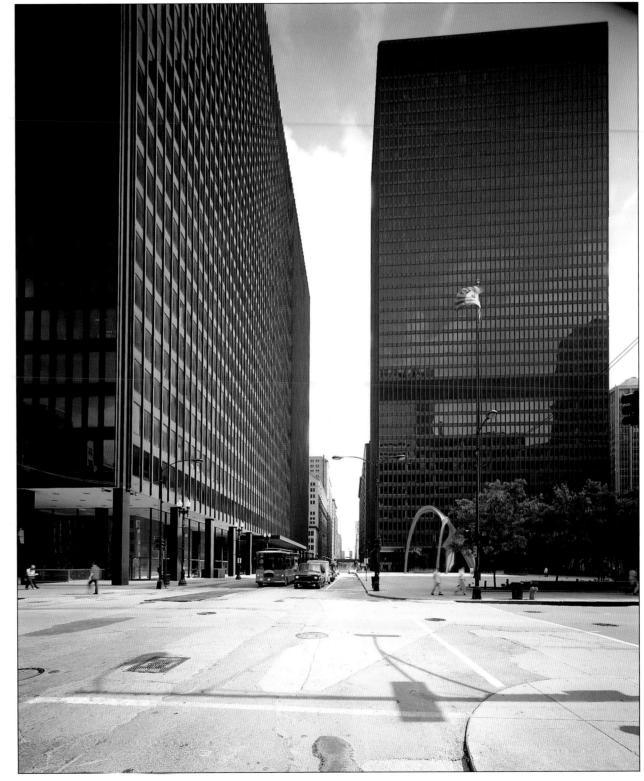

Today, the block of Dearborn between Adams and Jackson is dominated by the Chicago Federal Center, actually an assortment of mid-twentieth-century curtain-wall buildings designed by reductivist ("less is more") pioneer, Mies van der Rohe. In the midst of the plaza at right is Alexander Calder's vermilion-painted steel construction *Flamingo*. The Monadnock Building, both masonry and steel-frame portions, still stand, as does Dearborn Street Station, although it is partially obscured now by the elevated rail.

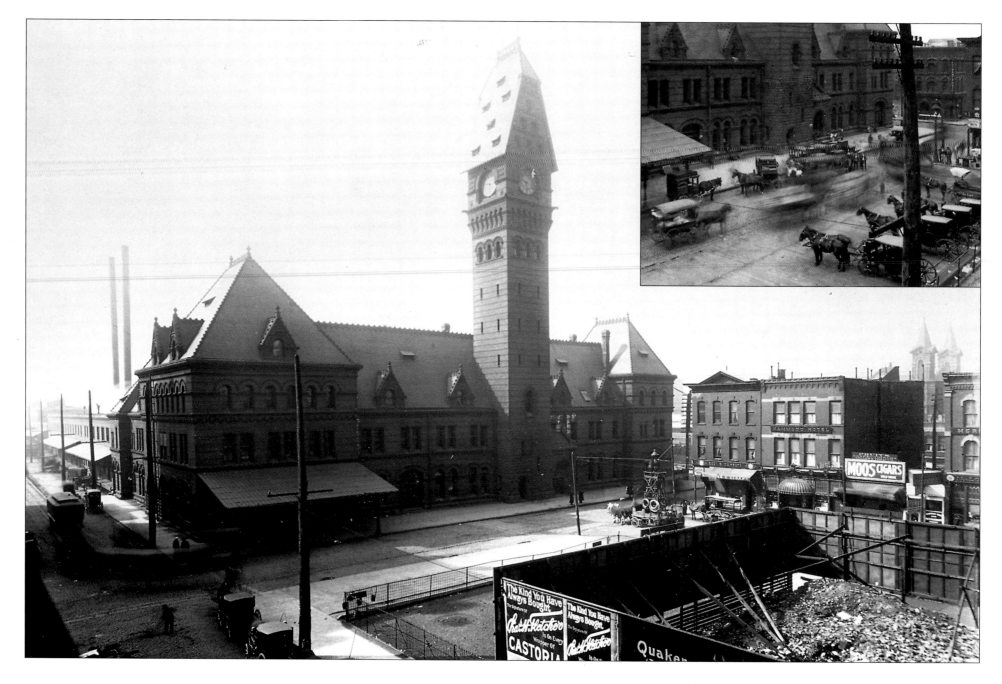

Polk Street at the foot of South Dearborn, circa 1890. Designed by noted New York architect Cyrus Eidlitz in 1885, Dearborn Station (also known as Polk Street Station) caps the Dearborn Street vista. The brick Romanesque building featured a hipped roof complete with Flemish clock tower. Toward the end of the nineteenth century, the station was among the city's busiest (*inset*).

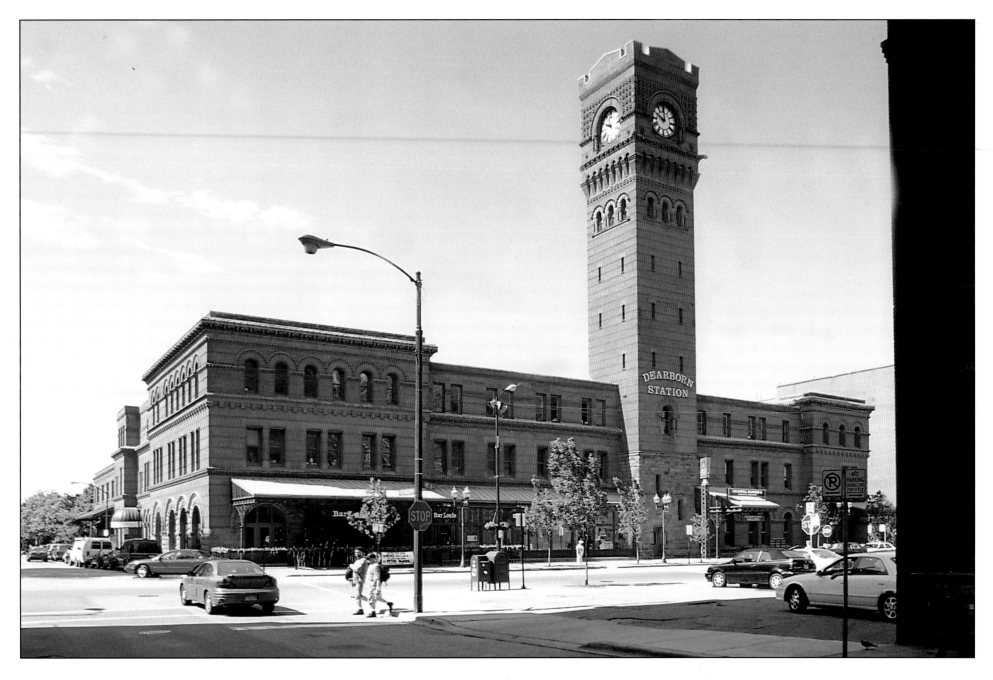

The station enabled the quick and easy transport of heavy paper goods, attracting printers to create the Printers Row neighborhood. Today, Dearborn Station is the oldest surviving railroad passenger terminal in Chicago. A 1922 fire destroyed the original tower and roofline, but the building was quickly restored. Operations ceased at this terminal in 1971, but it now houses offices and eateries.

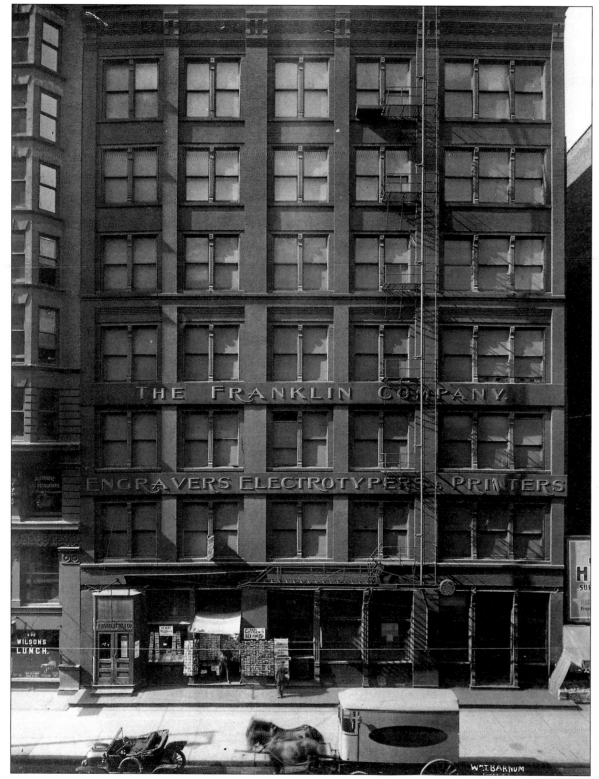

525 South Dearborn, circa 1910. Designed by Baumann & Lotz in 1887, the original Franklin Building demonstrates how, in an effort to provide light for printers' detail work, architects began grouping windows by supporting them with cast-iron mullions. This in turn gave rise in the 1890s to the "Chicago window," with its wide central pane flanked by narrow sash windows.

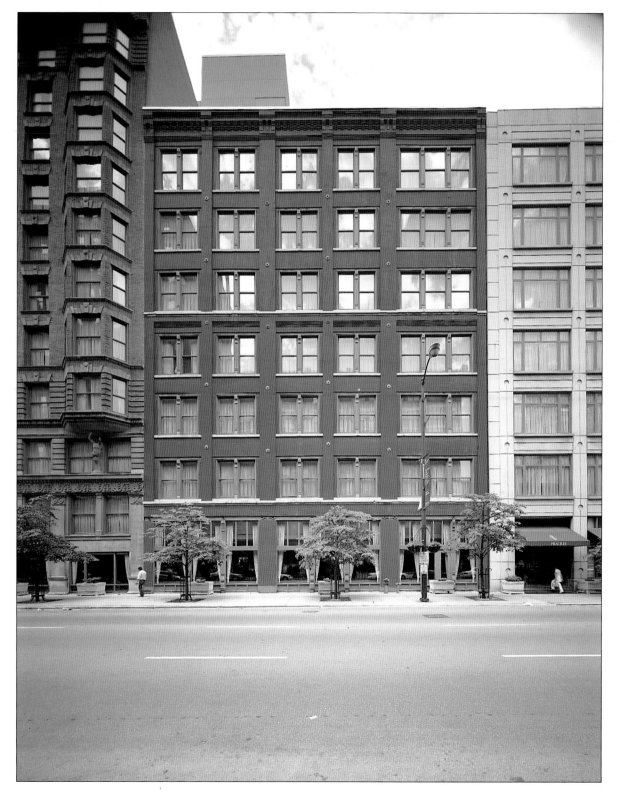

Once occupied by turn-of-the-century printing and publishing firms who built facilities near Dearborn Station, today Printers Row is undergoing a renaissance. The area's unusual street pattern of long narrow blocks provides maximum natural light, a necessity for engraving and typesetting, now a delightful feature for loft apartments and luxury condos.

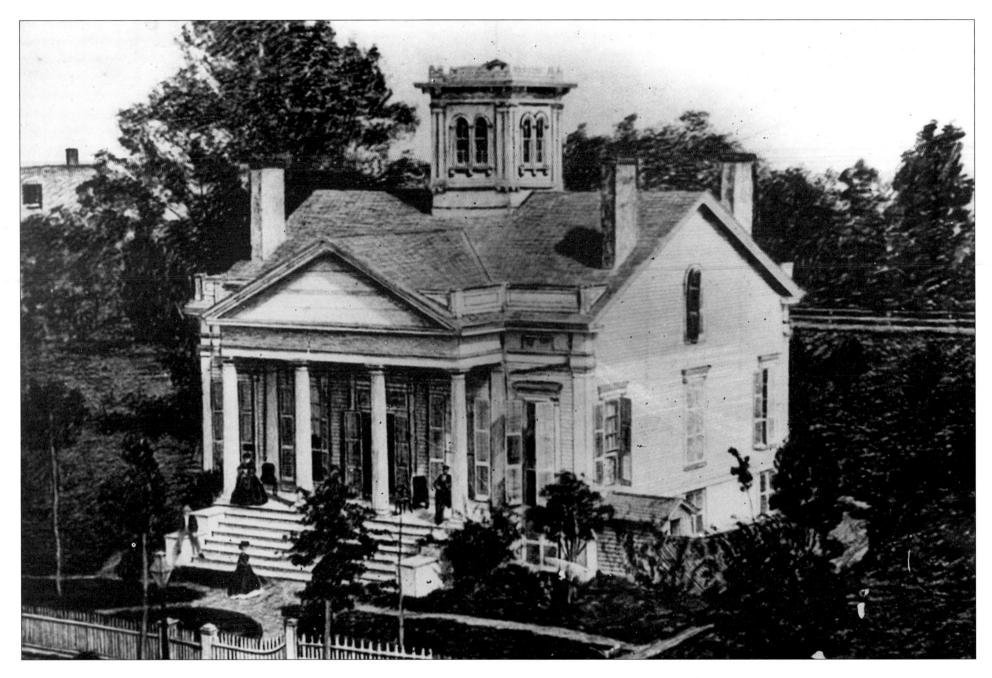

This retouched photo of an antebellum daguerreotype shows the Henry Clarke residence. When it was first constructed in 1836, this wooden Greek Revival mansion sat on a thirty-five-acre strip of land that ran from near Michigan and 16th all the way to the lake. Owner Henry Brown Clarke, director of the Illinois State Bank, suffered severe losses in the U.S. financial Panic of 1837. He supplemented his income by farming and hunting wild game.

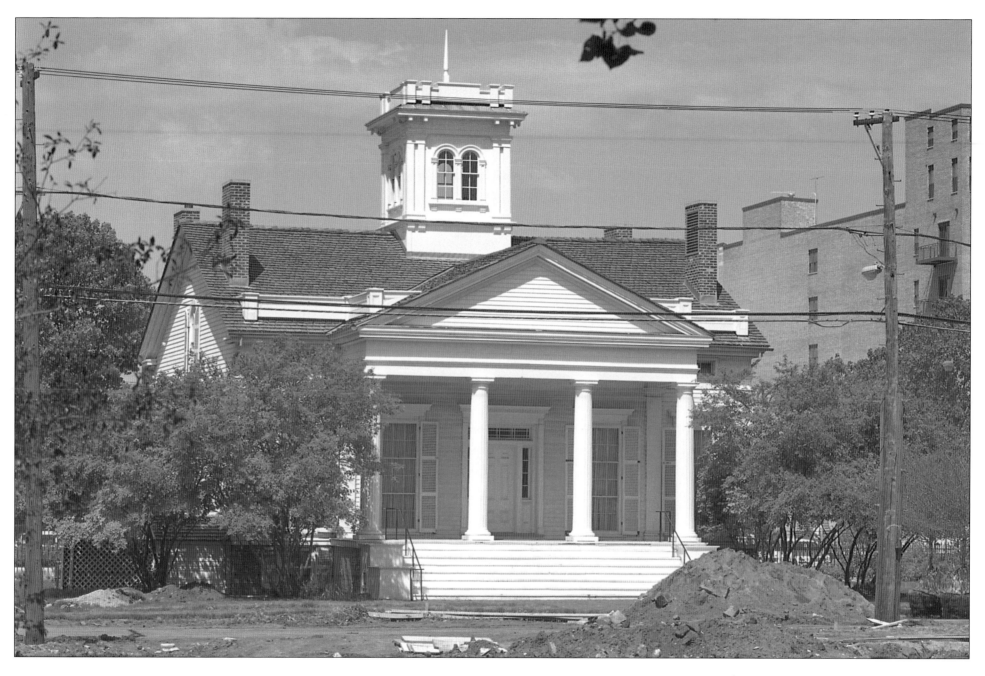

Today, the Clarke House is quite likely the oldest building in Chicago, and one of the only wood-frame structures to escape the Great Fire of 1871. The building was relocated twice, housing the St. Paul Church of God in Christ for thirty years, but now sits near its original location at 1855 South Indiana. It is meticulously restored and is run as a museum by the Chicago Architecture Foundation. Beside it is the newly dug Hillary Rodham Clinton Women's Park.

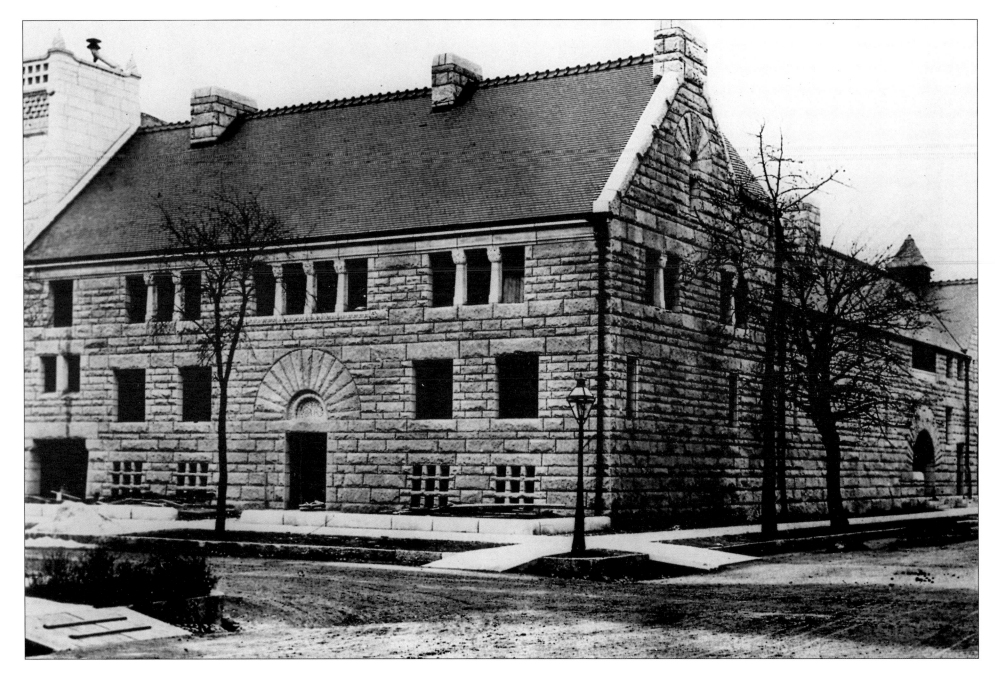

After the Great Fire of 1871, Prairie Avenue, conveniently situated to the business district, became the neighborhood of choice for the city's elite. Home to the Fields, Armours, Palmers, Kimballs, Pullmans, Sears, and Glessners, Prairie Avenue was a showplace for some of the nation's foremost architects and featured houses of every period and style. The Romanesque Glessner House seen here is considered the foremost residential work of preeminent Boston architect Henry Hobson Richardson.

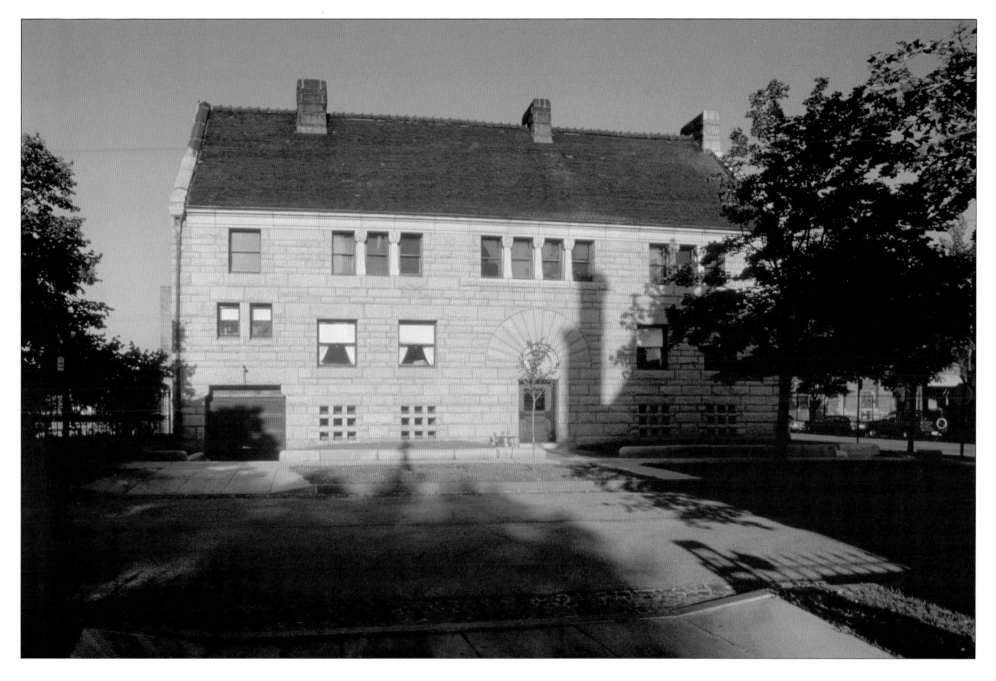

As the neighborhood became more industrial at the turn of the century, the "sifted few" relocated to the city's North Side. Today, the Glessner is one of a handful of houses that remain in the Prairie District. Constructed in rusticated granite around a central courtyard, the home was termed a "fortress" by the grumbling neighbors when completed in 1887. Today, it is a museum run by the Chicago Architecture Foundation, which was formed in 1966 to save it. The Arts and Crafts interior is particularly well preserved.

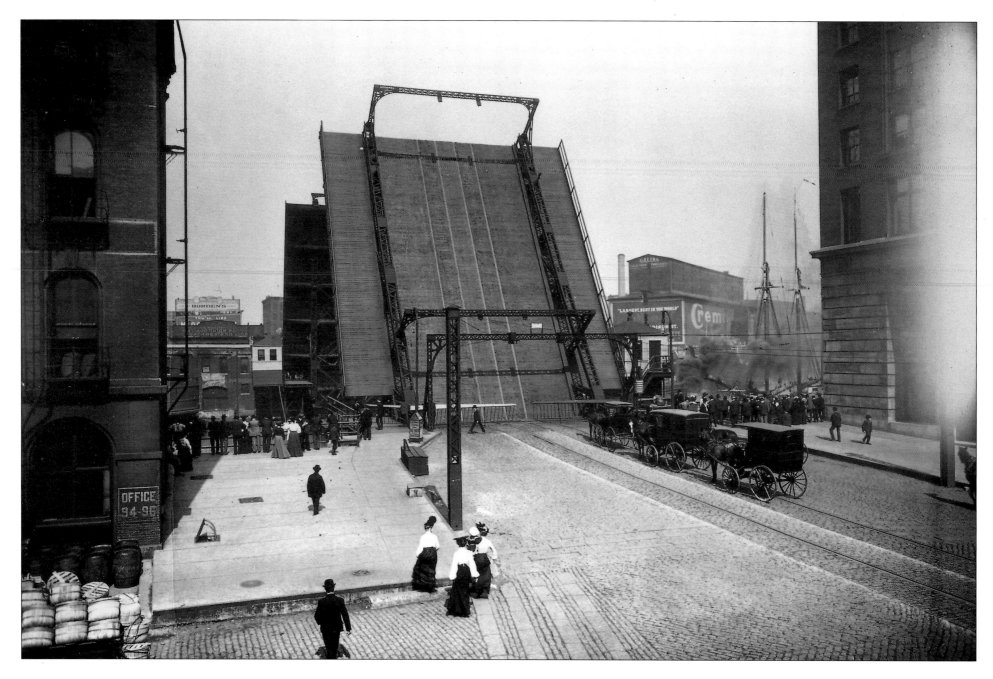

View north around the turn of the century. Chicago pioneered the rolling-lift (or "bascule") bridge, where the bridge splits evenly in half, with each weighted end functioning like a seesaw when released. By the time of this photo, the heavy river traffic and frequent bridge openings made north-south commuting a nightmare, stunting North Side development. Well into the twentieth century, industrial buildings lined the north bank of the East Branch.

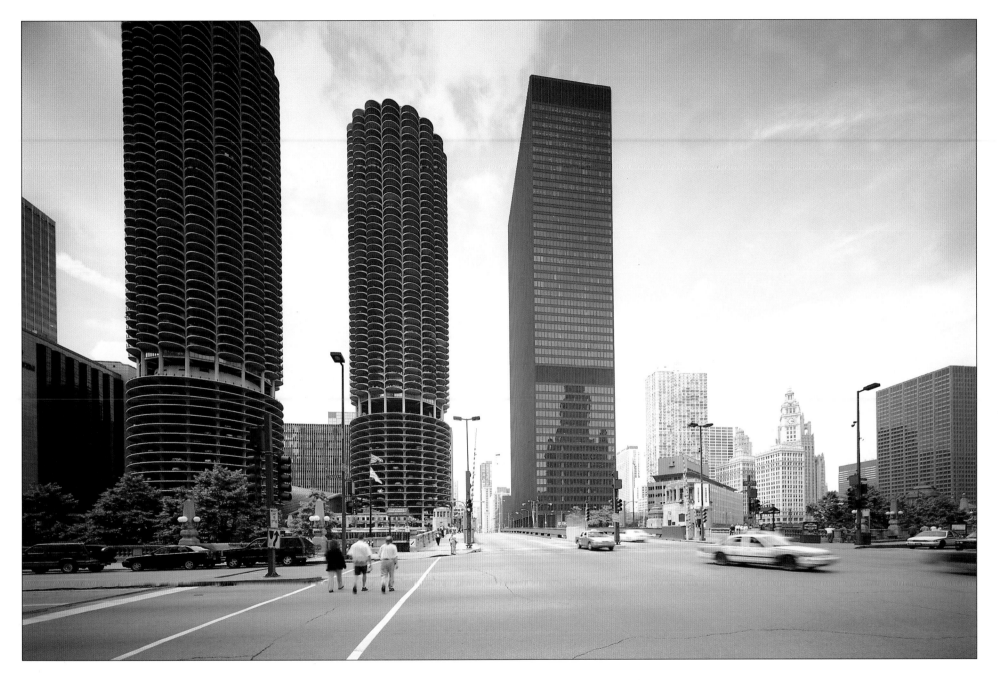

Today, bridge openings are just as aggravating for drivers and pedestrians, although less frequent. What was, at the turn of the century, an industrial warehouse district north of the river, is today a mix of upscale residential and office space. At left, the most famous example of Bertrand Goldberg's "organic" architecture, Marina City (1967), whose twin towers are known locally as the "corncob buildings." At right, with the bronze-tinted glass, Mies van der Rohe's last American work, the IBM Building (1971).

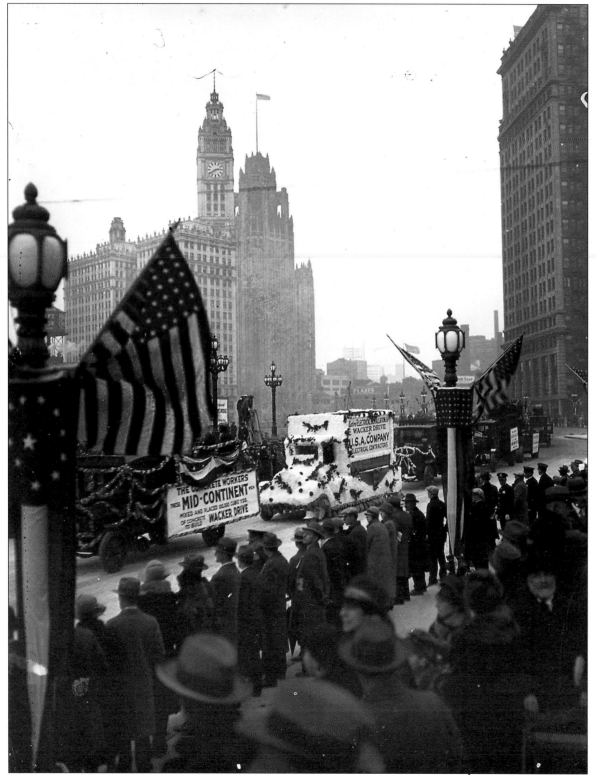

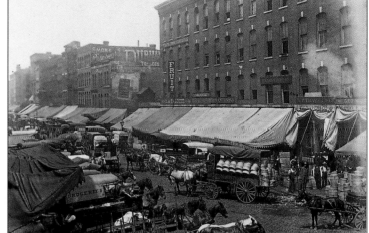

From the early 1800s, the south bank of the Chicago River was the center of the wholesale produce market (*inset*). The riverfront improvement project in the 1920s displaced the open-air produce and poultry market with the east-west segment of Wacker Drive, a decorative double-decked thoroughfare, seen here during the grand opening in 1926.

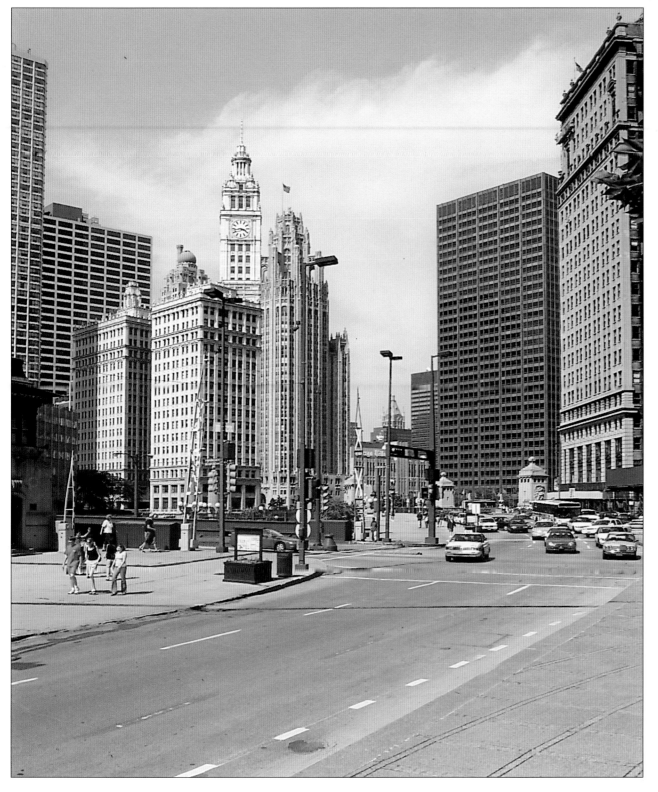

Today, this view still features the Wrigley Building and the Tribune Tower at its heart. Lining Wacker at right stands a variety of art deco gems from the twenties, including the London Guarantee Building (1923) and the city's slenderest skyscraper, the Mather Tower (1928). North of the river, at right, stands the Equitable Building (1965).

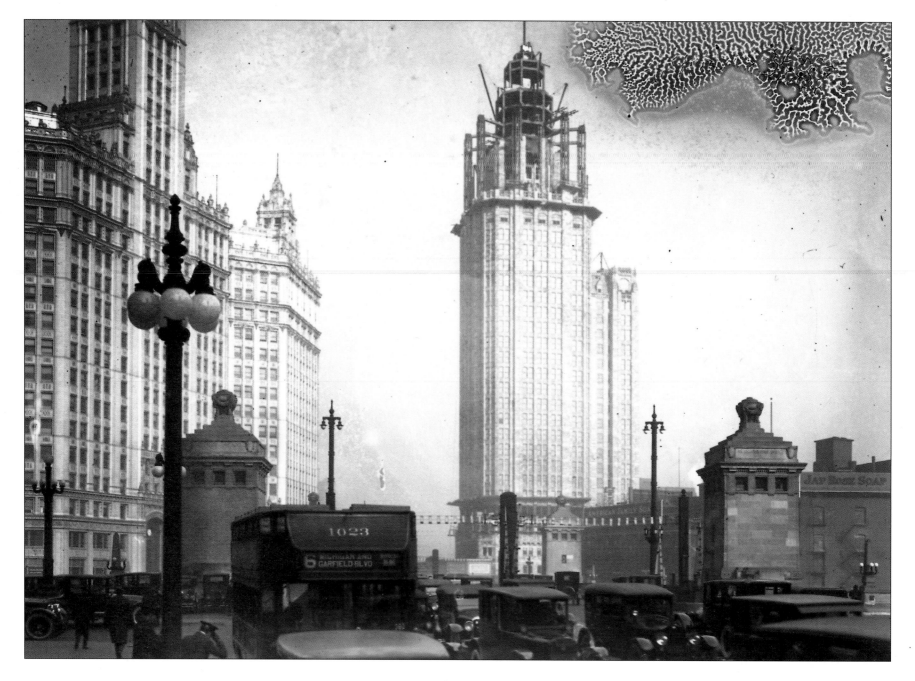

Until 1920, Michigan Avenue stopped at the river. The north bank bordered on scruffy landfill; the roads were unpaved and lined with soap factories, breweries, and other industry. When this landmark "Chicago-style" bridge opened, it paved the way for the development of humble Pine Street, the extension of Michigan north of the river. It was the first double-decker bridge of its kind, accommodating cars up top and truck traffic on a lower level. By the time of this photo, a mere seven years later, the Wrigley Building was complete and the Tribune Tower under construction.

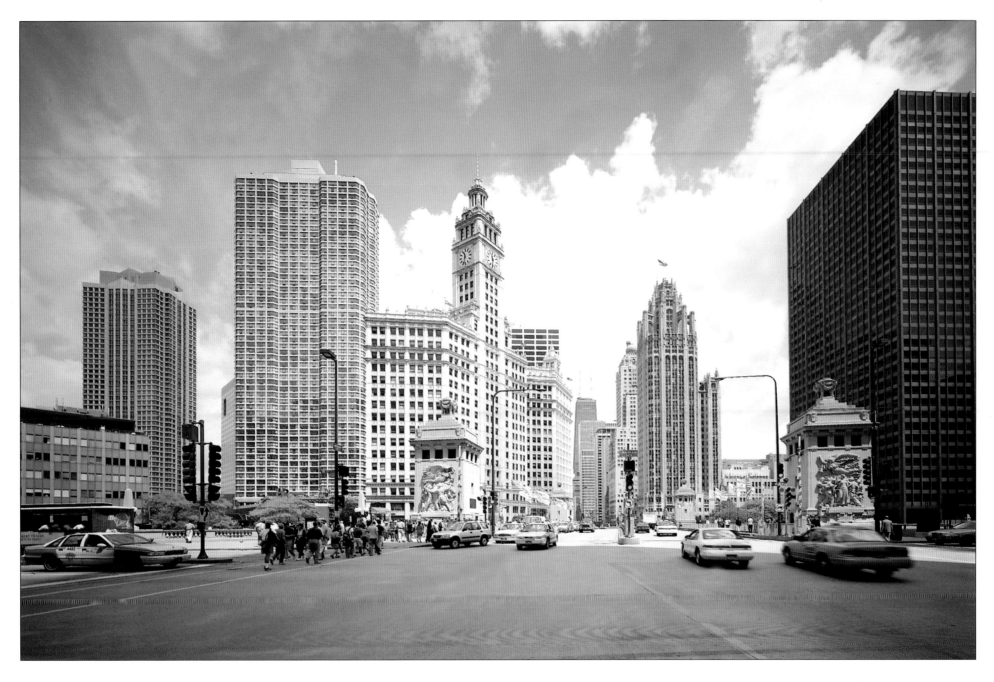

Today, North Michigan, with its unparalleled upscale shopping, is known around the world as the "Magnificent Mile" (so-dubbed in 1947 by a real-estate developer). Crowding this scene are many newer buildings, such as the boxy Equitable (1965) and the neo-Deco NBC Tower (1989), but they don't really compete with the twin flights of fancy at center. Completed in 1924, the Wrigley, with its luminous white terra-cotta cladding, has been compared to London's Big Ben; it is brilliantly floodlit at night. At right, the Tribune Tower's design resulted from a 1922 competition to create "the most beautiful office building in the world." Howells & Hood's Gothic structure, complete with flying buttresses, was built in 1925 and is inset with stones from famous monuments around the world such as the Parthenon, Notre Dame, and the Pyramids.

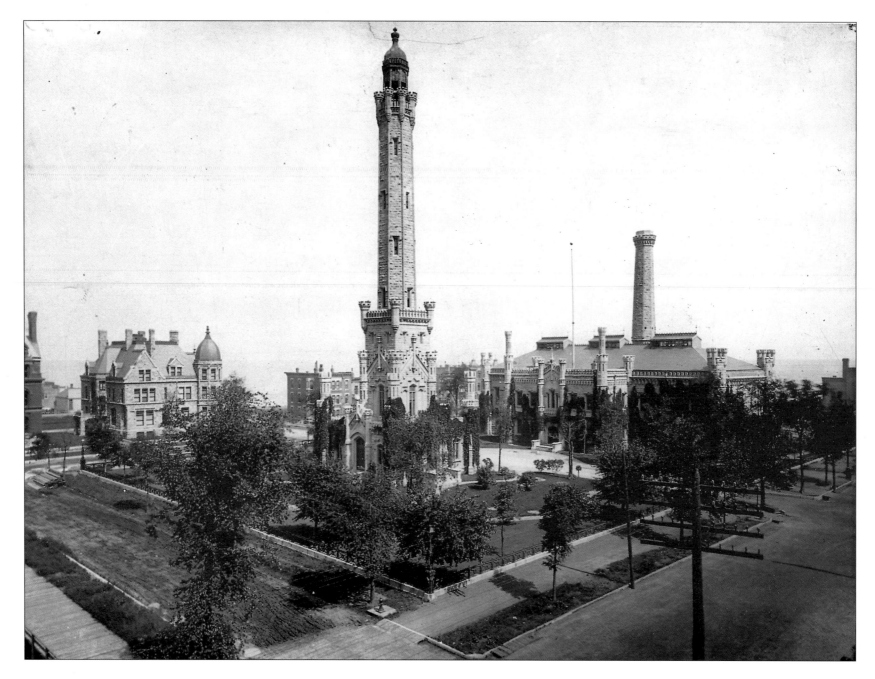

Photo circa 1891. It wasn't until the 1860s that the "city on the lake" obtained good-quality drinking water. Chicagoans were accustomed to foul, muddy, even fishy water until the construction of the waterworks in 1866, which drew water from two miles out. To provide water pressure, a standpipe was constructed; the 154-foot tower housing it was designed by William Boyington in Joliet limestone in a style that has been called "naive Gothic." Oscar Wilde on a visit to the city called it something else: "a castellated monstrosity with pepper boxes stuck all over it."

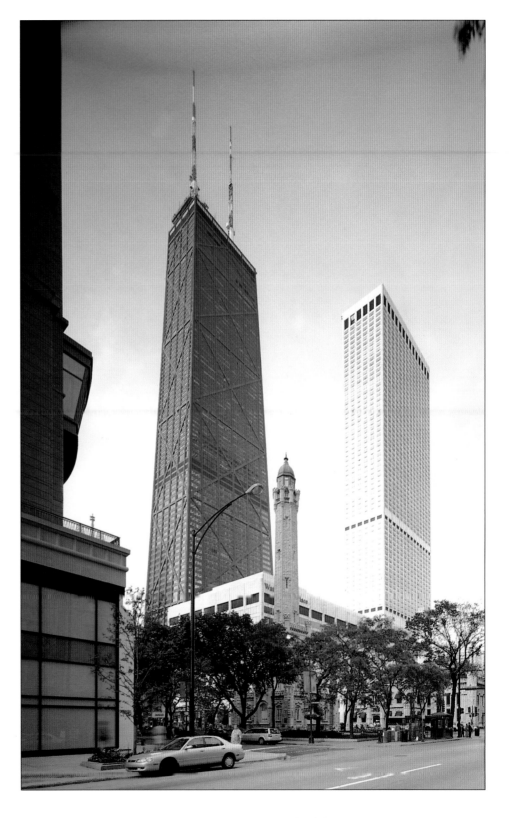

Today, the Chicago Water Tower is one of the city's best-loved monuments. One of only a handful of structures to survive the Great Fire of 1871, it became a symbol of the city's will to survive. The tower has been obsolete since 1906, but is meticulously preserved and spotlit at night. The pumping station contains the city's tourist information center. The tallest building on north Michigan until 1920, the Water Tower today is dwarfed by one of Chicago's tallest (and most famous) buildings, the 100-story John Hancock, completed in 1969. Water Tower Place (1976) is at right.

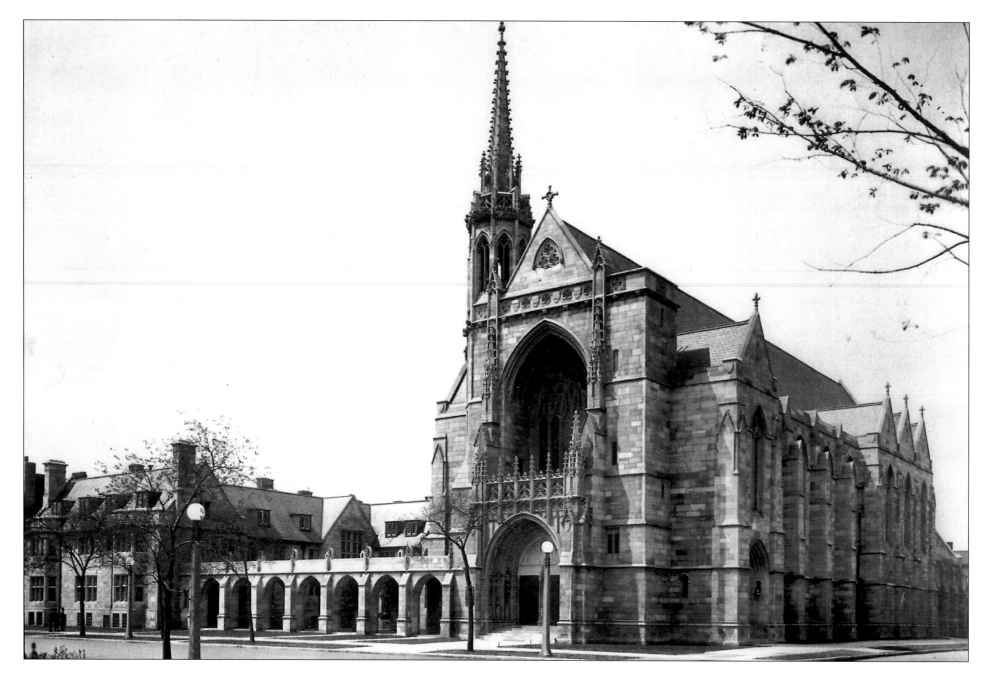

The founders of this congregation inaugurated their first church on October 8, 1871, just hours before the Great Fire raged through the city. The first structure was burned to the ground, and all but five church members lost their homes. In February 1874, the congregation dedicated a new facility on the northwest corner of Rush and Superior Streets. After forty years at this location, the growing congregation and its many programs called for a new facility. The wealthy congregation hired famed Boston architect Ralph Adams Cram.

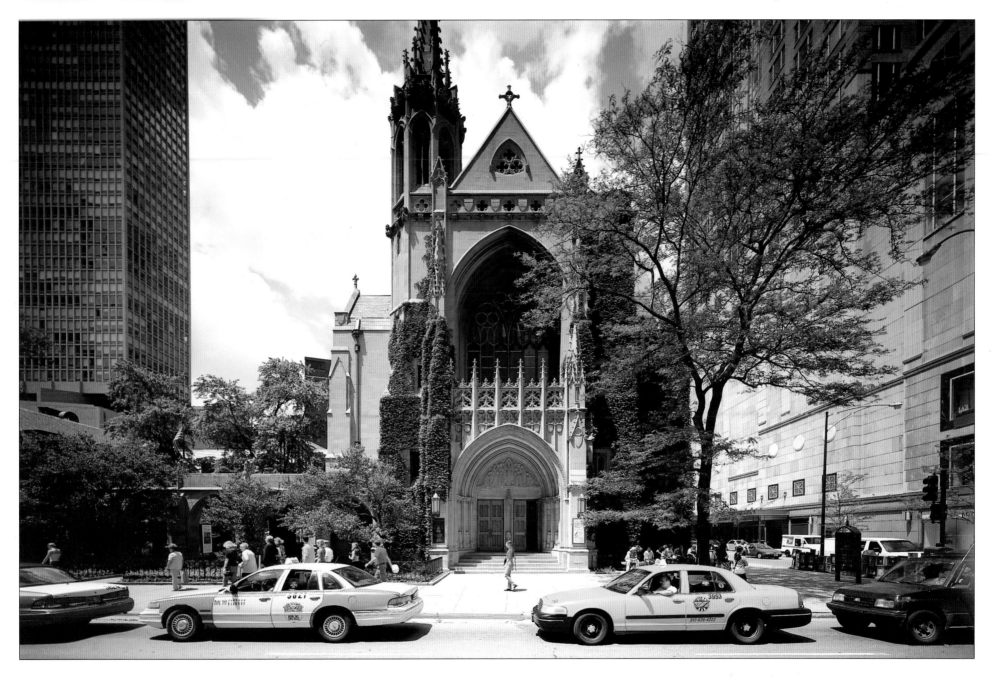

Cram's impressive Gothic Revival church building at the corner of Michigan and Chestnut opened in 1914 after two years of construction. The location was a gamble, as Chicago's now famous "Magnificent Mile" was then just an underdeveloped road called Pine Street. It wasn't until the construction of the Michigan Avenue Bridge in 1920 that North Michigan "took off." Today, except for the familiar Water Tower two blocks to the south, Fourth Church is the oldest surviving structure on Michigan Avenue north of the river.

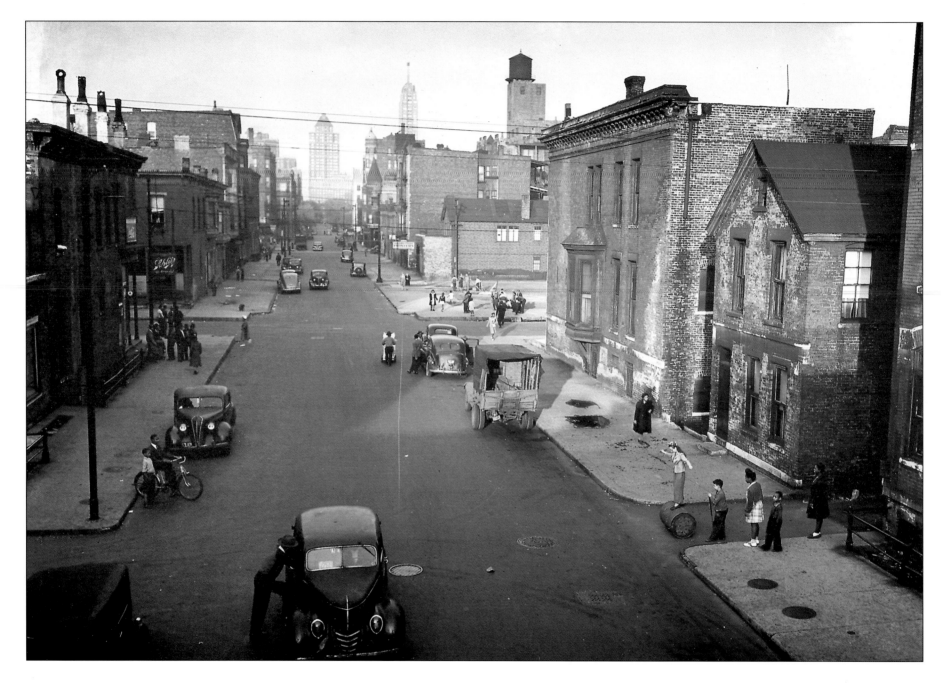

View looking east toward the Drake Hotel. Until the 1920 construction of the Michigan Avenue Bridge, with its double decks of traffic, the frequent openings of the other bascule bridges made the north side of the river difficult to access, and development was slow. North Michigan was known as "Pine Street" home to a variety of industrial factories. Oak Street, seen here in the 1930s, was a lower-rent residential district.

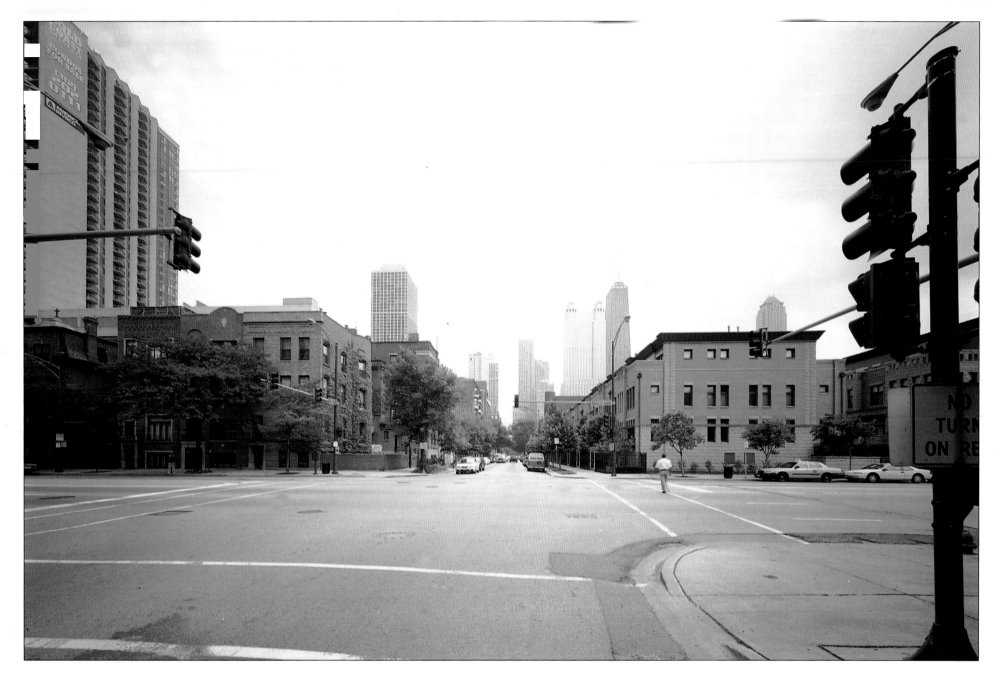

Michigan Avenue was dubbed the "Magnificent Mile" in the 1940s, as development skyrocketed. The street became the city's premier shopping district, home today to the world's most glitzy retailers, and surrounding neighborhoods benefited. If the "Mag Mile" is home to great, glittering palaces of consumerism, Oak Street today is the location for Chicago's most exclusive boutique shopping, with rows of elite designers' shops.

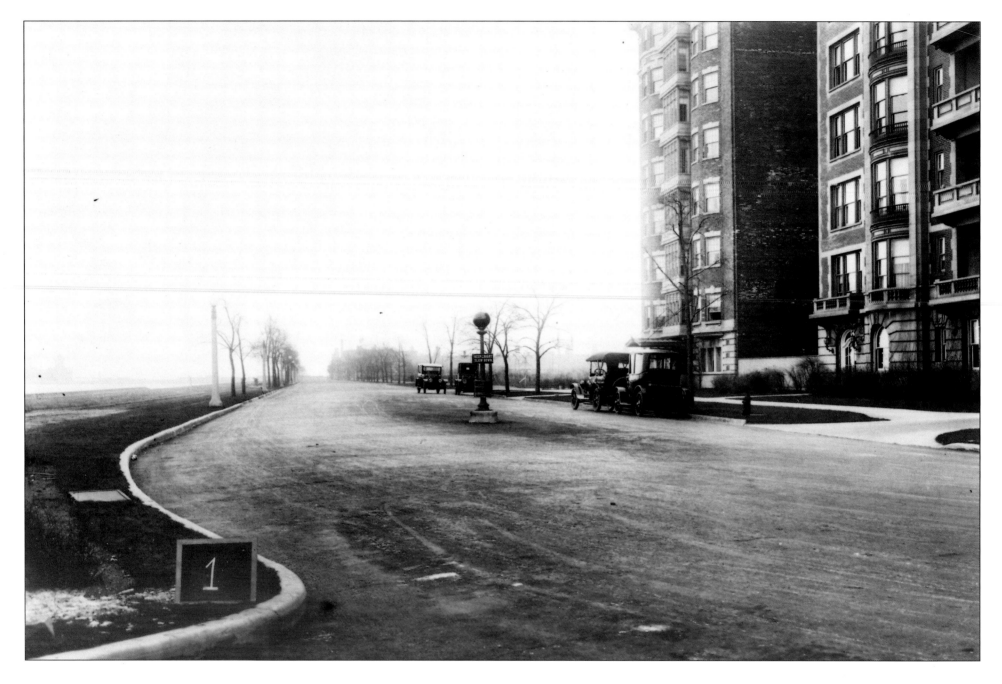

Lake Shore Drive is so much a part of Chicago's identity that it is difficult to imagine a time it did not exist. Nevertheless, Michigan Avenue constituted the easternmost street for downtown's lakefront until several changes in shoreline, namely, the filling of the Grant Park area and Streeterville in the later 1800s. By the time of this photo (1914, view south from Oak), Daniel Burnham's great Plan of Chicago (1906) had set aside the lakefront for the enjoyment of all citizens, and Lake Shore Drive connected all twenty-nine miles of it.

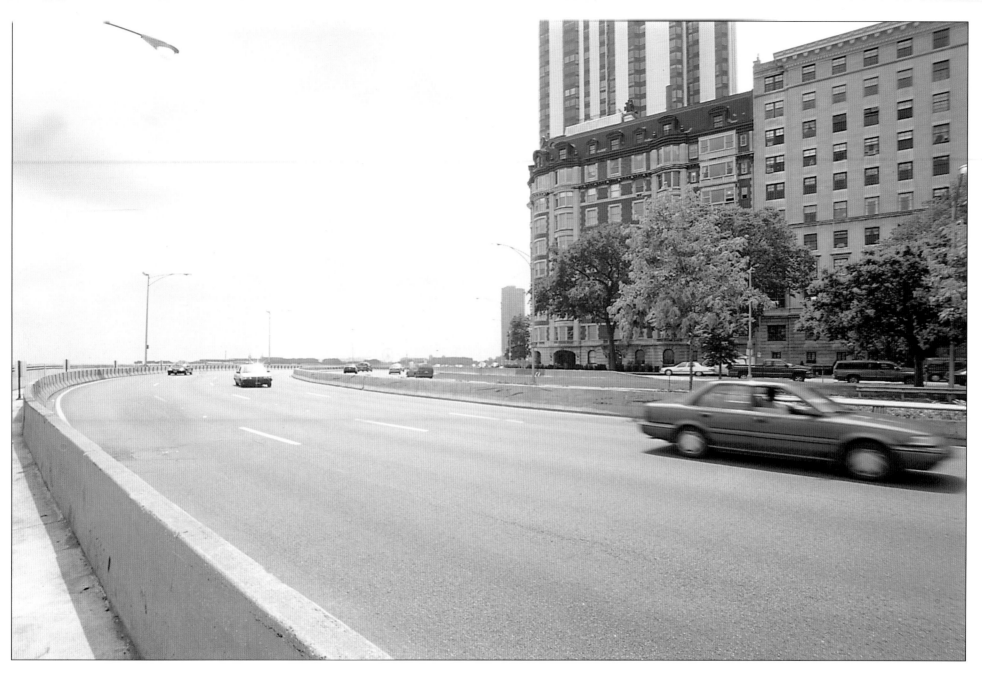

Today, Lake Shore Drive is fully developed and provides some of the most gorgeous views of the city. In 1884, successful businessman Potter Palmer built an elaborate mansion on the (otherwise desolate) lakefront, giving an impetus to construction along what would become the drive. Just twenty years later, one commentator wrote that "Along Lake Shore Drive you will find the homes of all the great merchants, the makers of Chicago." Much of LSD, particularly north of the city, is still lined with luxury apartment buildings.

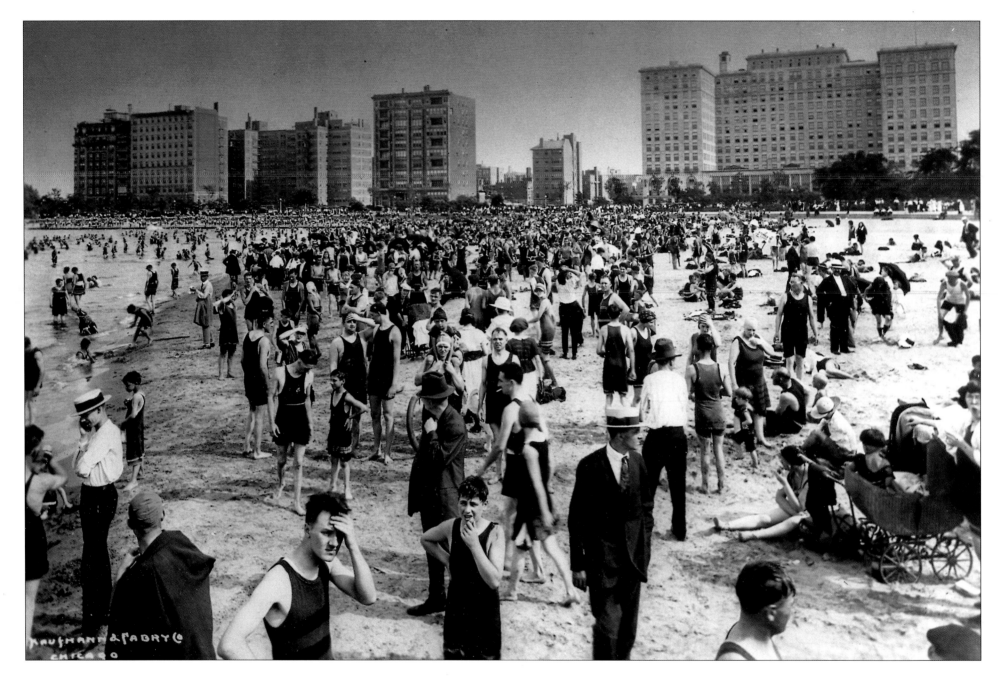

View south, 1922. With the residential boom on the newly created Lake Shore Drive (note the high-rise apartment buildings) came the demand for beaches. The city's first public facility, the Lincoln Park Beach opened in 1895, and because "bathing" was still a new sport, the first swimmer went au naturel. By 1916, the city had three beaches and four inland pools with a combined attendance of 1.2 million people.

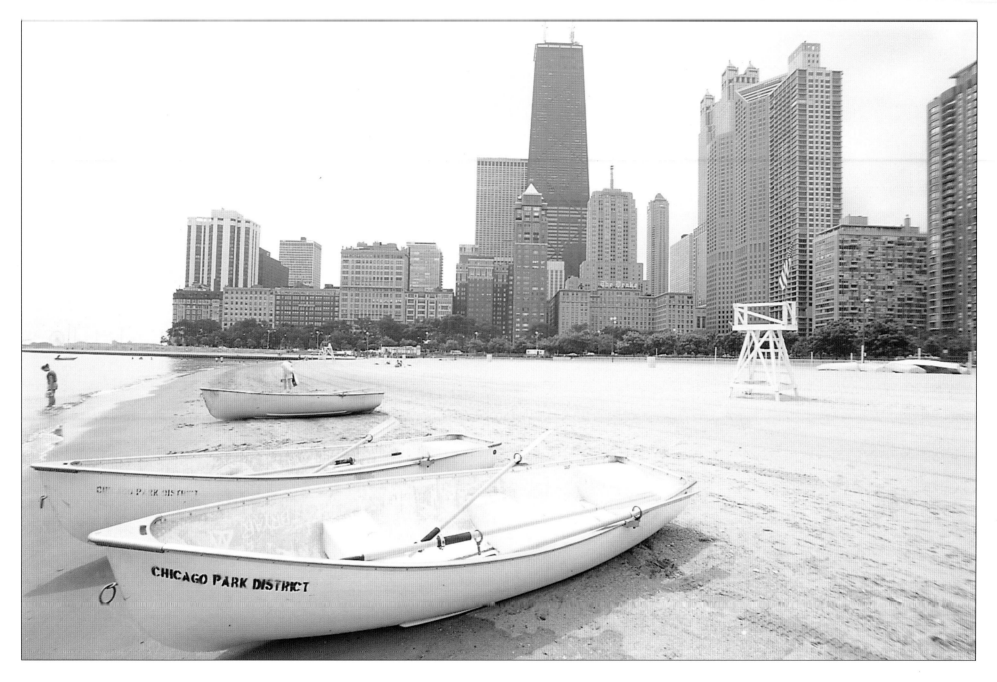

Today, the white sandy strip off Oak Street is Chicago's most fashionable beach, the place for beautiful people to sunbathe, see and be seen, and even sometimes swim. A natural beach, Oak Street still requires imported sand from time to time, due to wintertime erosion by the choppy waters of Lake Michigan. Luxury residential buildings have continued to sprout on LSD, and this beach provides a lovely view of the downtown skyline.

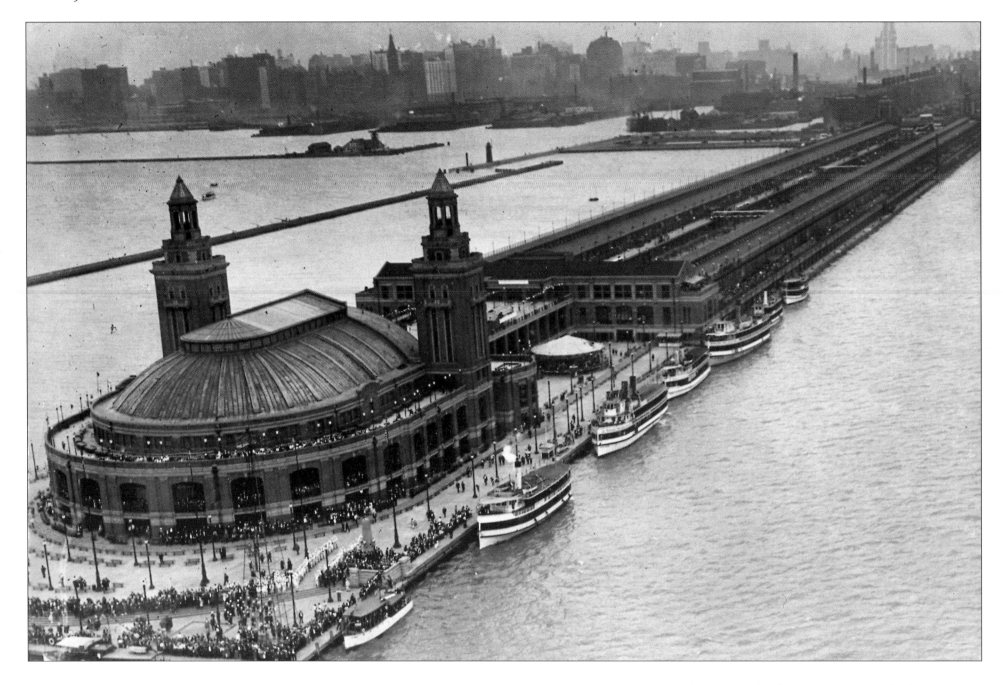

Municipal Pier No. 2 was the only pier built by the city out of a plan for five piers. Constructed in 1916, the pier, at 3,000 feet in length, was then the world's longest. During the 1920s, when this photo was taken, the pier served both commercial and excursion vessels seen here lined up as throngs of people crowd the dock. The U.S. Navy occupied the pier during World War II (thus the name), and later it became the original Chicago campus of the University of Illinois.

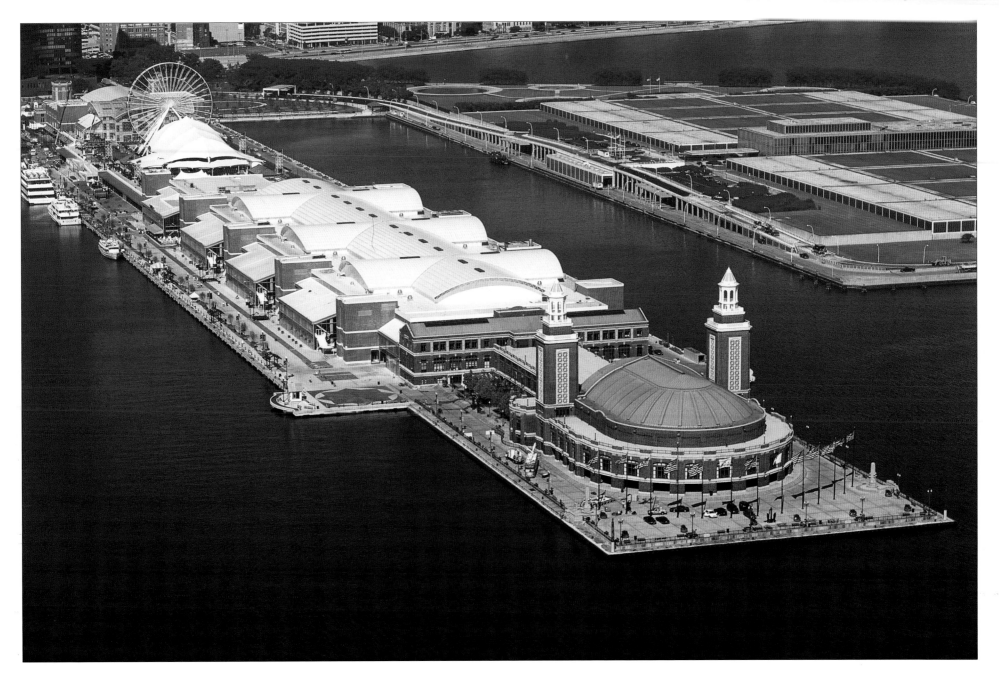

In the early 1990s, the city committed to a multimillion-dollar overhaul of the pier as a public recreation and cultural center. Today, Navy Pier is one of Chicago's major attractions, with gorgeous views of the city skyline provided along its half-mile promenade as well as from the top of its 150-foot Ferris wheel. The domed auditorium has been restored, and the long new building houses shops and restaurants. There is also a six-story glass atrium filled with a lush indoor botanical park.

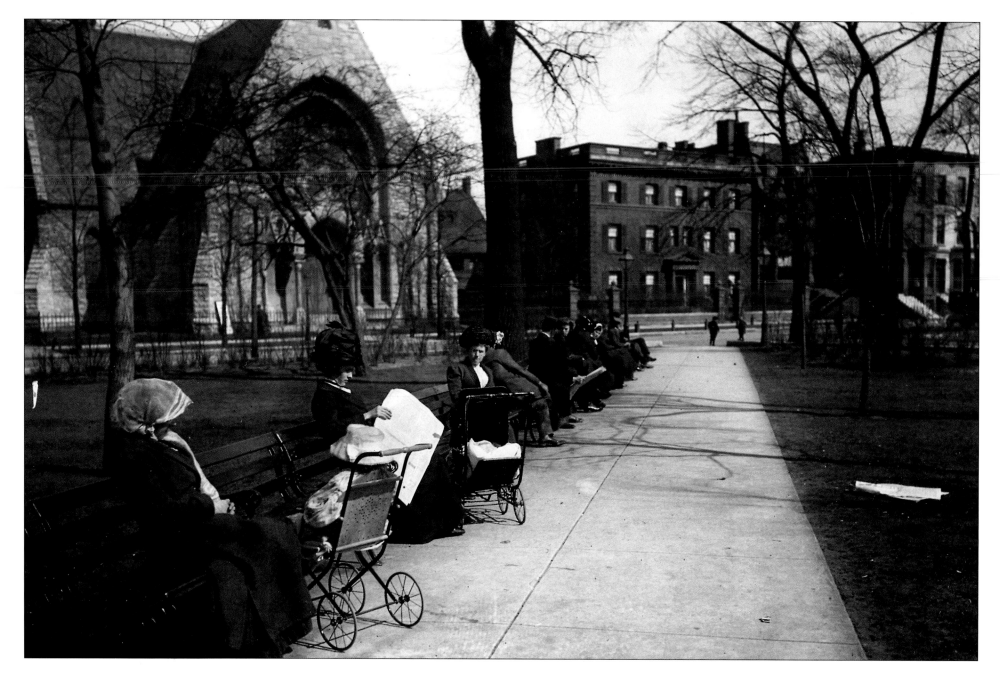

Chicago's oldest park, Washington Square, was donated to the city by Orsamus [sic] Bushnell in 1842 as the focal point of his residential development bordered by State, Chicago, Division, and LaSalle. At first the park was used for public demonstrations, such as the protest against the hike in liquor-license fees by Germans, who owned many of the city's beer gardens in 1855. By the late 1800s, however, Washington Square was a genteel city park with a central fountain, where elegant ladies promenaded with baby carriages.

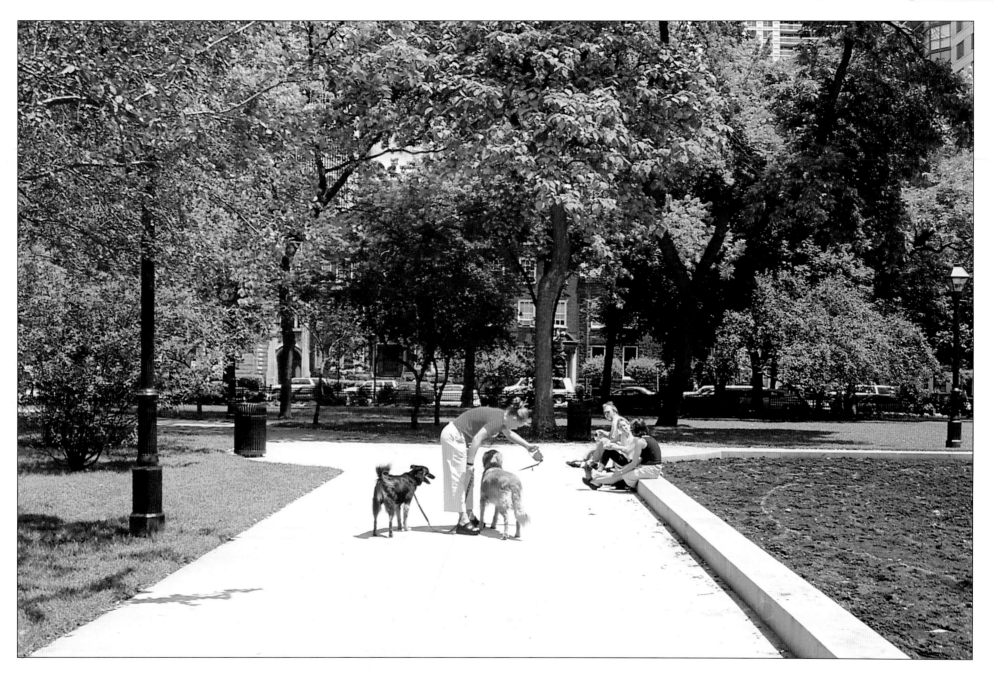

After 1900, as many buildings in the neighborhood were converted into rooming houses, the square became "the outdoor forum of garrulous hobohemia" known as Bughouse Square. Every Sunday, crowds gathered in the park to hear radical soapbox speakers, a tradition that still continues thanks to events sponsored by the Newberry Library, located on the square. Accordingly, a raised concrete speakers' platform was built in 1985. Most of the original buildings, including Unity Church, still line the square.

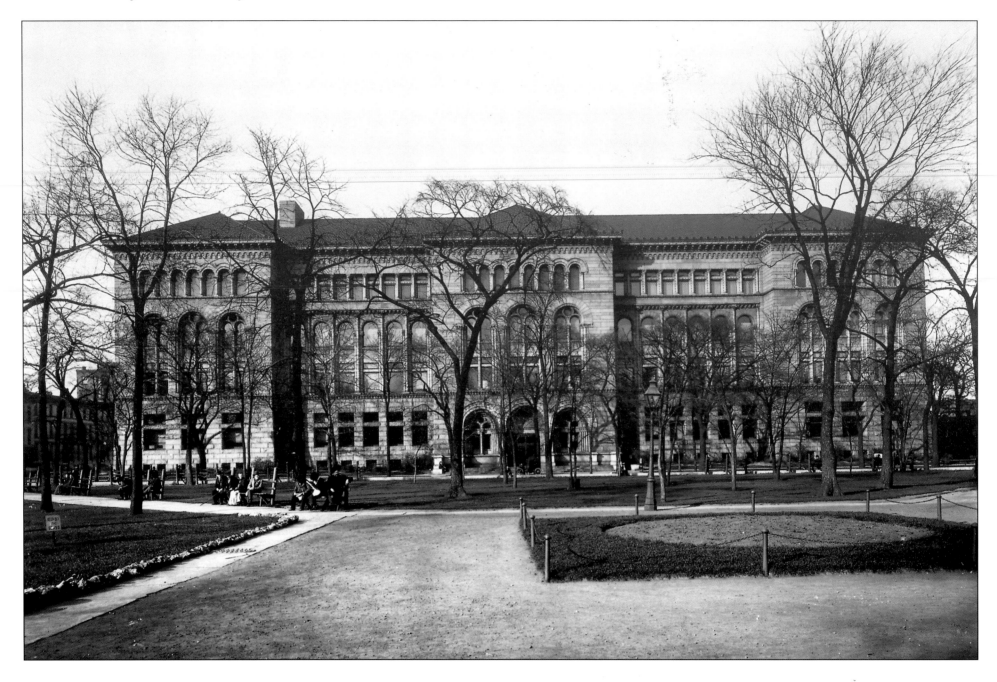

60 West Walton on Washington Square, circa 1905. The Newberry was founded as a public library by the bequest of Walter Loomis Newberry, a businessman and prominent citizen, who had been an active book collector and president of the Chicago Historical Society before his death in 1868. Henry Ives Cobb designed this building (one of Chicago's first to have electricity) in 1893 in the Romanesque Revival style.

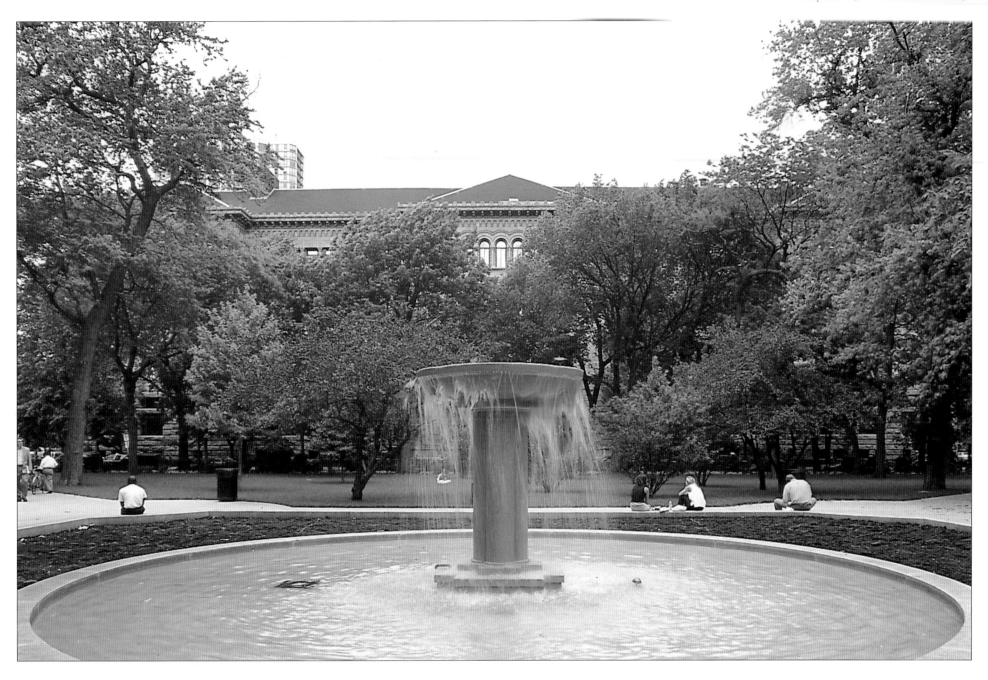

Today, the Newberry is one of Chicago's cultural treasures. The library's holdings specialize in the humanities and include 1.5 million books, five million manuscript pages, and 300,000 historic maps. Although the collection is noncirculating, it is open to the general public. In addition to concerts, lectures, and exhibits, the library is home to the Chicago Genealogical Society with one of the nation's finest genealogy archives.

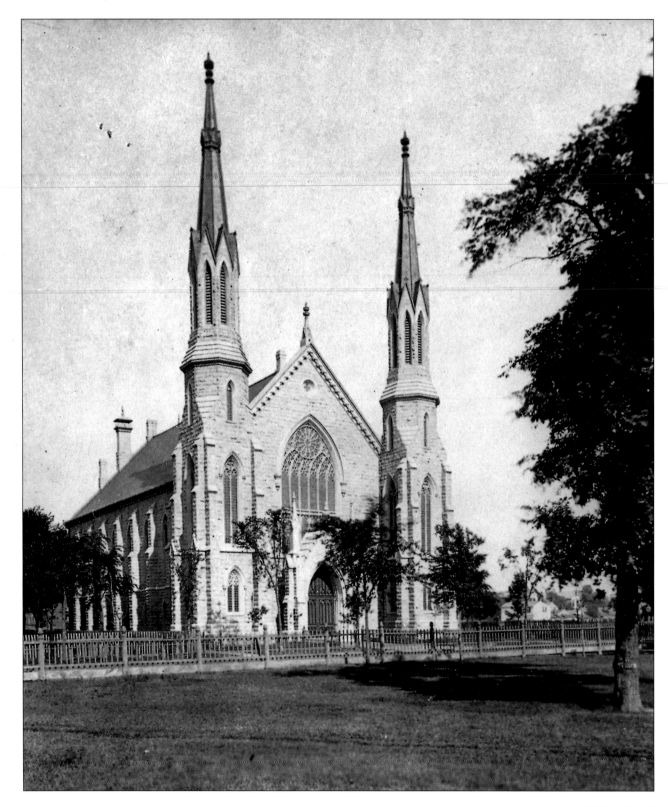

Dearborn and Walton on Washington Square, late 1860s. With its matched Gothic towers, Unity Church was touted as the grandest of Chicago's Joliet limestone churches when it was completed in 1867. This view shows precisely how rural the Washington Square area was throughout much of the nineteenth century. Designed by Theodore Wadskier, the church was gutted in the Great Fire of 1871. The external stone survived mostly intact, except for the towers.

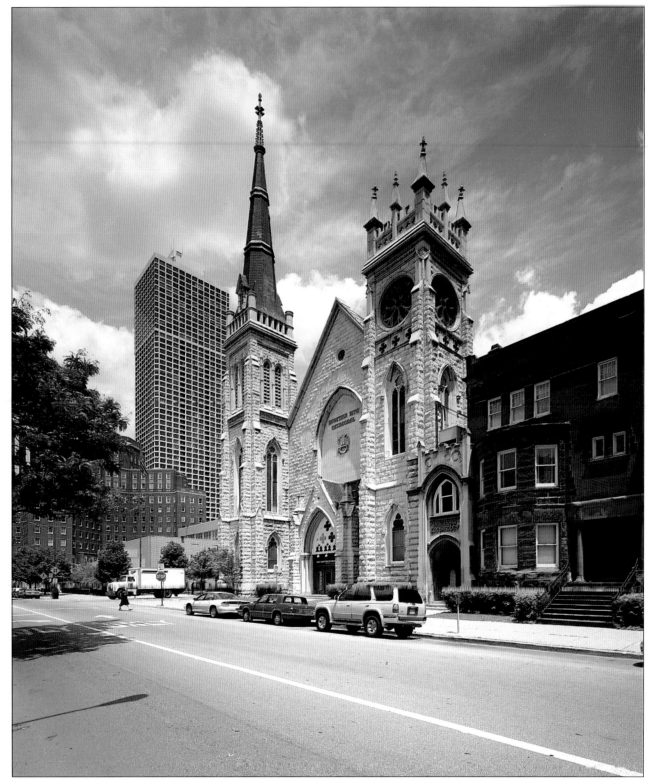

After the fire, Dankmar Adler supervised the rebuilding, installing raked seating for better acoustics. In 1900, the church was sold to the Freemasons, who leveled the floor and removed the altar, but have maintained the church's woodwork, stained glass, and upper floors ever since. The Scottish Rite Cathedral, as it is now known, is one building in a complex of several Masonic buildings, including the Romanesque-style Thompson House (1888) next-door.

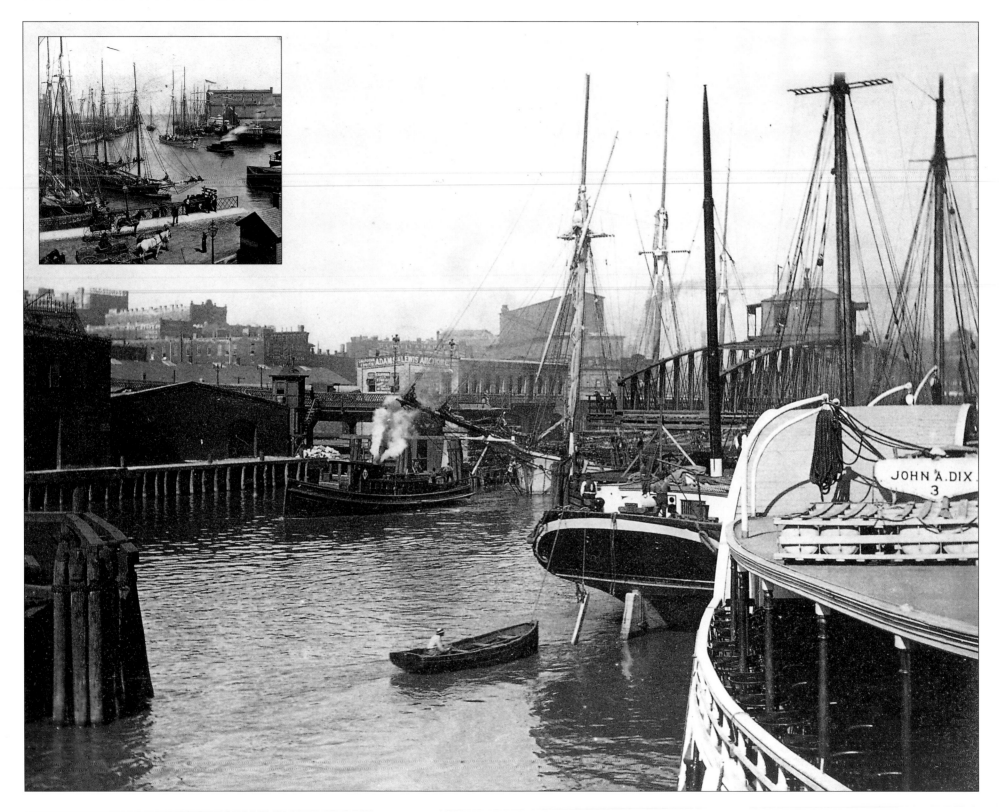

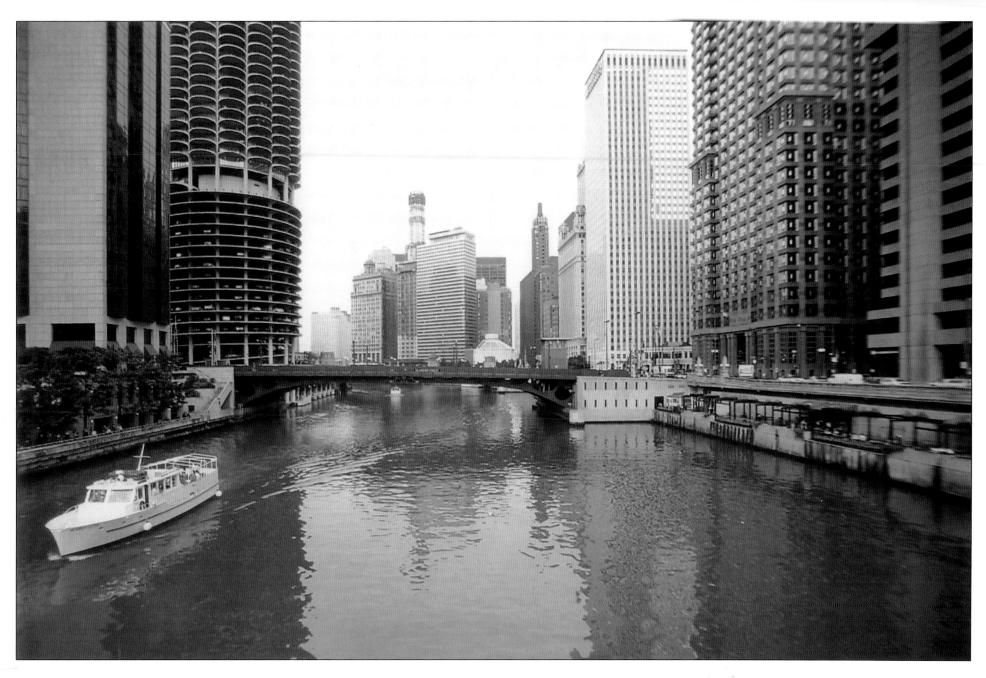

*Left*: View east from the Clark Street Bridge, circa 1893. The river was Chicago's industrial lifeblood, jam-packed with freight-hauling vessels and lined with docks, warehouses, and factories. Land traffic was often delayed while ships passed through open bridges. *Inset*: view from the Rush Street Bridge, circa 1860s, with a steam tug towing a sailboat upriver. In 1863, stampeding cattle caused the bridge to collapse; over 100 animals died.

*Above*: Today, skyscrapers replace the formerly industrial structures lining the riverbanks. The bridges still delay traffic, and there are more of them—one for every major north-south thoroughfare except Rush (the city never rebuilt it). One difference between these photos is invisible. To improve water quality, the city created the "eighth wonder of the world," a new canal and grade change that actually reversed the flow of the river. When the channel opened in 1900 with the river now flowing out of the lake, it was an engineering triumph to rival the Panama Canal.

*Below:* The Lake, Randolph, and Madison street bridges seen in the hazy early morning light in the 1860s. Commercial buildings and wharves lined all shores of the river, including the South Branch, which led to the I&M Canal (the link to the Mississippi River). Traffic was bad when bridges were raised. Noted one 1850s commentator, "A row of vehicles and impatience frequently accumulates that is quite terrific. I have seen a closely-packed column a quarter of a mile in length, every individual driver looking as if he thought he could have turned the bridge sixteen times, while he had been waiting…"

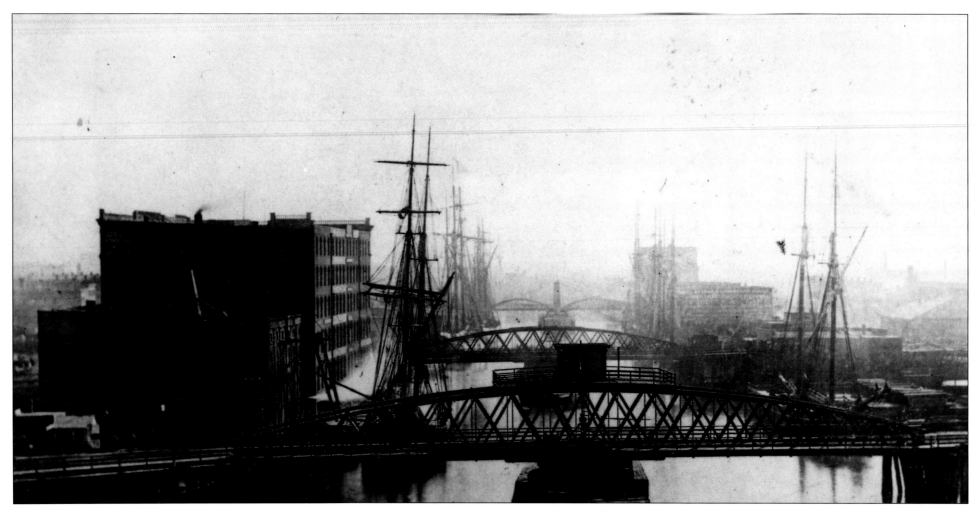

*Right:* Today, Chicago boasts the greatest number of movable bridges, 52 in all. Almost all are "trunnion bascule" (or seesaw) bridges. They still open in synchronization (what one writer has called the "Ballet of Bridges"), much to the annoyance of pedestrians and motorists. It is truly a sight to behold. Gone today are the commercial sailing vessels and low-slung wharves; the downtown South Branch is lined with tall buildings. At left, the Morton Building (1961), the Civic Opera House (1929), Chicago Mercantile Exchange Center (1983).

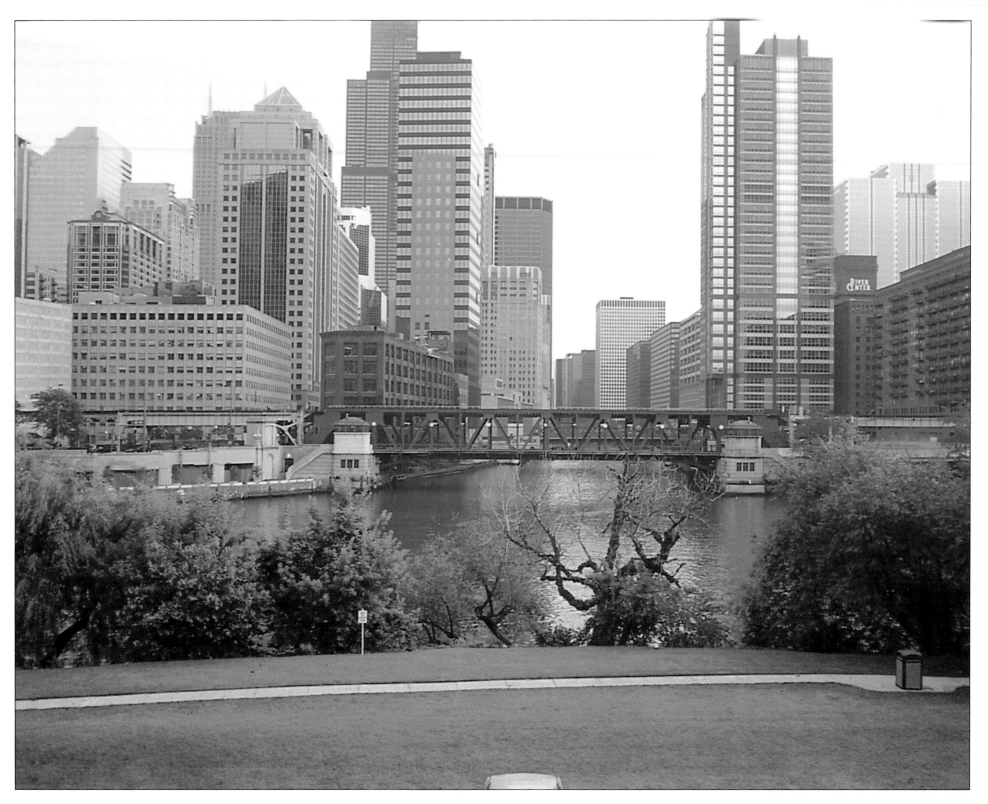

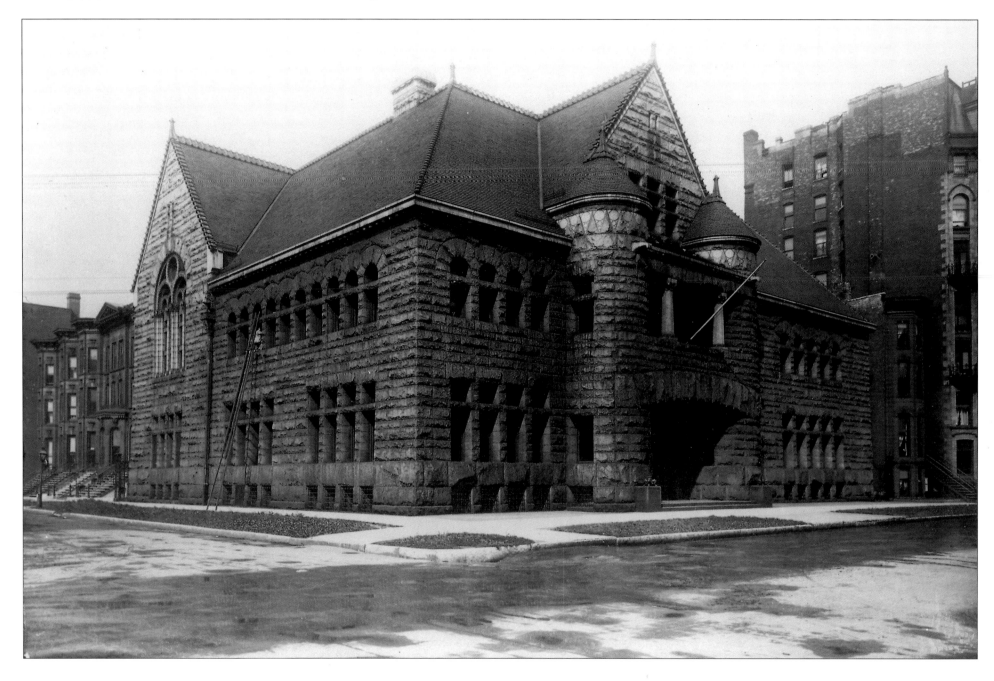

Northwest corner of North Dearborn and West Ontario streets, 1896. The Chicago Historical Society was founded in 1857, but its original building went up in flames in the Great Fire of 1871. In 1892, the Society commissioned Henry Ives Cobb to design this fireproof Richardsonian Romanesque structure as their headquarters. One admiring critic called it a "pyramidal pile of brownstone," and the building quickly garnered the nickname "The Castle" when it opened in 1892.

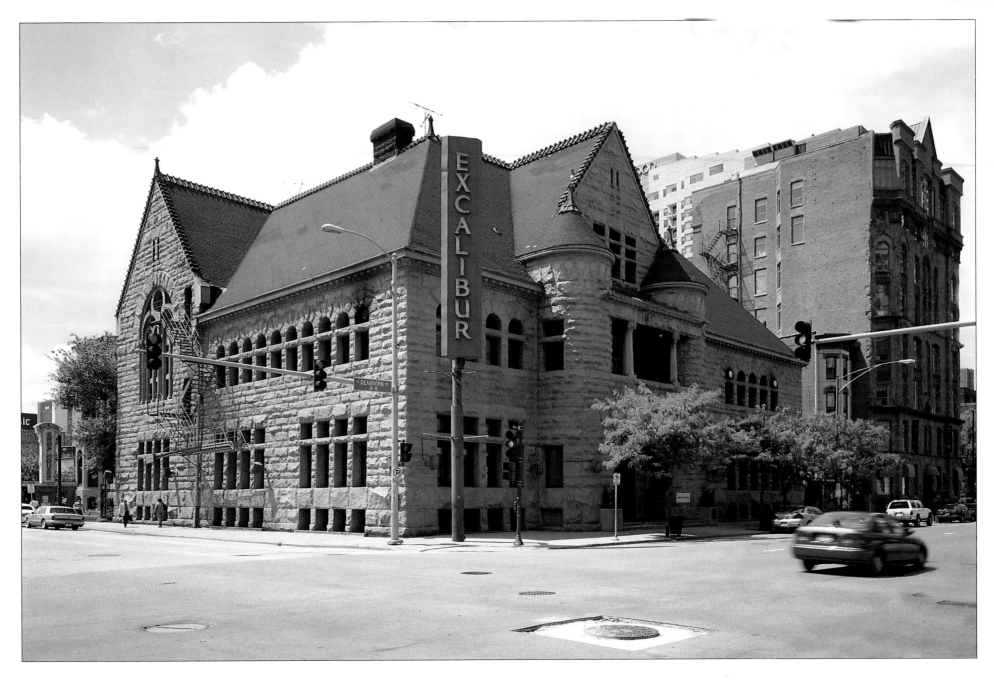

When the Chicago Historical Society moved to its present digs on the edge of Lincoln Park in 1931, the Castle became home to everything from a Moose lodge to WPA offices, to the prestigious Institute of Design, and even recording studios for influential blues and rock-'n'-roll performers in the 1950s and '60s. Attorney F. Lee Bailey purchased the building in the 1960s, converting it to a nightclub. When the surrounding River North neighborhood underwent a renaissance in the 1980s, the structure became a gigantic, multilevel dance club known as Excalibur.

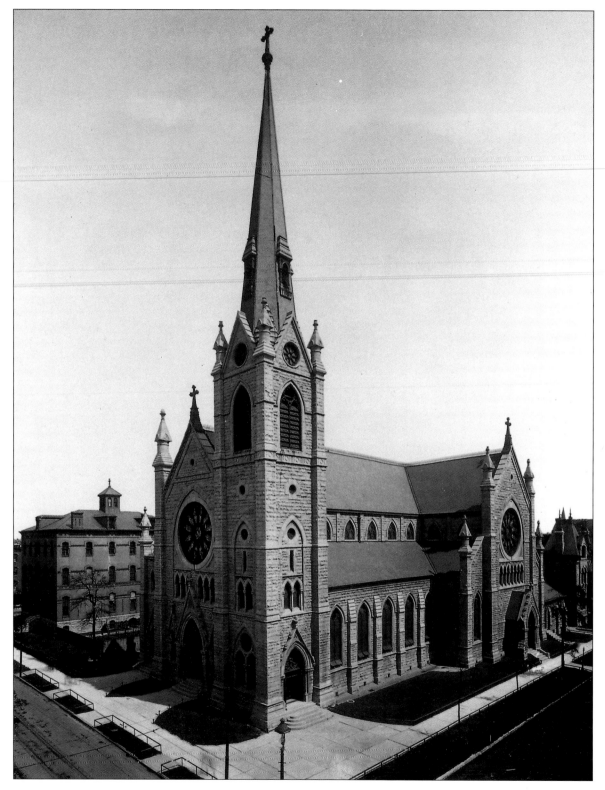

Northeast corner of North State and East Superior Streets, circa 1874. In the wake of the Great Fire of 1871, Chicagoans launched any number of ambitious construction and reconstruction projects. The Catholic diocese of Chicago commissioned ecclesiastical architect Patrick Keeley to design a replacement for a smaller Victorian building destroyed in the fire. Its dedication in 1874 drew a crowd of more than 5,000 and featured a parade of eighteen bands and a twenty-five-priest choir. In 1880, the diocese of Chicago was made an archdiocese.

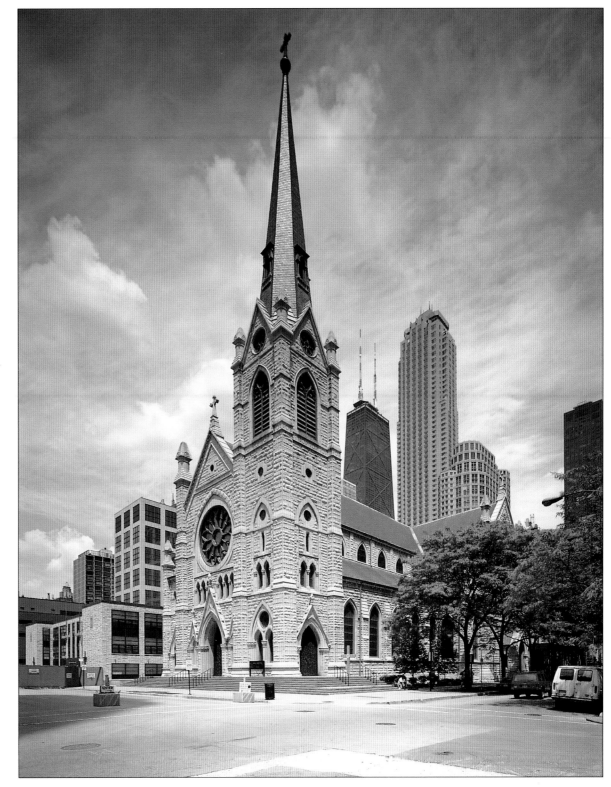

Holy Name Cathedral is a cornerstone of the River North neighborhood and the archdiocese remains one of the most powerful influences in Chicago, serving over 2.5 million Roman Catholics. After renovations in 1914, the building was made 15 feet longer. Pope John Paul II celebrated mass here in 1979, and both Luciano Pavarotti and the Chicago Symphony Orchestra have performed here. During Chicago's Gangland heyday, Capone rival Dion O'Banion was shot point-blank outside a neighboring flower shop; several bullets glanced off the cathedral.

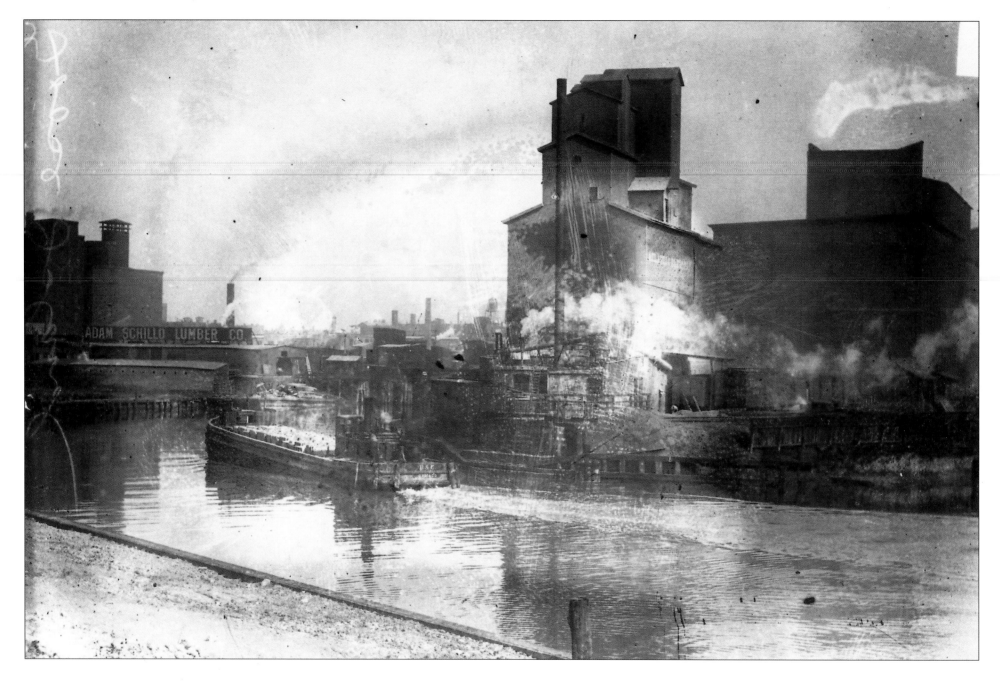

North Branch of the Chicago River, circa 1909. As early as the 1830s, the North Branch became the focus of manufacturing activity when the city's first meat-packing plant was established there. A lumber mill soon followed (note the Schillo Lumber Company seen here), and the North Branch became the most heavily industrial section of the river. Goose Island was created in the 1860s when the North Branch canal was dug on its north side.

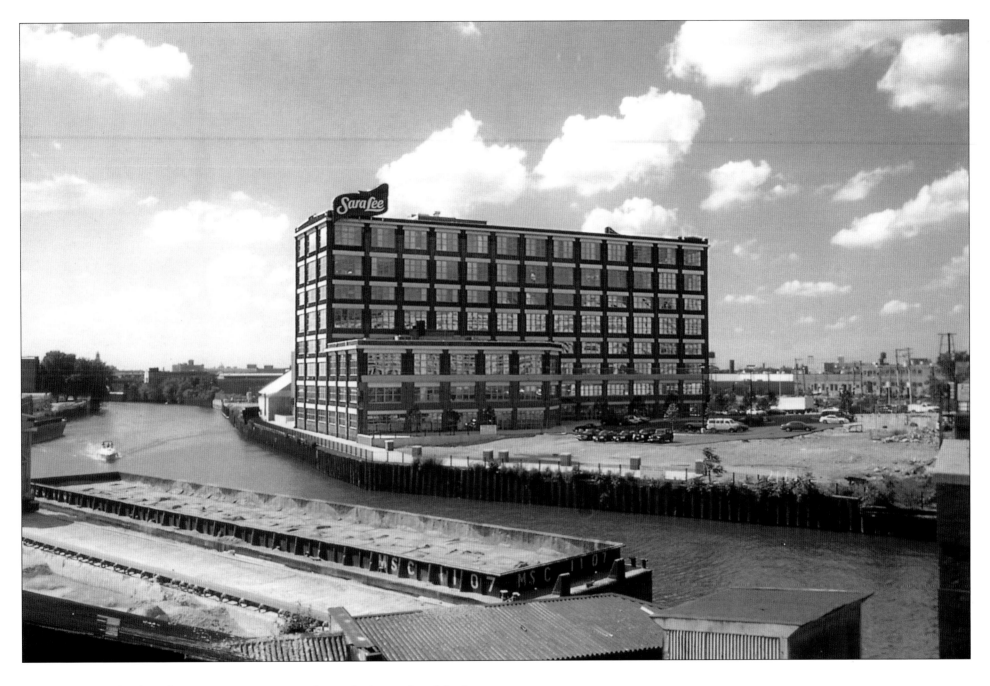

By 1924, Goose Island was home to meat-processing, chemical, electrical, and food
and brewing enterprises. With the decline of hard industry in the U.S., Goose Island
also suffered, but today, has been reinvigorated thanks to governmental tax
incentives. In the last ten years, Federal Express, Republic Windows, and Sara Lee
have moved their facilities to Goose Island, and the beer-making history lives on in
Chicago's Goose Island Brewery.

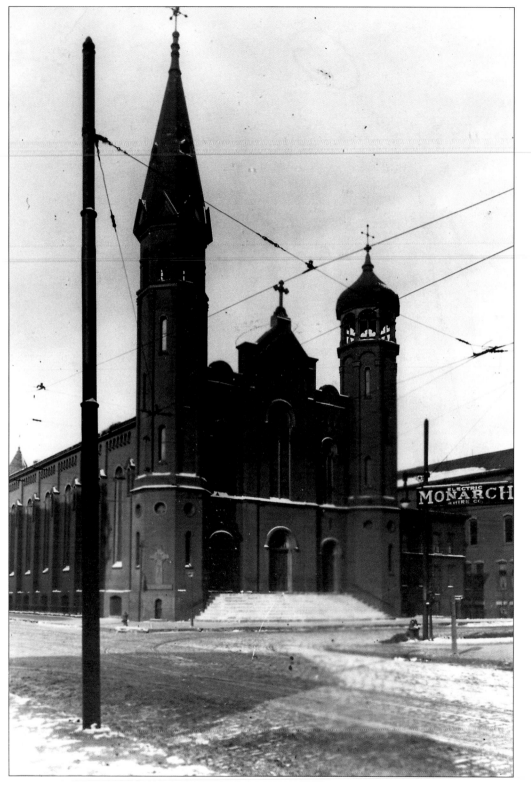

Northwest corner of Adams and Desplaines, circa 1880s. Constructed in 1852–1856, St. Patrick's Roman Catholic Church was designed by Carter & Bauer of Milwaukee common (yellow) brick above a Joliet limestone base. The onion dome at right was meant to symbolize the Church in the East, the spire, the Church in the West.

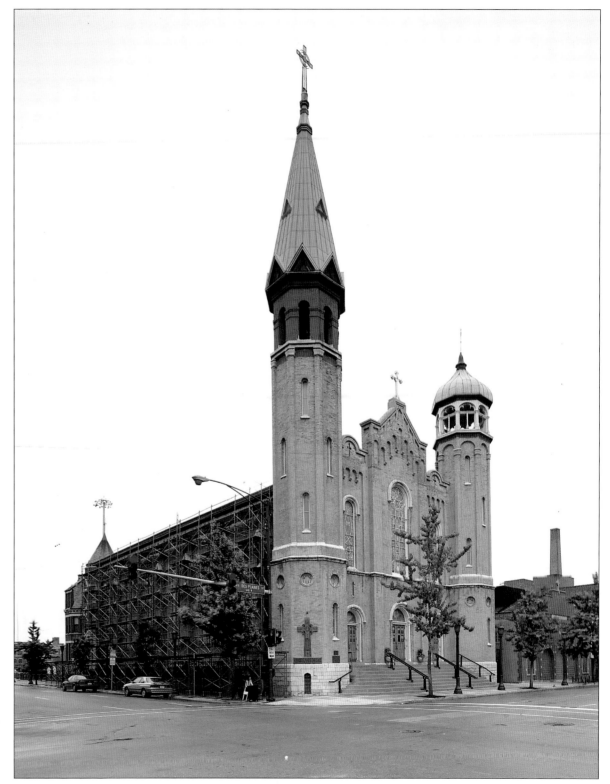

Today, St. Patrick's is the oldest church in Chicago, and one of the few buildings to survive the great fire. Built on the original far-western border of the city, St. Patrick's today is in the heart of the near West Side, a thriving Catholic community. The electric streetcar lines are gone now, but the Kennedy Expressway (I90/94) just out of sight at left.

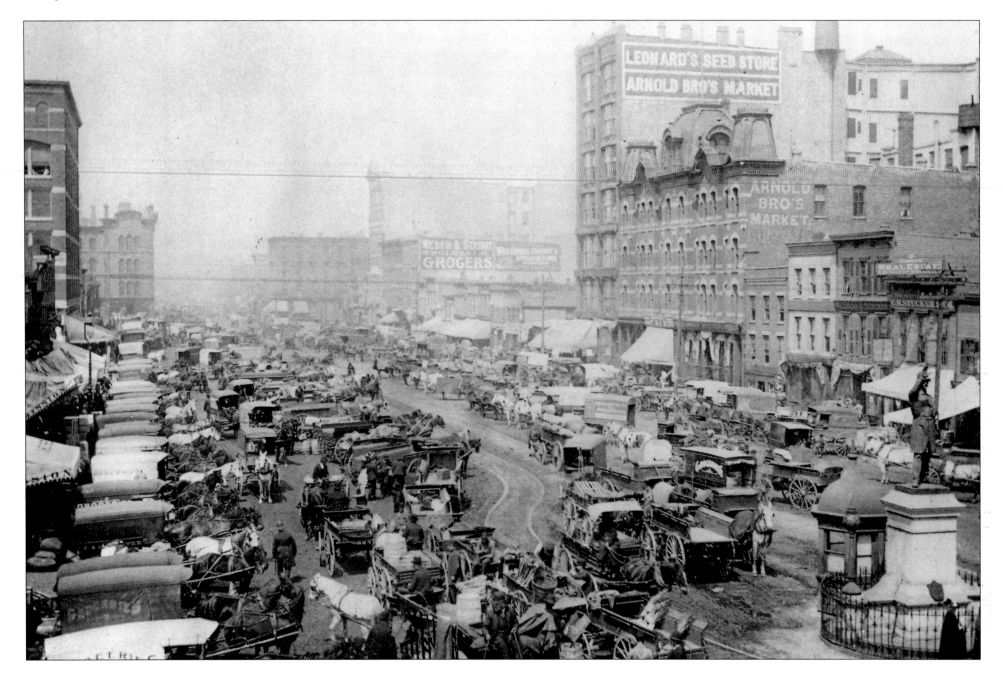

West Randolph at Desplaines, 1892. Where Randolph Street widens as it approaches Halsted Street was the center of wholesale produce distribution. On May 4, 1886, a bomb went off at a workers' rally in this Haymarket district, killing one policeman instantly. Officers open fired on the crowd, killing perhaps as many as 10, and wounding more than 30. A total of eight policemen died, many injured by each other's gunfire. In what was later deemed very dubious justice, eight anarchists were sentenced to death. Four were hanged, one committed suicide, and three were later pardoned.

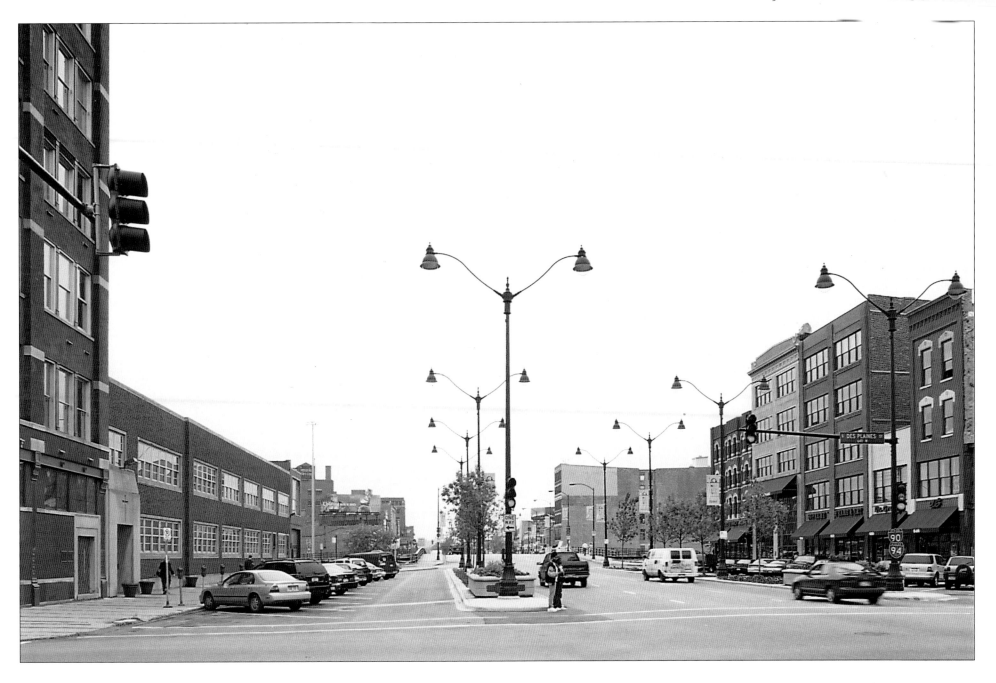

The statue at lower right of the archival photo is a police officer with upraised arm, restraining an invisible mob. The plaque commands peace "In the name of the people of Illinois." The controversy surrounding the riot plagued the statue as well, which was repeatedly vandalized, e.g., in 1903 a streetcar motorman intentionally rammed it. The statue was moved to Union Park where it was again defaced during the civil unrest of the 1960s. It resides today at the Police Training Academy. Today, the Haymarket Riot is acknowledged as a violent landmark in American labor history; the stretch of Randolph Street has been transformed into a hot new restaurant district.

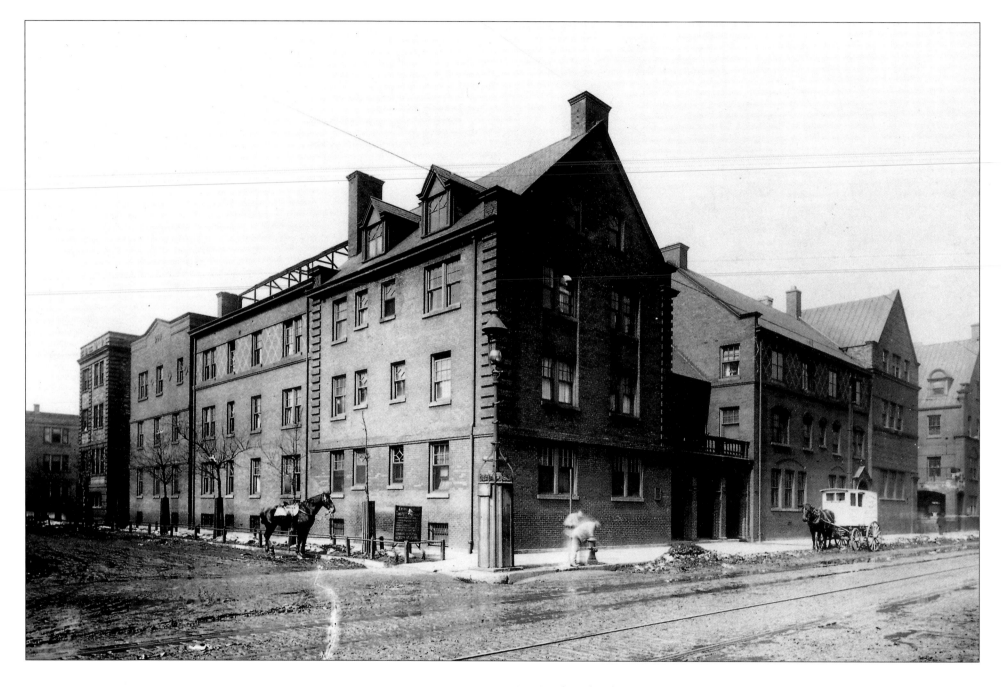

800 South Halsted at Polk Street, circa 1912. Built in 1856 for wealthy real-estate baron Charles J. Hull, this brick Italianate house was originally in a chichi neighborhood, but the elite moved north to follow Potter Palmer, and the West Side became the "port of entry" for many of Chicago's immigrant groups. In 1889, Jane Addams and her college friend moved into this house to live among and help Chicago's poor immigrant communities. By the turn of the century, the settlement complex consisted of thirteen buildings covering a city block.

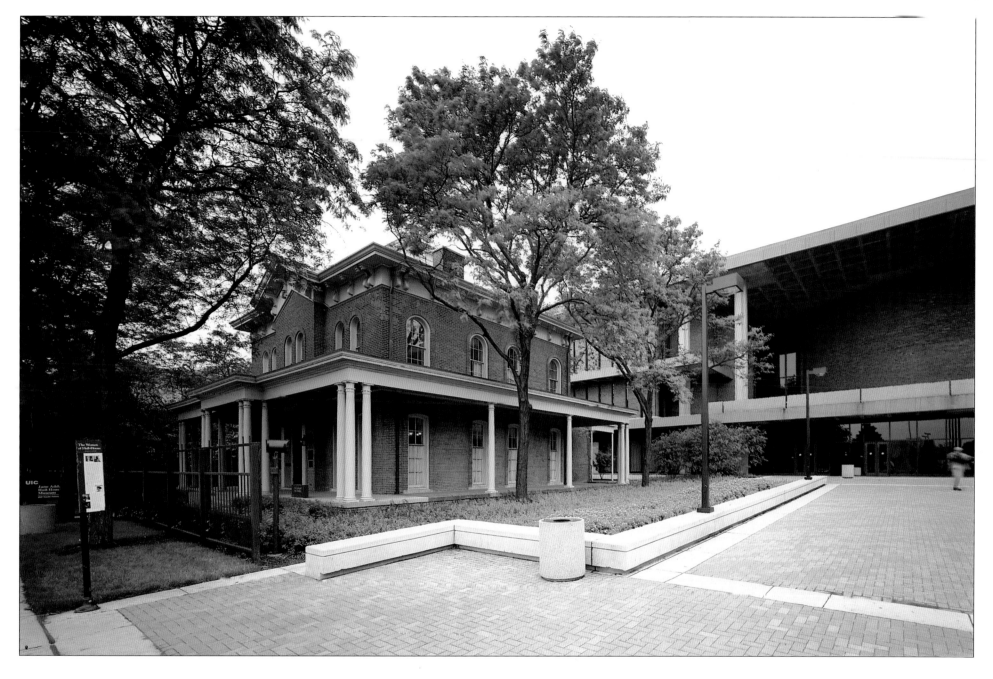

In 1931, Jane Addams became the first American woman to win the Nobel Peace Prize; she was acknowledged for her work for a variety of good causes: women's suffrage, child-labor laws, better schools and sanitation, among others. In the 1960s, this site became part of a large parcel of land slated for development by the city into the new University of Illinois at Chicago. In 1963, the university dedicated the original Charles Hull home as a museum of the settlement, but tore down all the other buildings in the complex.

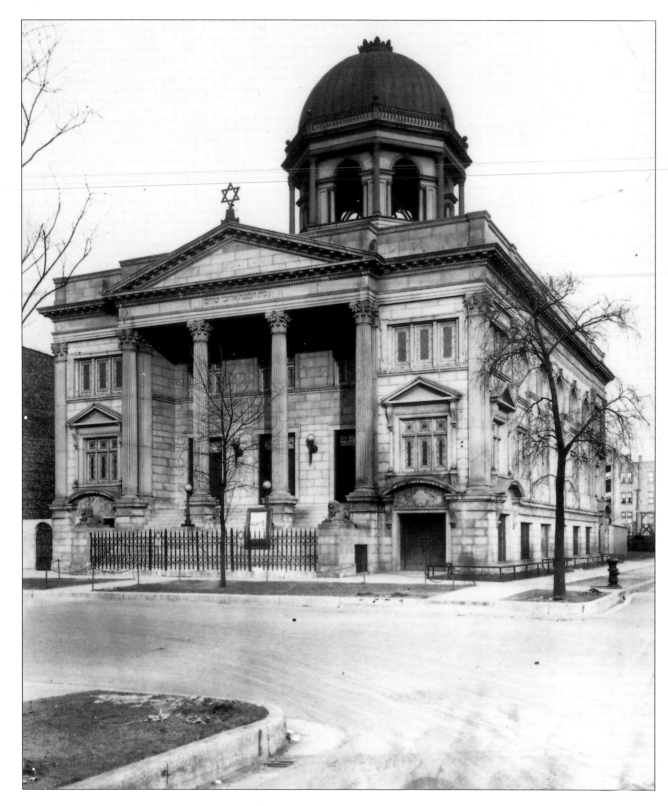

Chicago is a town of immigrant communities, particularly the West Side. When Jane Addams established Hull House in this neighborhood, she described the ethnic patchwork: "Between Halsted Street and the river live about 10,000 Italians. In the south on 12th Street are many Germans, and side streets are given over to Polish and Russian Jews. Still farther south, thin Jewish colonies merge into a huge Bohemian colony." To the northwest were French Canadians, Irish to the north and beyond them, other "well-to-do English speaking families." Once families achieved a modicum of success, they often moved on to better-off immigrant communities, leaving their "ghettos" for new incoming immigrant groups.

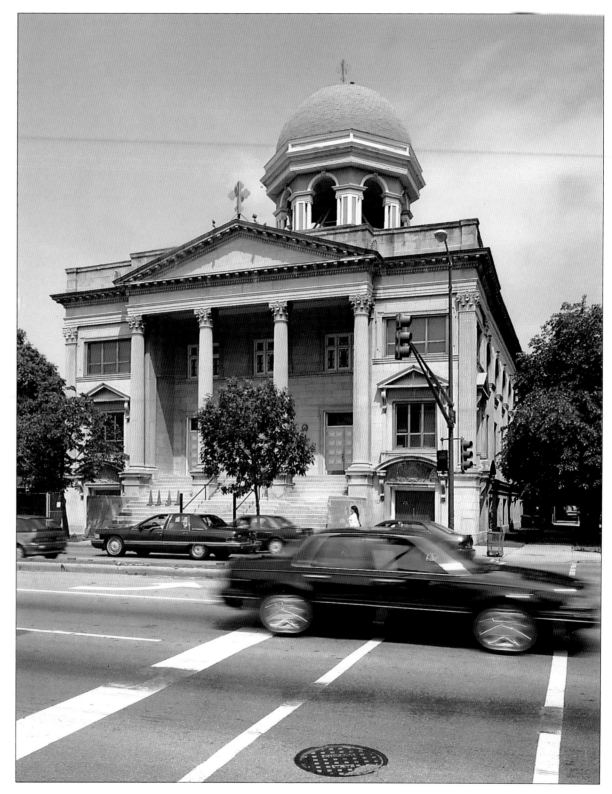

In the archival photo, we see Anshe Sholom Synagogue at 733 South Ashland at Polk Street. Built shortly after the turn of the century, the building was sold when the congregation moved out west to what was then called "Chicago's Jerusalem" in Douglas Park. Today, Anshe Sholom B'nai Chicago is on the city's North Side. The original Greek Revival style building, designed by Alexander Levy, was converted to a Greek Orthodox church in 1927. Today, St. Basil's is almost 75 years old. Located on the University of Illinois campus, the building's ribbed dome is now covered with shingles, but the original Hebrew carving is still visible on the portico.

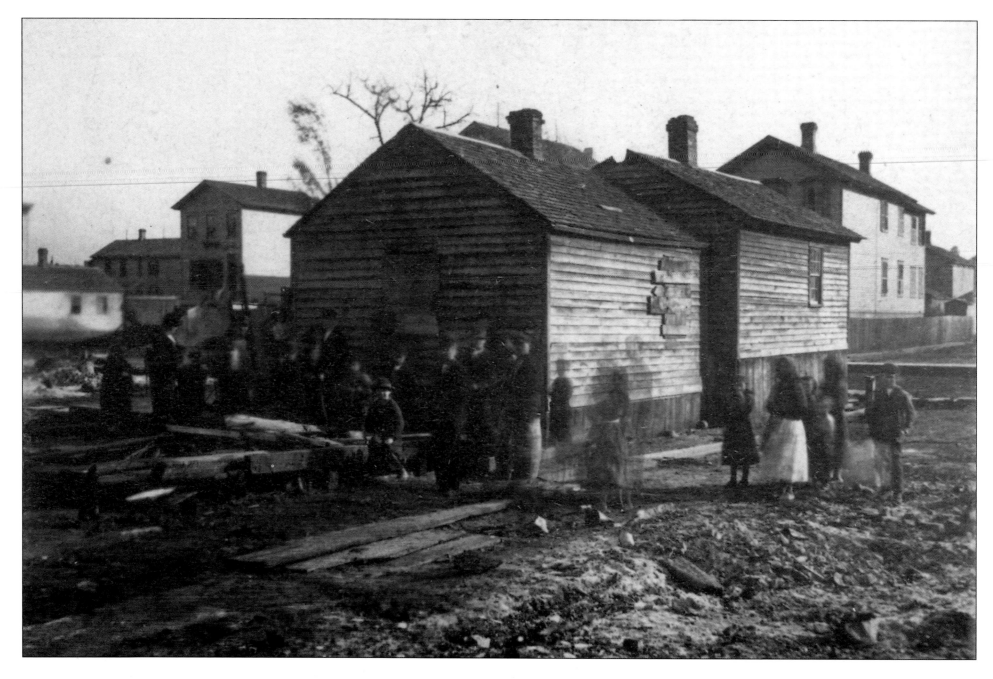

558 West DeKoven Street, 1871. It had been a hot, dry summer, and the whole Midwest was suffering a tremendous drought. Chicago, with its preponderance of wooden balloon-frame buildings, wooden sidewalks, and wooden tar-sealed paving blocks, was a tinderbox in search of a spark. On a windy Sunday evening, October 8, 1871, a fire broke out in the barn behind Patrick and Catherine O'Leary's West Side home. Within hours, a raging inferno had jumped the river twice and laid waste to the downtown. "Fire devils," whirling pockets of gas and air, rolled through the city streets for two days after, flattening buildings and sending survivors running into the lake. Eyewitness accounts relate that the heat of the fire was so intense the sand beaches melted into rough glass.

Three hundred Chicagoans died, 90,000 were made homeless, 17,500 buildings were destroyed, and total damages amounted to $200 million. Nevertheless, the Fire became the defining moment in Chicago's history, igniting the fierce spark of can-do pride and civic boosterism that led the *Chicago Tribune* to print in its first post-Fire edition (October 11): "CHEER UP! In the midst of a calamity without parallel in the world's history, looking upon the ashes of 30 years' accumulations, the people of this once beautiful city have resolved that CHICAGO SHALL RISE AGAIN!" Within two years, the city was essentially completely rebuilt. Today, on the site of the fire's origin stands the Chicago Fire Academy with its red-glazed brick exterior. A flame-shaped sculpture by Egon Weiner commemorates the Fire.

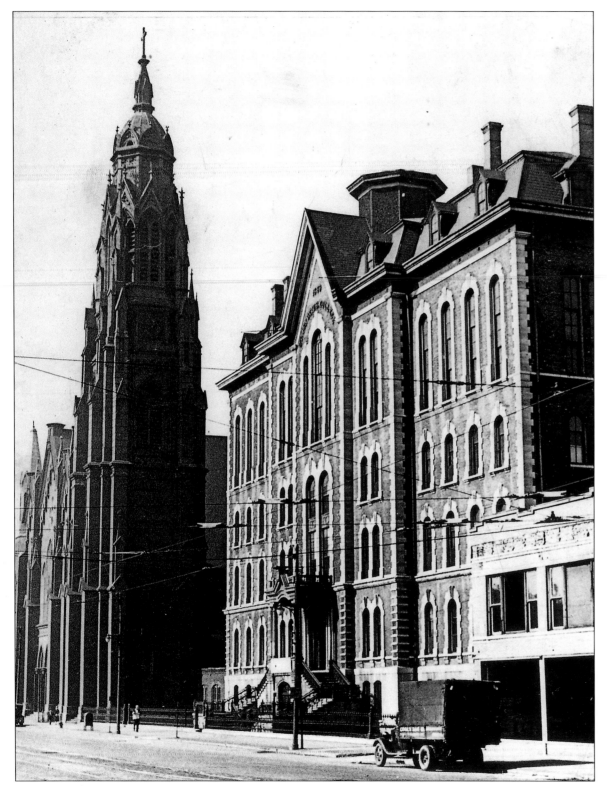

St. Ignatius College was founded in 1869 as a Jesuit Institution. It is the city's oldest school, and one of the only Chicago examples of decidedly French architecture, a rare and distinctive example of institutional design predating the Chicago Fire of 1871. Designed by Toussaint Menard, the building contains typical features of a nineteenth-century school, such as the top-floor assembly room, where it was structurally easier to include clear span space. In 1873, the fourth floor housed a natural history museum.

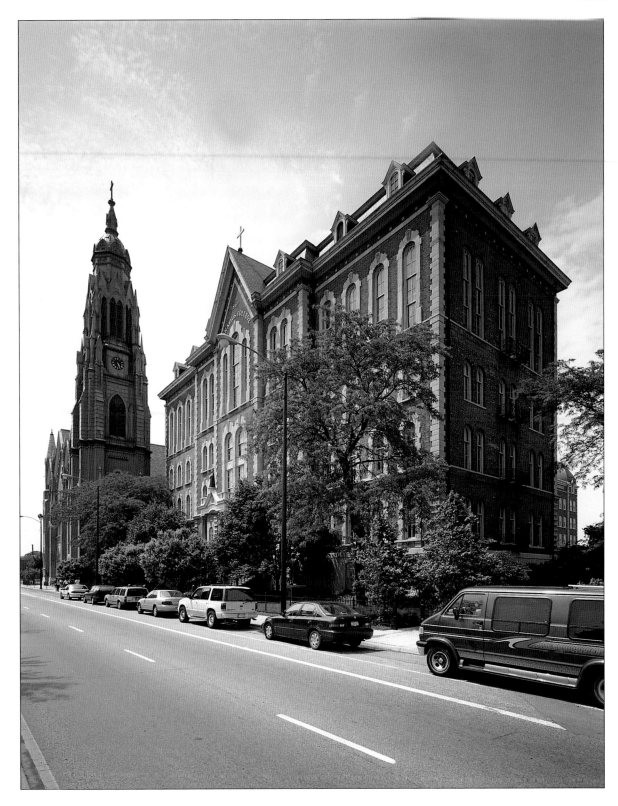

Loyola University originated from this institution but, since 1922, St. Ignatius has operated solely as a college preparatory school. It now sits on the edge of the University of Illinois campus on Chicago's West Side (1076 West Roosevelt). The streetcars are gone and the road is now paved, but the German Gothic-style Holy Family Church (1860) still stands, a testament to the German craftsmen of this neighborhood. The statue is of the school's pioneering founder, Father Arnold Damen, S.J.

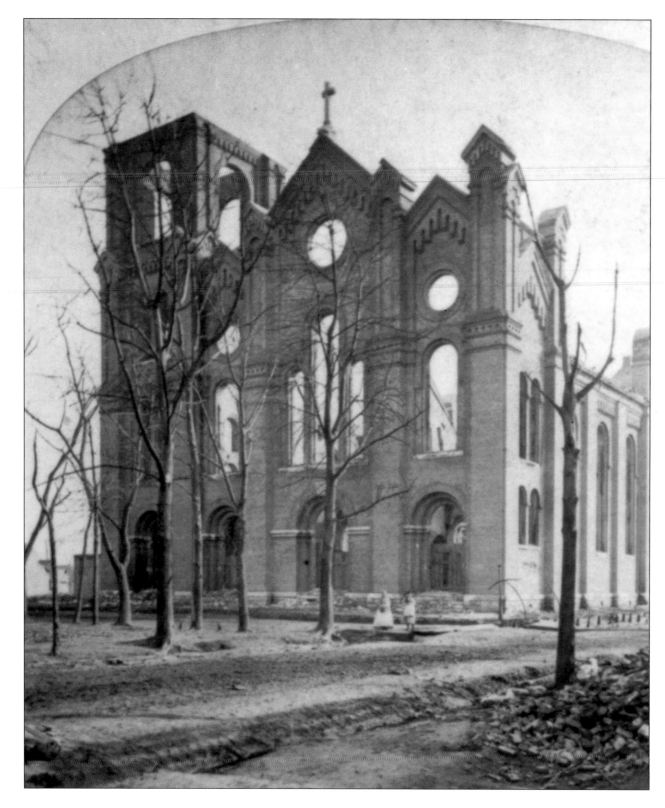

1633 North Cleveland, 1871. In 1852, Chicago's German community built a small church in the center of their North Side neighborhood, then known as "North Town." They replaced it with a much grander red-brick building with a 200-foot spire in 1869, only to see it gutted by the Great Fire of 1871. The picturesque remains seen here were declared the "most impressive remains on the North Side."

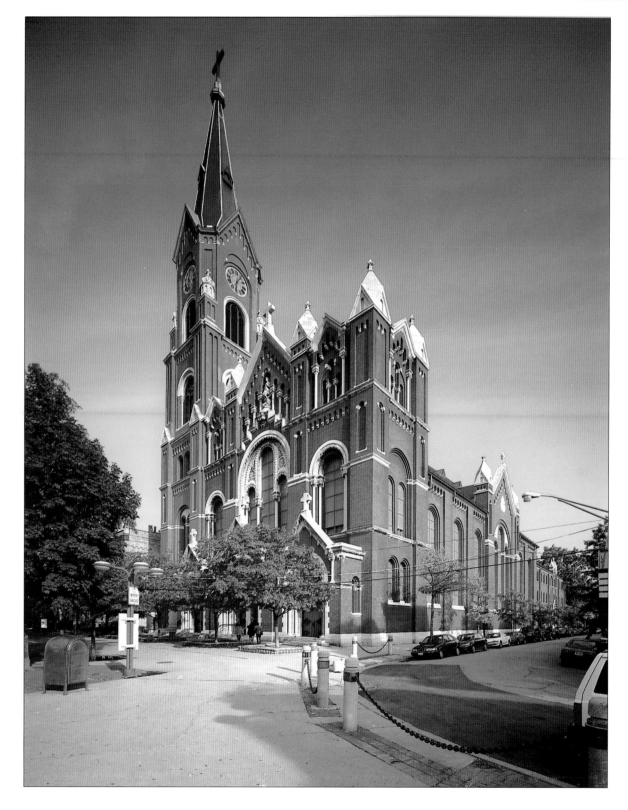

Today, St. Michael's is the heart and soul of the Old Town neighborhood, whose very boundaries are determined by their relationship to the church: if you can hear St. Michael's bells tolling, you are in Old Town. After the Great Fire, determined parishioners rebuilt in just one year; the steeple and clock were added in 1888; and the Munich stained glass windows in 1902. The neighborhood is gentrified today.

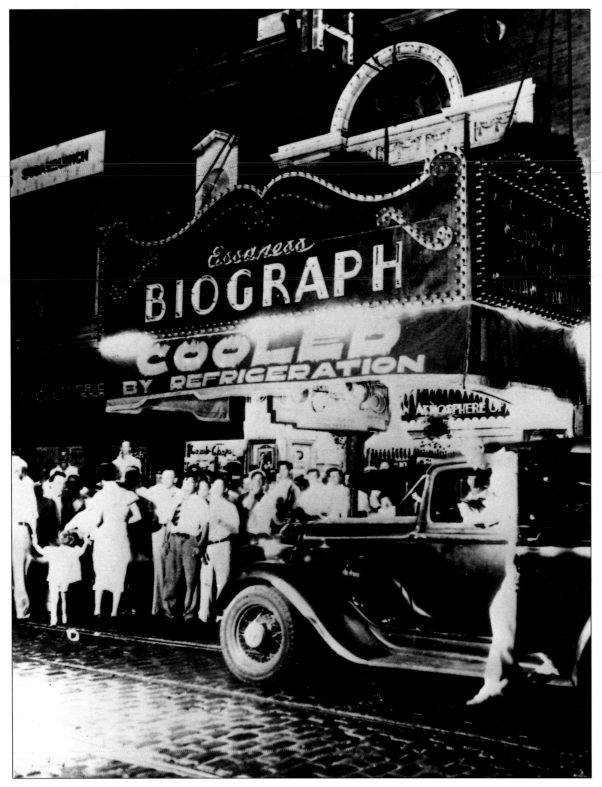

In the midst of an extremely hot Chicago-style summer, during which several people died from the heat, many Chicagoans opted to go to the movies, which had recently been advertising that they were "air cooled." The Biograph, at 2433 North Lincoln, was one such "refrigerated" theater, and on July 22, 1934, one of Chicago's most famous gangsters, wanted for multiple bank robbery and murder, met his fate there.

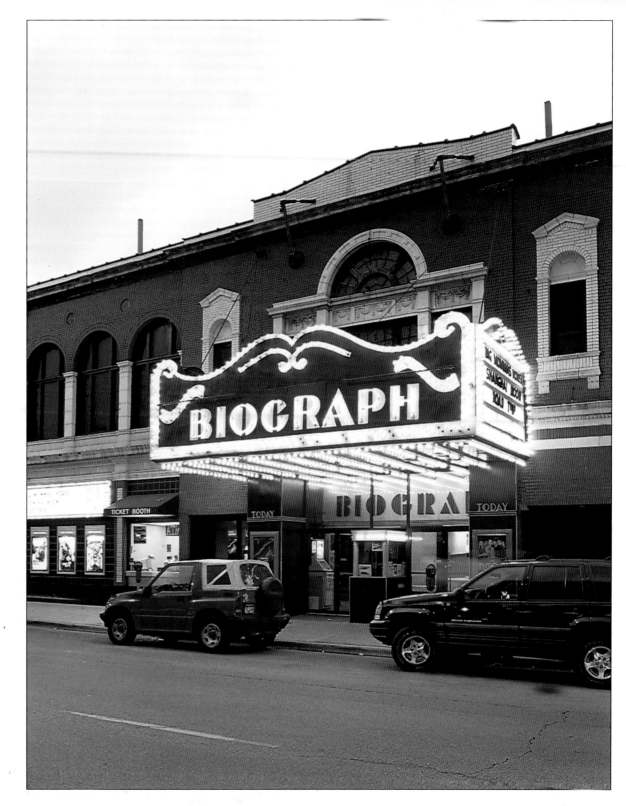

On his birthday a month earlier, John Dillinger had been declared "Public Enemy Number One" by the FBI. When he exited the show that evening (*Manhattan Melodrama*), twenty lawmen were waiting. Betrayed by "The Woman in Red," his girlfriend's landlady, Dillinger was gunned down as he tried to flee. Today, the Biograph has been divided into four screens showing first-run features.

Like the rest of the North Side, this area was considered inaccessible and remote for most of the nineteenth century—remote enough that the lakefront beyond North Avenue was used as the city cemetery. In 1864, the city agreed to move the cemetery farther north ("In Chicago, even the dead must 'move on,'" remarked one commentator), and dedicated Lake Park. It was renamed Lincoln Park the following year in honor of the assassinated president.

Today, Lincoln Park, at 5.5 miles, is the city's largest park. The park contains the free Lincoln Park Zoo; monuments to Lincoln, Grant, and Hamilton; a conservatory; the Nature Museum; the Chicago Historical Society; a community theater; a city beach and bath house; two ponds, and a lagoon large enough to accommodate rowing and sculling practice. The surrounding neighborhood is also called Lincoln Park, and is today one of the city's most desirable (and expensive).

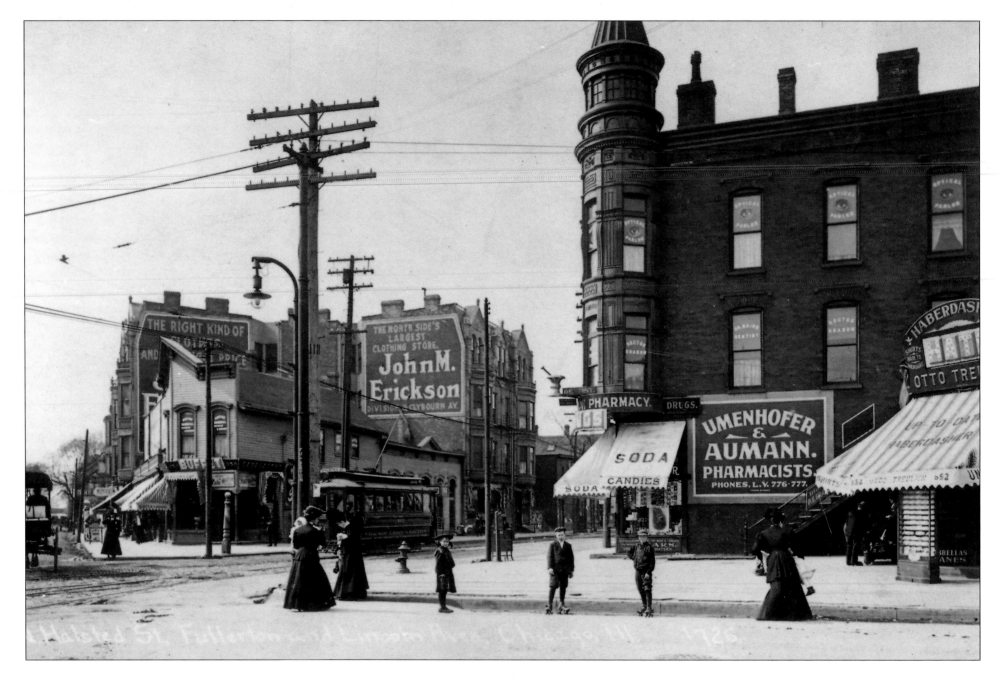

Already one of the busier intersections in turn-of-the-century Lincoln Park, Halsted, Fullerton, & Lincoln were home to a high-class residential district throughout the 1930s. Formerly German farmland, the neighborhood's ethnic heritage is reflected in the shop names. After World War II, however, many homes were converted into tenement rooming houses, and by the 1950s, the rise of the suburbs meant the blighting of Lincoln Park.

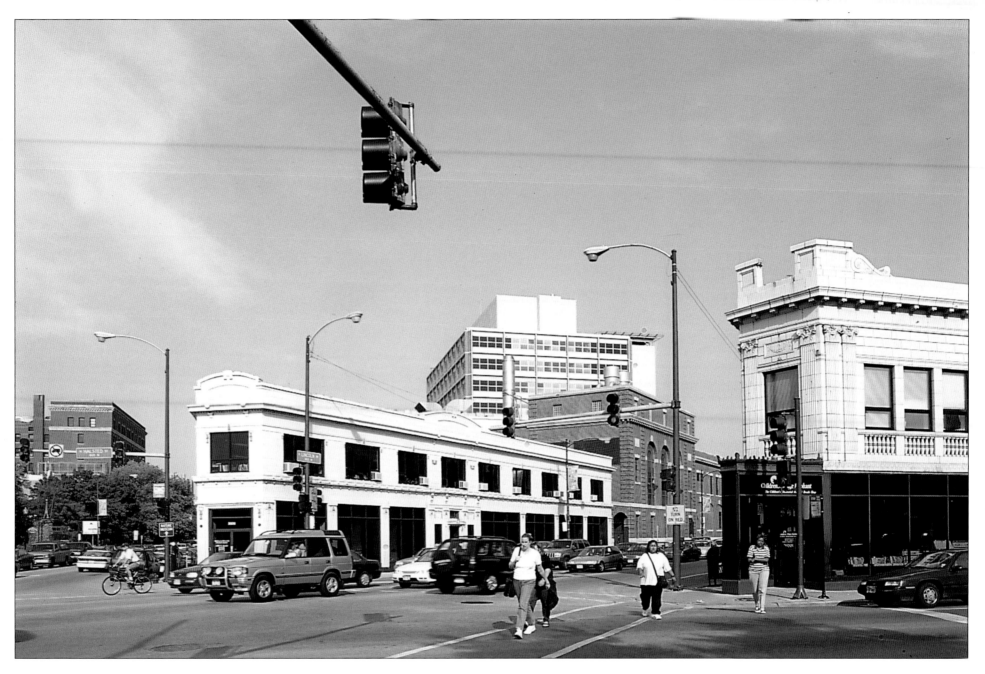

In the 1960s, DePaul University (who owns the southwest corner of this intersection) embarked on an ambitious land-buying program, acquiring nearby McCormick Seminary, one of Lincoln Park's largest landowners. The intervening decades have seen the urban renewal of the Lincoln Park/DePaul neighborhood, and it is today one of the city's most coveted addresses, drawing flocks of monied young professionals.

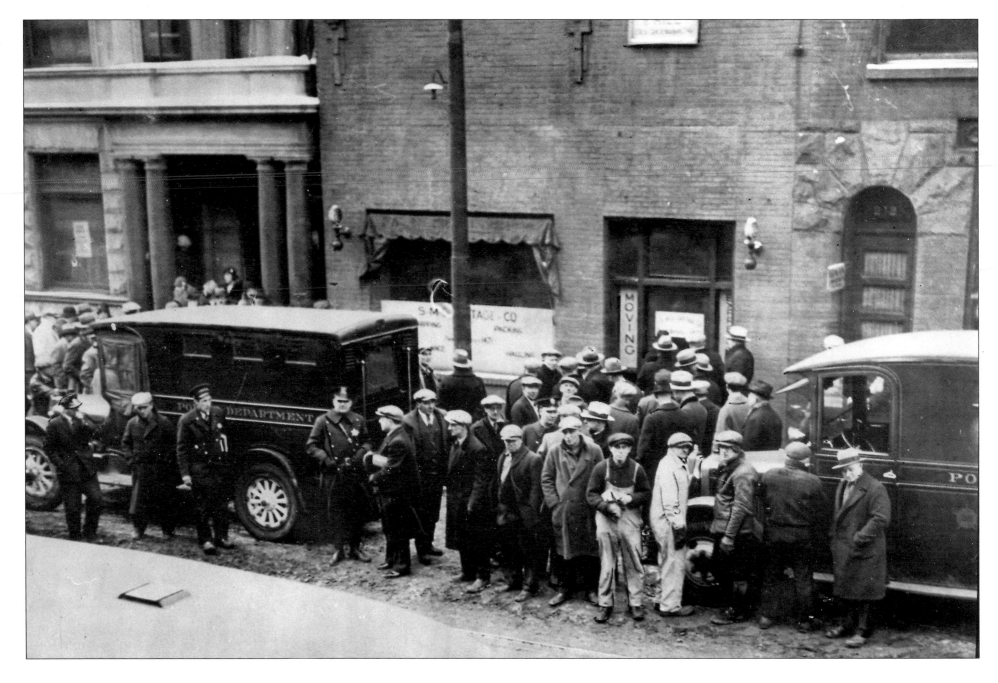

2122 North Clark, 1930s. Just like Hollywood's maps of the stars, Chicago's tourism industry features highlights from the city's Gangland heyday. Even in the Prohibition era's "roaring twenties," tourists to Chicago felt their trip was "a failure unless it included a view of Capone out for a spin." The climax of the Capone era was the horrendous St. Valentine's Day Massacre in 1929.

On a freezing morning, Capone's men, led by "Machine Gun" McGurn, dressed as policemen and "raided" the SMC Cartage Company, a business front for the Bugs Moran gang. Six members of the gang and one bystander were lined up and machine-gunned, although Capone's target, Moran himself, had overslept and was not in attendance. The garage was torn down in 1967.

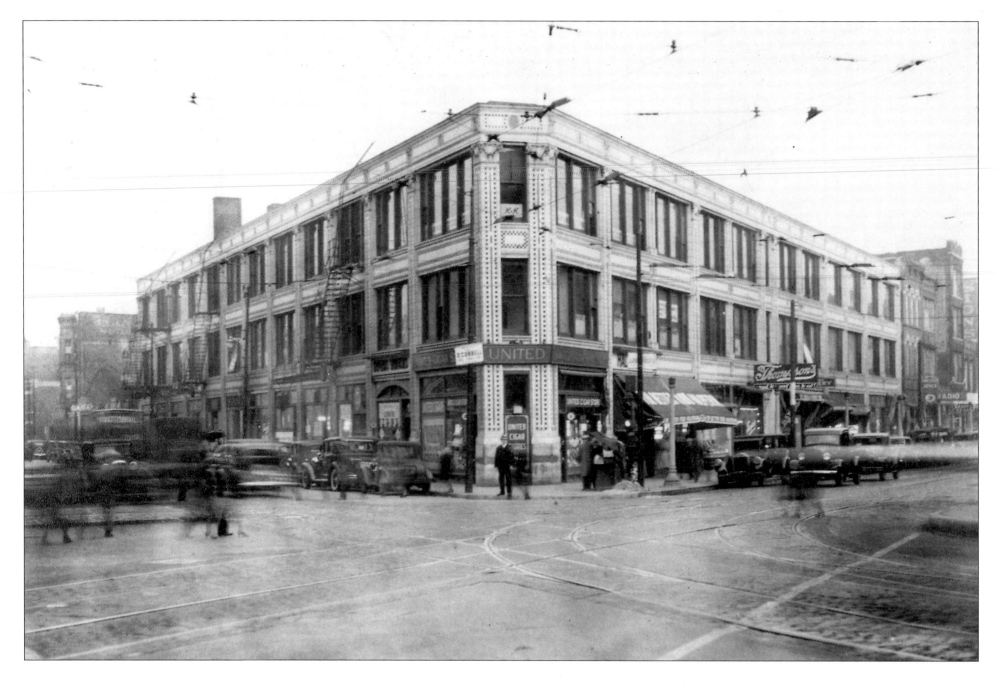

Like many of Chicago's diagonal roads, Milwaukee began life as a Native American trail that became a plank road and a streetcar route, and helped populate the northwest side with more recent immigrants. The intersection seen here is the commercial heart of a Polish neighborhood that became known as Wicker Park after the triangular-shaped public park that developer-politician Charles Wicker, and his brother Joel, donated to the city in 1870.

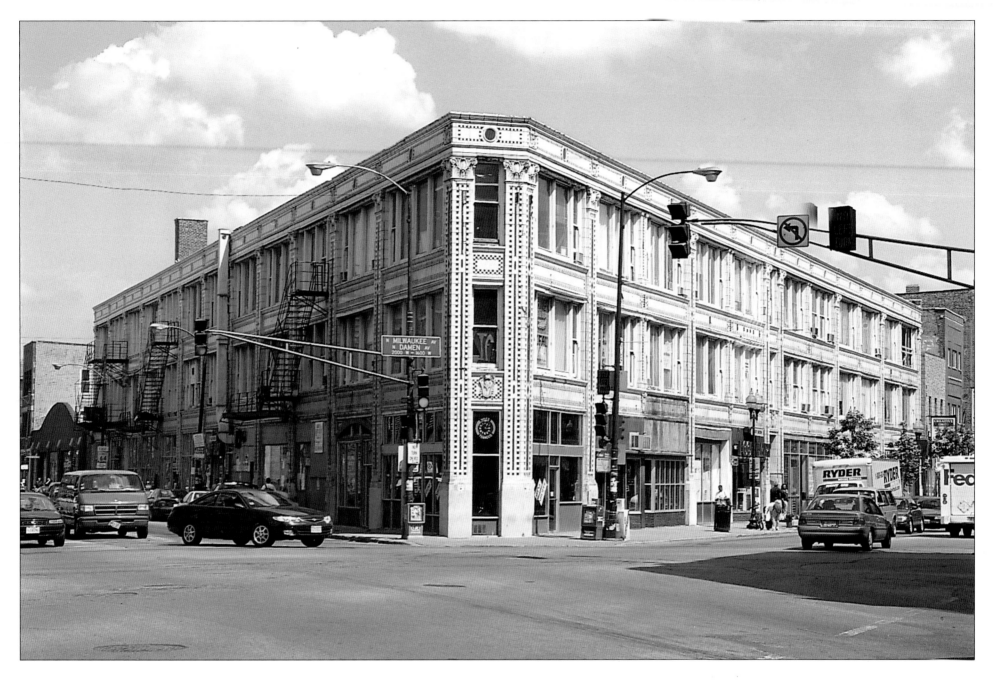

Today, after a long slide into blight once the Polish community moved farther out, Wicker Park is undergoing a renaissance. The cheap rents attracted an artist community in the 1980s/1990s, and now the area is home to hip urban nightclubs and bars, cool coffeehouses, and trendy stores. Nearby streets are lined with some of the city's largest and best examples of Victorian-era architecture, earning the area the nickname the "Polish Gold Coast."

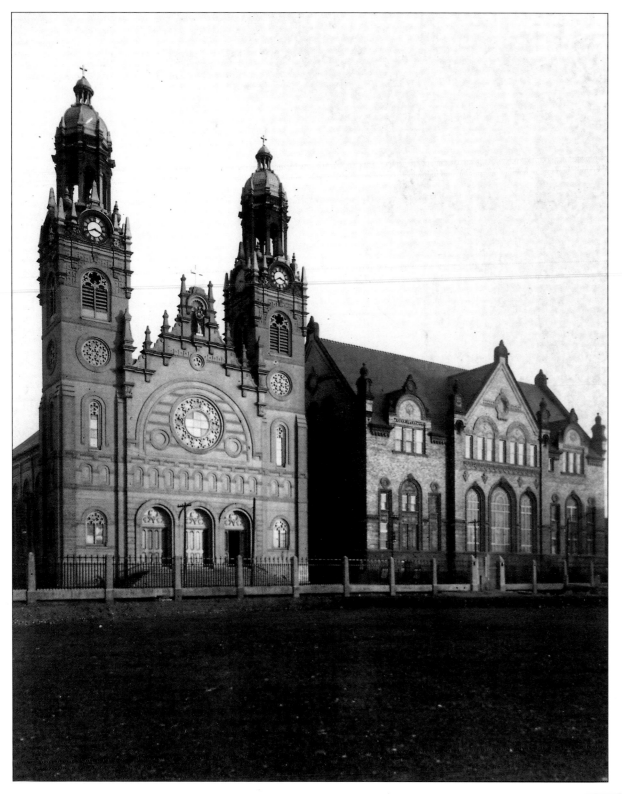

One of America's first Polish churches, St. Stanislaus was founded in 1868. Wealthy Polish beer magnates helped fund the commission of architect Patrick Keeley, who had just finished the Holy Name Cathedral downtown, to design a church in honor of the St. Stanislaus Kostka S.J., who was named for the patron saint of Poland. The building was constructed in 1876–1881 in brick. The towers were added in 1892 under direction of German architect Adolphus Druiding, and the photo was taken around that time.

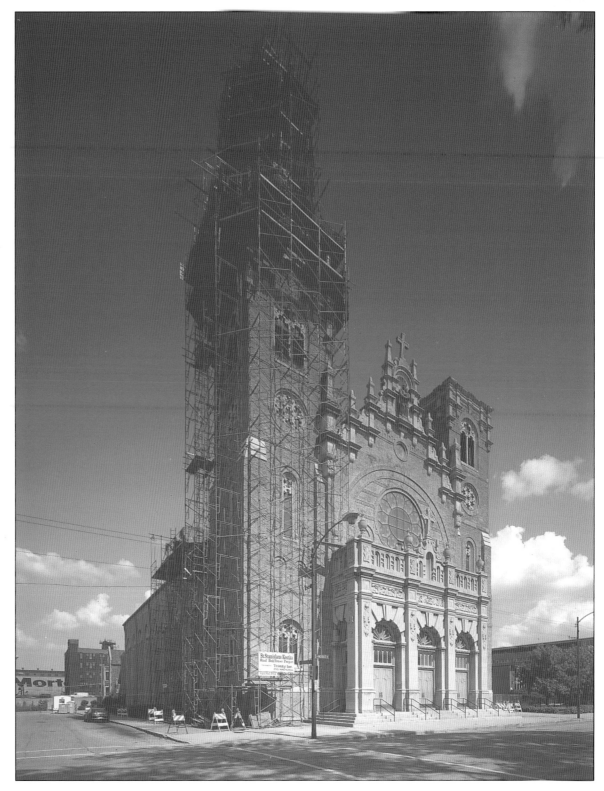

Today, St. Stanislaus reflects the shifting ethnic makeup of the neighborhood, offering masses in English, Polish, and Spanish. In 1923, the congregation had the brick walls stuccoed over in an imitation of stone. The southern tower was struck by lightning in 1964 and left, as is, an act of God. The construction of the Kennedy Expressway (I90/94) was routed around the church, but it destroyed the original school (seen in the archival photo). The new building dates to 1959.

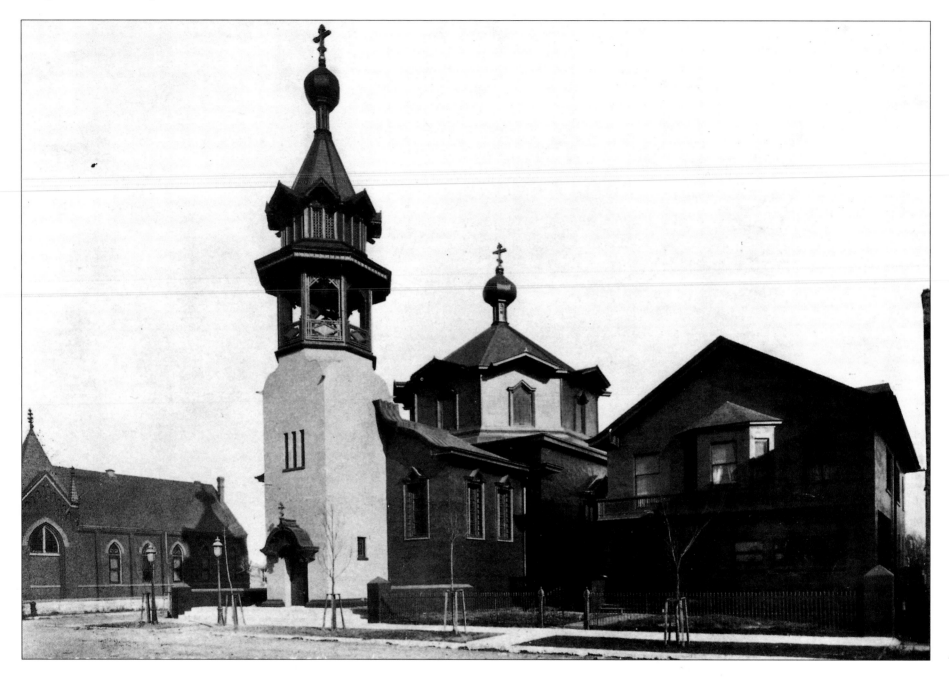

1121 North Leavitt, circa 1903. Another example of Chicago's diverse ethnic history, this Russian Orthodox church formed the center of a Russian neighborhood in the Northwest Side. Designed to resemble the Russian provincial churches known to its first parishioners, this elegant church is an unexpected feature of its neighborhood. Even more surprising is the fact that its construction was partially paid for by Russian Czar Nicholas II.

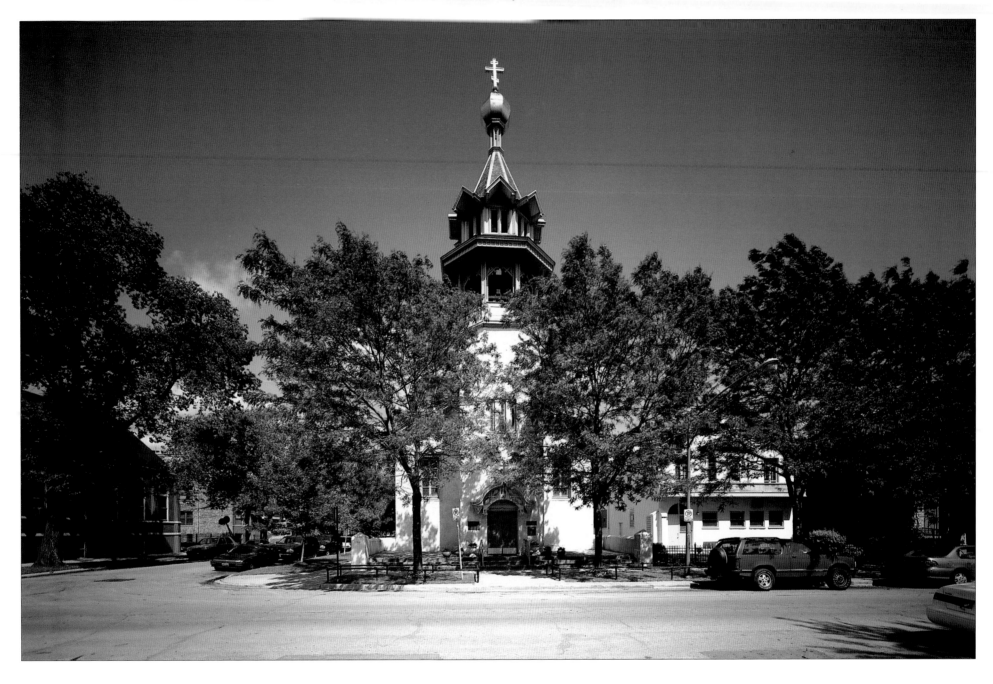

Today, Holy Trinity is perhaps most famous for its architect—Louis Sullivan, pioneer of the Chicago School and designer of the famed Carson Pirie Scott downtown. In one of his rare sacred projects, Sullivan synthesized iconic Orthodox tradition with his own contemporary design ideals, resulting in, most evidently, the lovely streamlined variation on the traditional Eastern onion domes. The ideologies harmonized well, producing one of the most inspired small-scale works of one of Chicago's most influential architects.

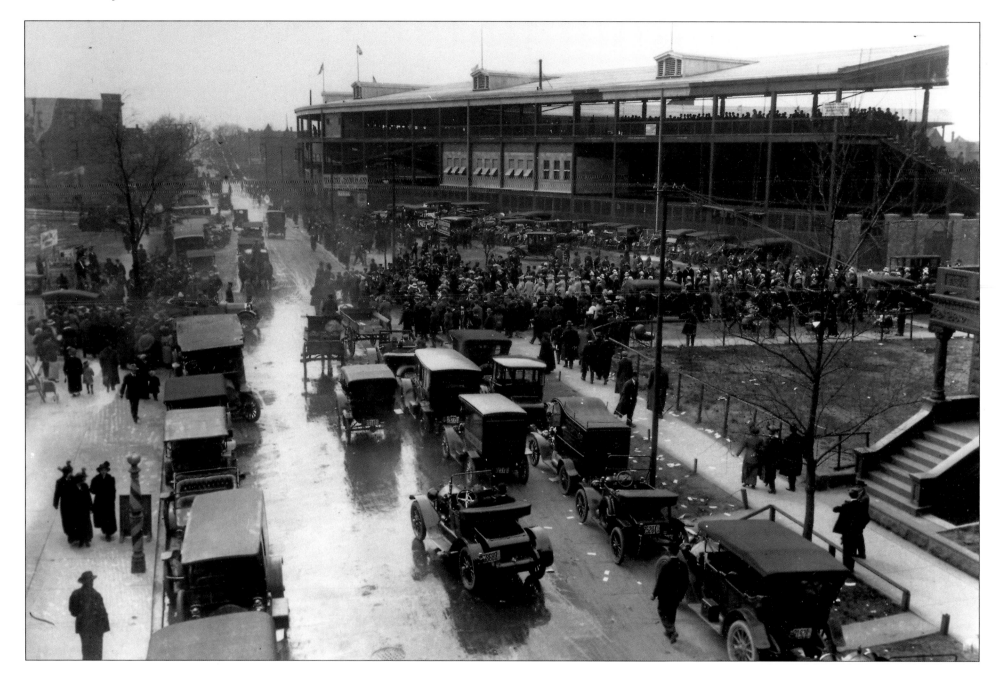

West on Addison, circa 1915. One of the oldest fields in the country (certainly the oldest in the National League), Wrigley Field was built in 1914 and designed by Zachary Taylor Davis, who also designed the first Comiskey Park. A live bear cub was on hand when the team played its first game. Originally called Weeghman Park after the first owner, the park was renamed when William Wrigley purchased the team in 1926. Dedicated to tradition, for years Wrigley was one of the only major-league stadiums to change numbers by hand and to forego modern lighting.

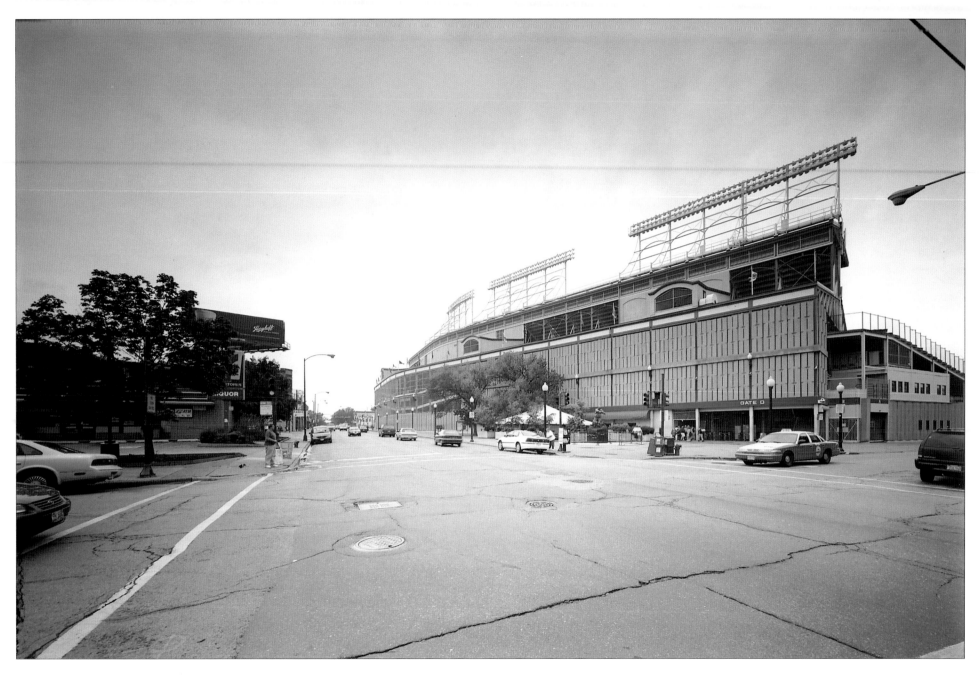

Known as "the Friendly Confines," the tiny ivy-walled pillbox of a park is one of Chicago's best-loved landmarks. The necessity of television revenue finally brought night games to the park in 1988, but despite repeated enlargements and remodeling, the home of the Cubs still offers that rare ambiance of an old-time ballpark in the heart of the city. Houses in the immediate environs (a neighborhood now known as Wrigleyville) sport rooftop bleachers, and although the Cubs haven't won the World Series since 1908, Chicagoans are diehard fans.

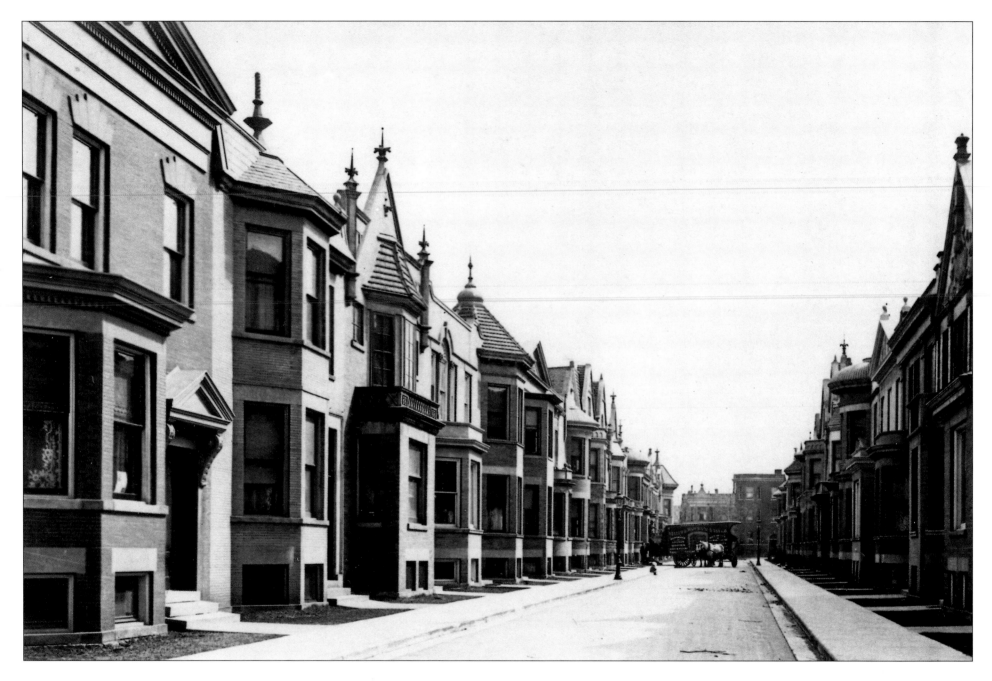

South from Byron Street, abutting Graceland Cemetery, 1905. One of the last real-estate developments of Samuel Eberly Gross, a colorful investor responsible for the development of thousands of working-class Chicago homes, Alta Vista Terrace is sometimes called the "Street of Forty Doors." The ensemble of forty row houses was designed by J. C. Brompton in 1900–1904 and modeled on moderately priced Georgian row houses Gross had just seen in London.

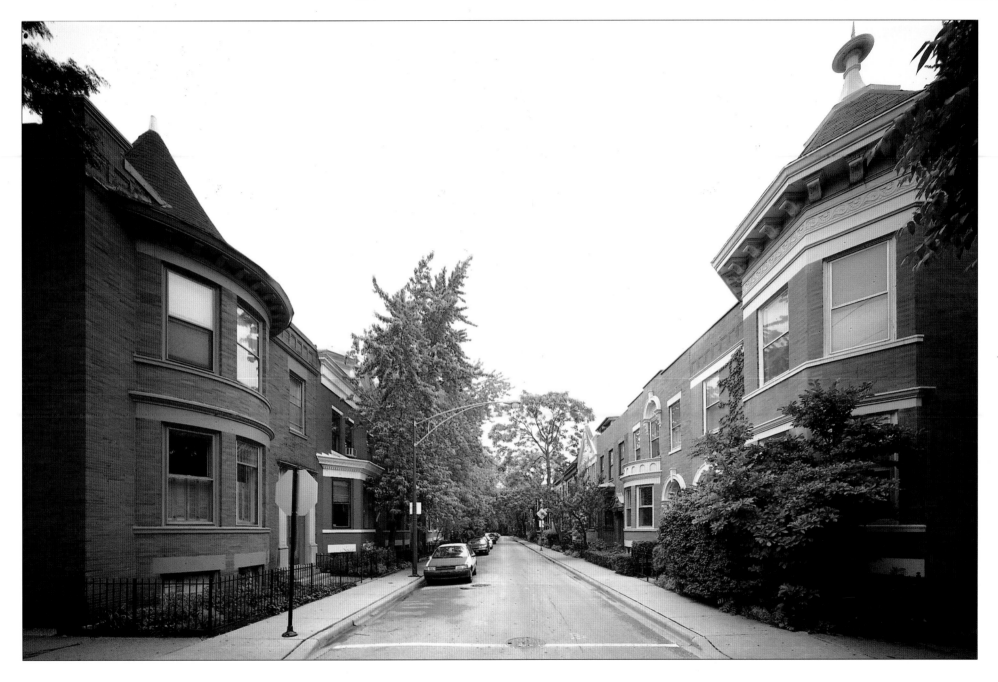

Alta Vista Terrace was designated Chicago's first historic district in 1971, setting standards for maintenance and preservation. The lively, human-sized terrace was designed as a street-long unit, but with an abundance of personalized contrasts in color, roofline, and architectural detail. The individual house designs are mirrored diagonally, so the southernmost home on the east side is the same as the northernmost on the west, and so on.

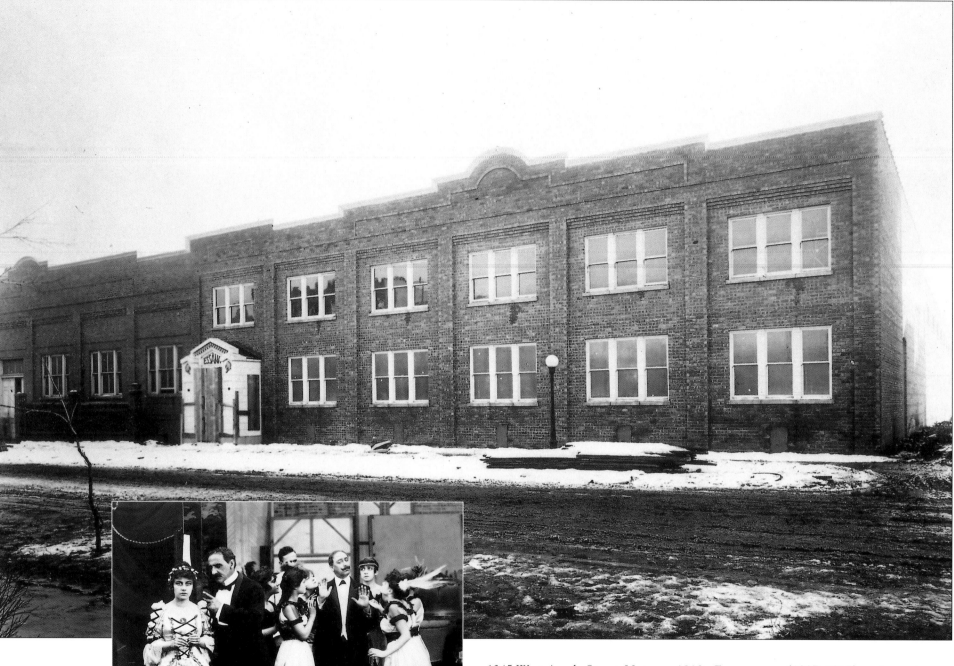

Scene From
ESSANAY'S
6 Act Feature
"The Crimson Wing"

1345 West Argyle Street, Uptown, 1910s. For ten years (1907–1917), a pioneering movie studio turned Chicago into "Hollywood on the prairie." Essanay Studios (an amalgam of the founders initials—S&A) boasted silent cinema's greatest stars on its contract roster: Charlie Chaplin, Gloria Swanson, Francis X. Bushman, "Bronco Billy" Anderson (a co-founder). The studio dominated the market in westerns and comedies. *Inset*: a promotional piece for a film shot in Chicago. Gloria Swanson is third from the left.

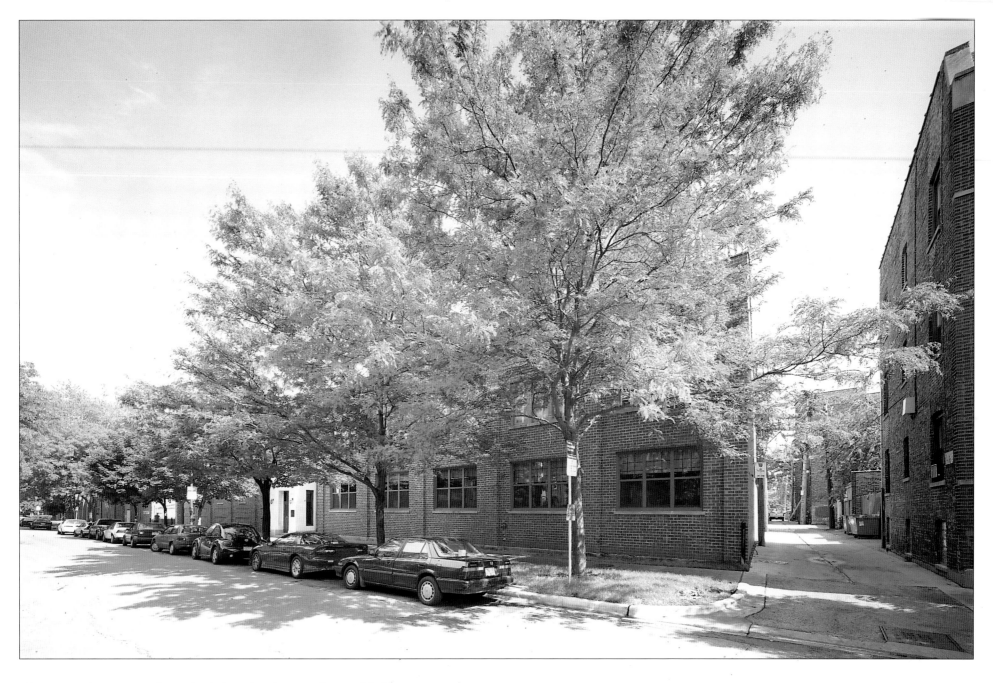

Changes in the movie industry (a shift to the clement climes of California—most movies were shot outdoors), the defection of Charlie Chaplin to a competitor, and internal dissension led to Essanay's collapse. Today, the building houses St. Augustine's College, a small liberal arts school. The terra-cotta Indian heads flanking the entrance were Essanay's trademarks. Argyle Street, once relatively rural, is today the heart of Little Saigon, Chicago's Vietnamese neighborhood.

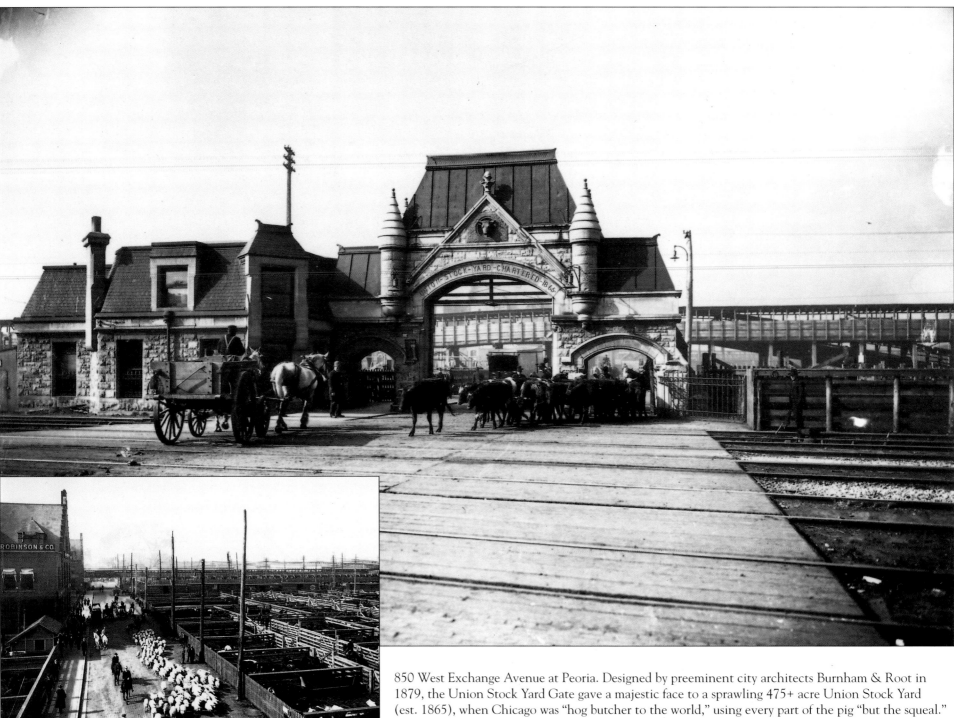

850 West Exchange Avenue at Peoria. Designed by preeminent city architects Burnham & Root in 1879, the Union Stock Yard Gate gave a majestic face to a sprawling 475+ acre Union Stock Yard (est. 1865), when Chicago was "hog butcher to the world," using every part of the pig "but the squeal." Tourist guidebooks of the mid-nineteenth century marveled at the scale and efficiency of the operation. Writers had already branded Chicago "The Great Bovine City of the World," thanks to the major role Chicago played in supplying Union troops with beef during the Civil War. *Inset*: Almost a city in itself, the yards included pen space for up to 25,000 cattle, 80,000 hogs, and 25,000 sheep.

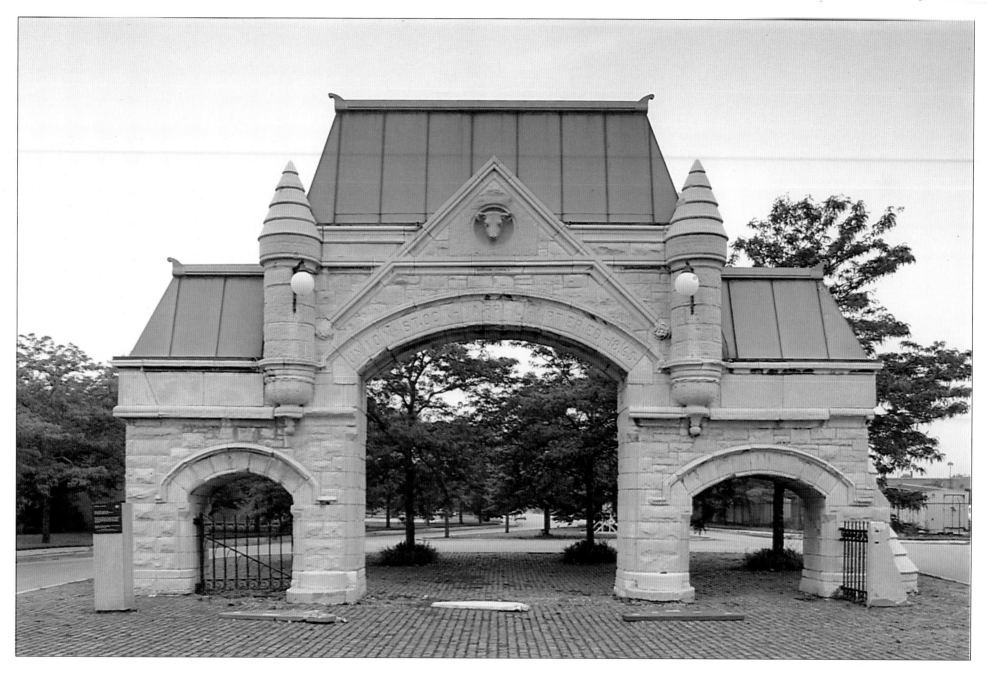

The publication of Upton Sinclair's *The Jungle* in 1906 led to reforms in sanitation and labor conditions for the yards, but Chicago still dominated the meat-packing industry. After providing employment for the Bridgeport and Back of the Yards communities for over a century, the Union Stock Yard closed in 1971. The gate was designated a Chicago Landmark in 1972. The "bust" over the central limestone arch is thought to be "Sherman," a prize-winning steer named after the yard's co-founder, John B. Sherman. Today, industrial parks have filled in some of the vacant space where slaughterhouses once stood.

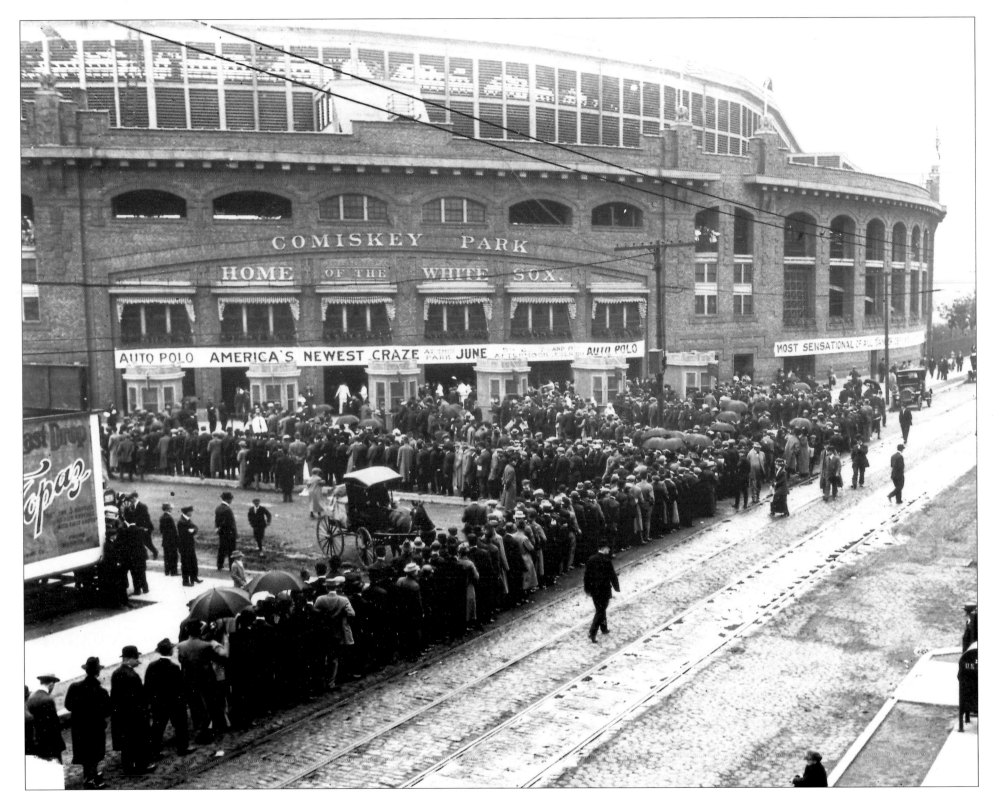

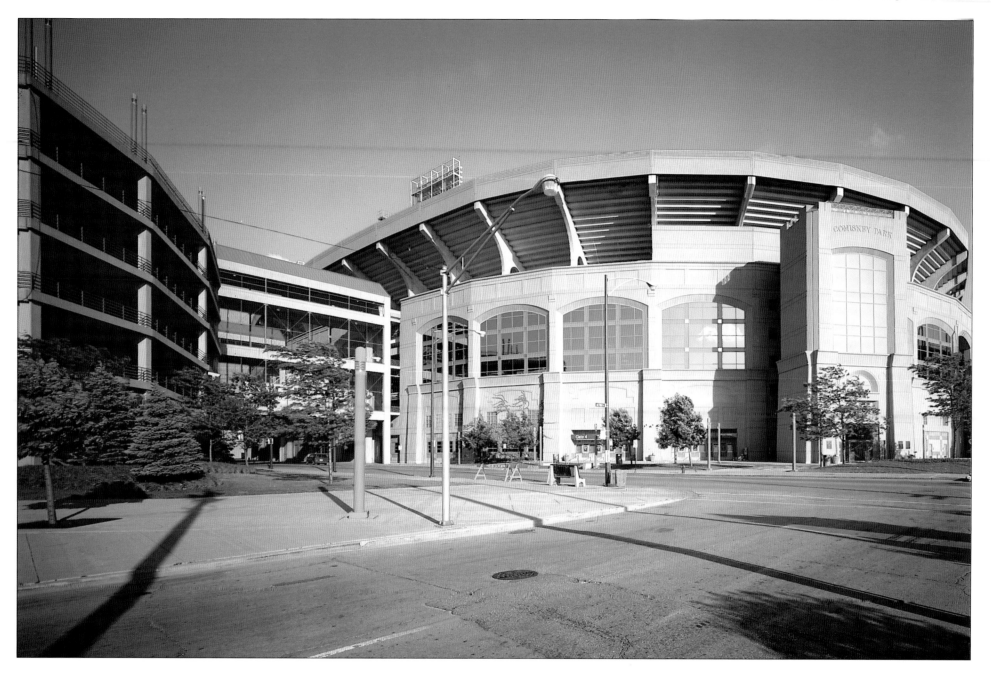

*Left:* Shields and 35th, 1913. Built in 1910 and designed by Zachary Taylor Davis, who would go on to design Wrigley Field as well, the original Comiskey billed itself in typical Chicago hyperbole as "Baseball Palace to the World." Home to the American League's White Sox, Comiskey also was the venue for a variety of events, including several boxing title fights, Beatles concerts, and, evidently, "auto polo."

*Above:* After the owner threatened to move the White Sox franchise, the city sought state financing to build a new facility (designed by St. Louis architectural firm Hellmuth, Obata & Kassabaum) on an adjacent lot. On September 30, 1990, the last game was played at the original Comiskey Park, and the following year, America's oldest ballpark was torn down. A plaque in the giant parking lot marks old home plate.

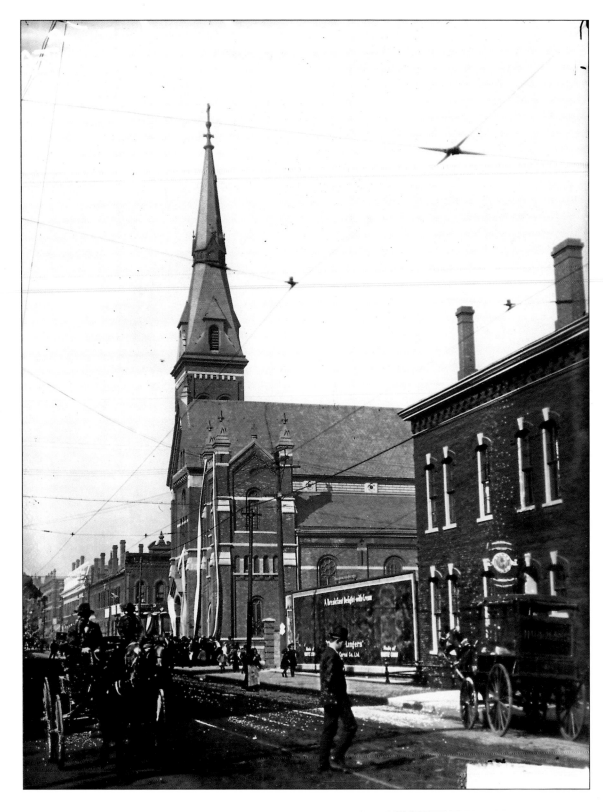

*Left:* View west on 18th Street at Racine, circa 1908. The lower West Side boomed after the Great Fire of 1871, when burned-out industries and workers moved west. Immigrants from Bohemia were the earliest settlers, and they named the neighborhood after the second largest Czech city. At center, St. Procopius, built 1883 and designed by Julius Huber, honors Bohemia's patron saint.

*Right:* Today, the Romanesque Revival-style St. Procopius is considered the "mother church" of Chicago's many Bohemian parishes. However, in the tradition of churches serving immigrant neighborhoods, it has kept pace with the community. By the late 1900s, Pilsen, and next-door Little Village, were steadily becoming Chicago's biggest Mexican neighborhoods.

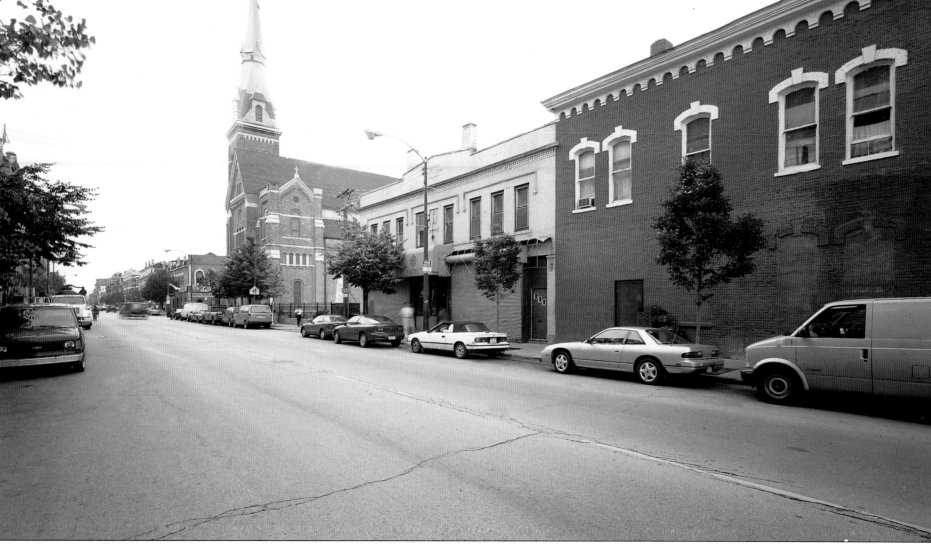

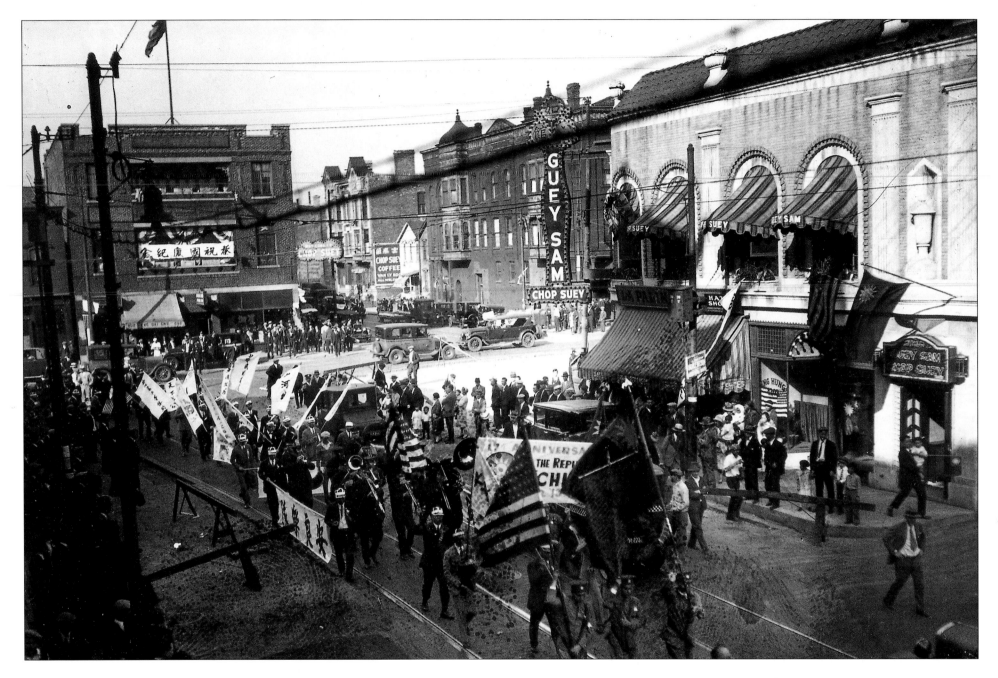

Intersection of Cermak (22nd) and Wentworth. The parade celebrates Chinese
Independence Day, October 10, 1928. Chinatown was created in 1912, when a large
group of Chinese immigrants was displaced from the South Loop by a construction
project. The Chinese Benevolent Association (*On Leong*) negotiated fifty leases for
shops and flats en masse, and Chinatown was born almost overnight.

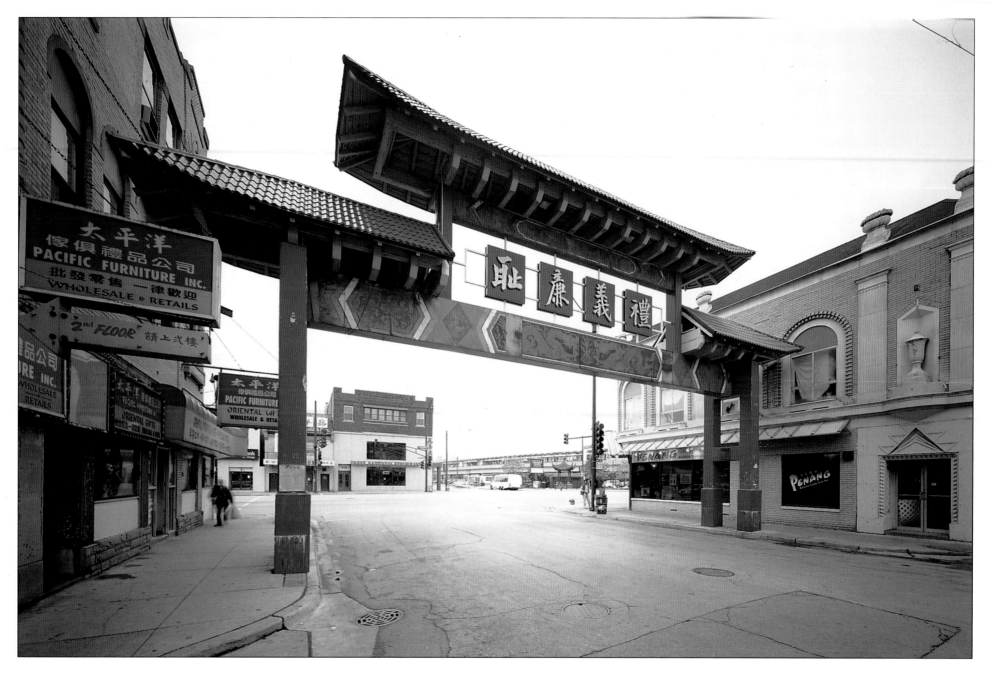

Today, many buildings here are inspired by traditional Chinese architecture, and those that predate Chinatown's founding, have often been submitted to cosmetic Chinese architectural gestures. Only a few blocks long, the streets are packed with about 10,000 residents. Listed in both English and Chinese characters on the street signs, the main thoroughfares are Wentworth, Cermak, and Archer.

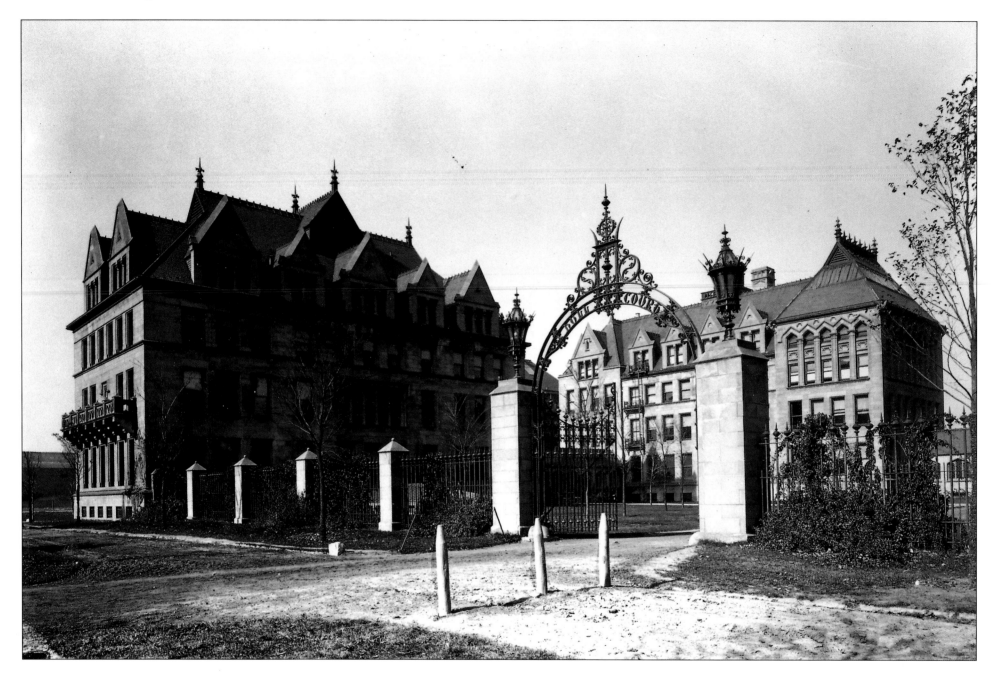

57th and Greenwood, circa 1905. The first University of Chicago, which opened in 1857, went bankrupt in 1886. It wasn't until the 1890s, when John D. Rockefeller pledged $35 million to create a university to rival "Princeton and Yale," and department store magnate Marshall Field donated the land, that the U of C took shape. Architect Henry Ives Cobb designed the campus as a self-contained Gothic village. Culver Hall is at left; the Anatomy Building at right, both designed by Cobb in 1897. The Olmsted Brothers designed Hull Courtyard and the gate in 1903.

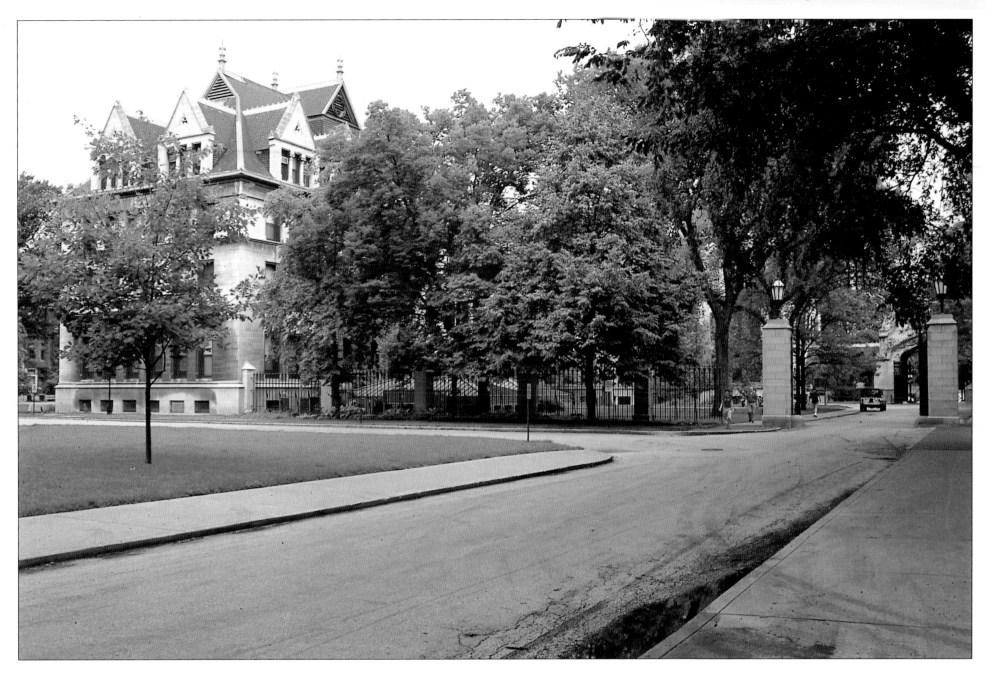

Most universities gradually achieve renown over time; the U of C seemed to spring fully formed from the collaboration of its great early leaders. Today, the school has over 10,000 students attending prestigious graduate programs in law, medicine, business, and theology (among others). The University claims sixty-seven Nobel Prize winners (between students and faculty), more than any other university. Since the Nobel Prize in economics was instituted in 1969, the U of C has had a virtual monopoly on the award: seventeen wins, that's roughly every other year.

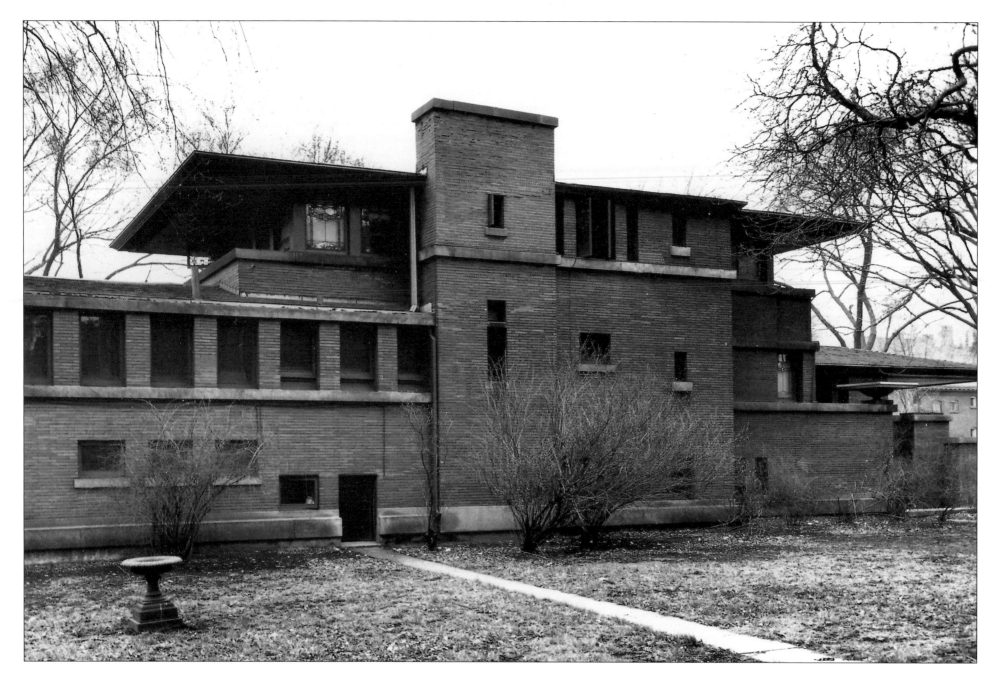

5757 South Woodlawn, circa 1940s. In 1906, bicycle manufacturer Frederick Robie hired Frank Lloyd Wright to build a house with "lots of sunlight, no curtains," and flowing rooms. What he got was an American masterpiece. With a budget of $60,000, Wright designed a restful home with strong horizontal lines (using long thin "Roman" bricks and a "hovering" roof with deep eaves) and inscrutable privacy (the entrance is at the back of the house seen here).

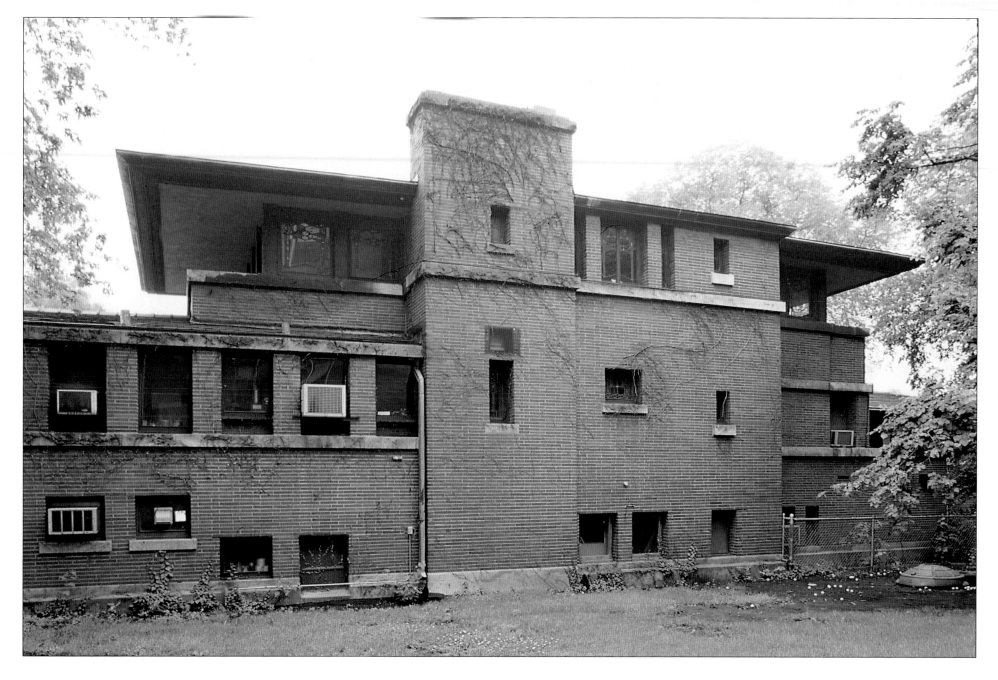

Today, the Robie House is considered the best example of the Prairie School of architecture, and one of Wright's best designs in general. It is a National Historic Landmark and is currently owned by the University of Chicago, who has a full-scale renovation in the works. Wright designed the interior as well, down to the light fixtures and the furniture, the most famous example being the high-backed, "room-within-a-room" dining set.

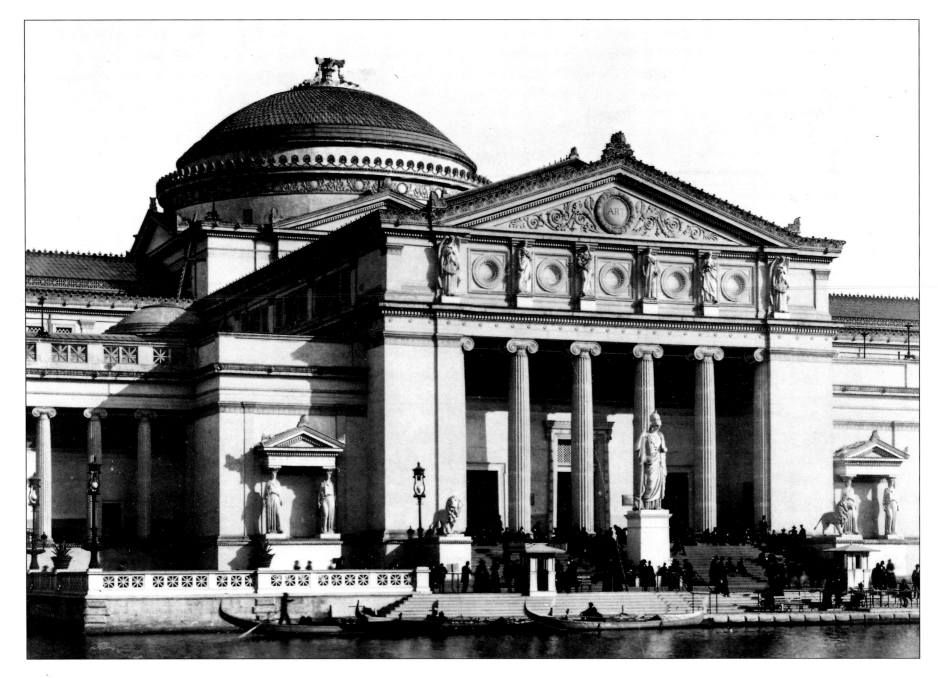

In 1893, Chicago hosted the World's Columbian Exposition, a World's Fair commemorating Columbus' voyage to the new world. On the then-swank South Side, the city constructed a "White City" of fanciful staff (plaster) temporary buildings. Charles B. Atwood (Burnham & Co.), however, designed the Palace of Fine Arts in brick as a permanent museum for the city. During the Fair, visitors could approach the Palace by gondola over the lagoon.

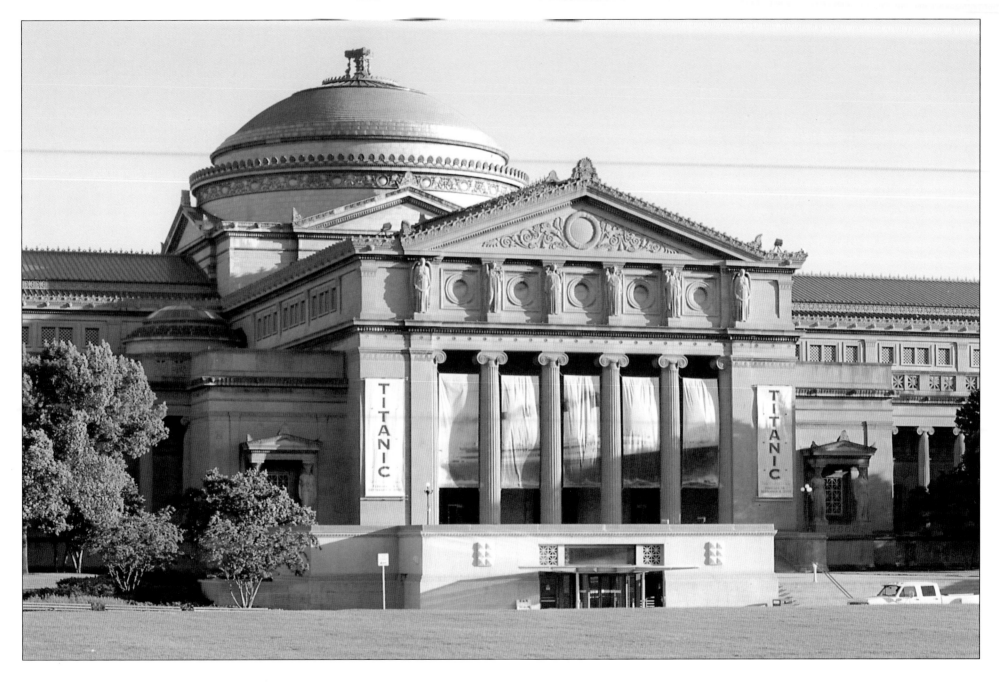

After the Fair, the neo-Classical, Beaux-Arts building housed the Field Museum until it moved north to a new facility in 1920. In the thirties, Sears heir Julius Rosenwald funded total structural renovations to accommodate a new museum of science and technology. Until 1991, when the Museum of Science and Industry began charging admission, it was the second most visited museum in the country after the Smithsonian Air and Space Museum in Washington, D.C.

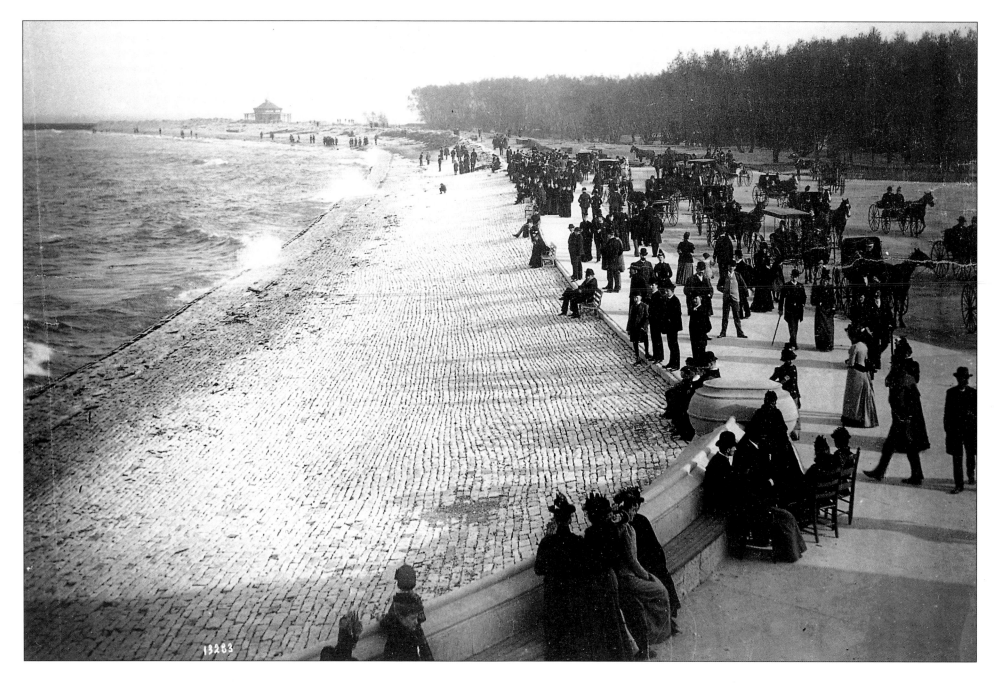

Although Hyde Park would not become an official part of Chicago until 1889, the area was developed as an exclusive residential neighborhood, with easy access to downtown via the train. To further suburban beautification, the South Park Commission hired Frederick Law Olmsted, designer of New York's Central Park, to design an extensive system of connected parks and landscaped boulevards on the South Side. Until the middle of the twentieth century, Chicagoans would train or ferry down for a day in the park.

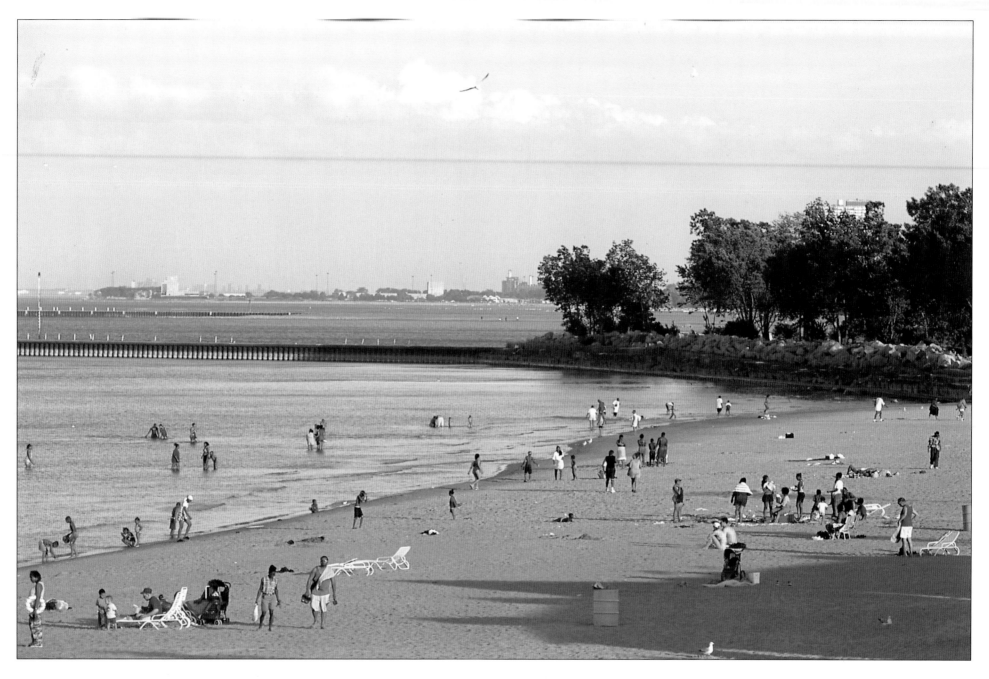

Part of Jackson Park, which in turn is part of the Olmsted-designed South Park system, 57th Street Beach was a swamp that had to be dredged in the 1870s and then paved with granite blocks in the 1880s in time for the 1893 World's Fair. Today, the waterfront from 56th down to 63rd street is utilized mostly by local Hyde Parkers in the summer. Lake Shore Drive, today almost a full-blown highway, has replaced the earlier forest and made access to the beaches more difficult.

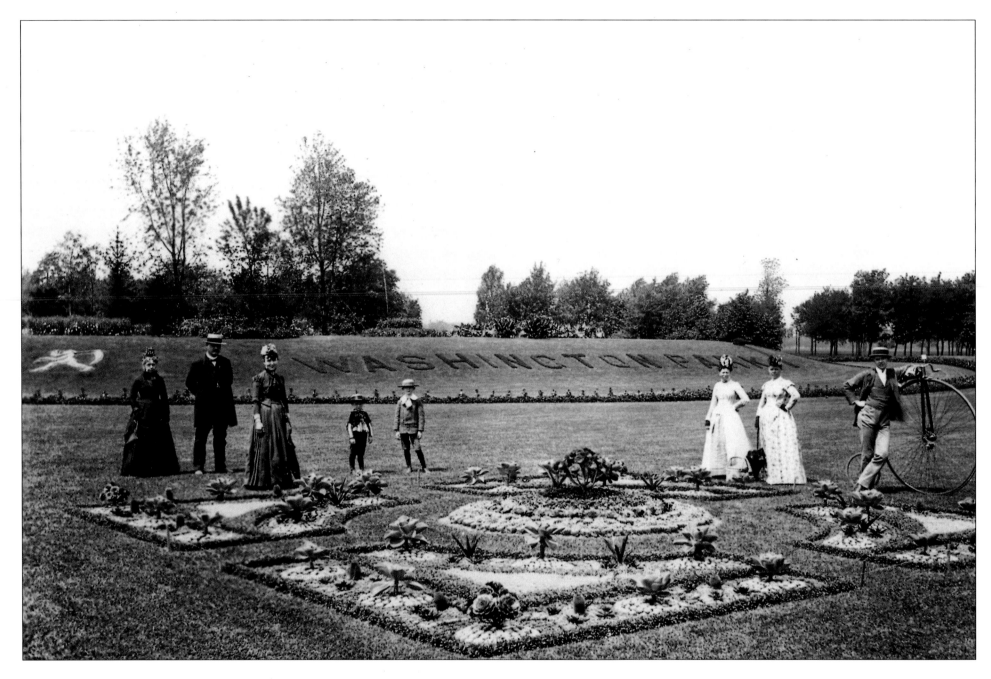

West side of Hyde Park. Washington Park was designed by Frederick Law Olmsted in 1871 as the "Upper Division" of great South Park, connected to the "Lower Division," i.e., Jackson Park, by the narrow Midway Plaisance. If Jackson Park was a swamp, Washington was a prairie flatland not naturally well-suited to a manicured public park. It was also the endpoint of three trafficky boulevards—Garfield, Drexel, and Grand (now MLK).

Olmsted's final plan combined the best of nature and design—the northern end, 100 acres in all, comprise a "large meadowy ground"; the southern half sports a manmade lagoon with verdant landscaping. The archival photo was taken in 1889, during the heyday of the Victorian penchant for floral design. Save floral design, many of the same activities—picnicking, biking, socializing with family—are enjoyed in the park today.

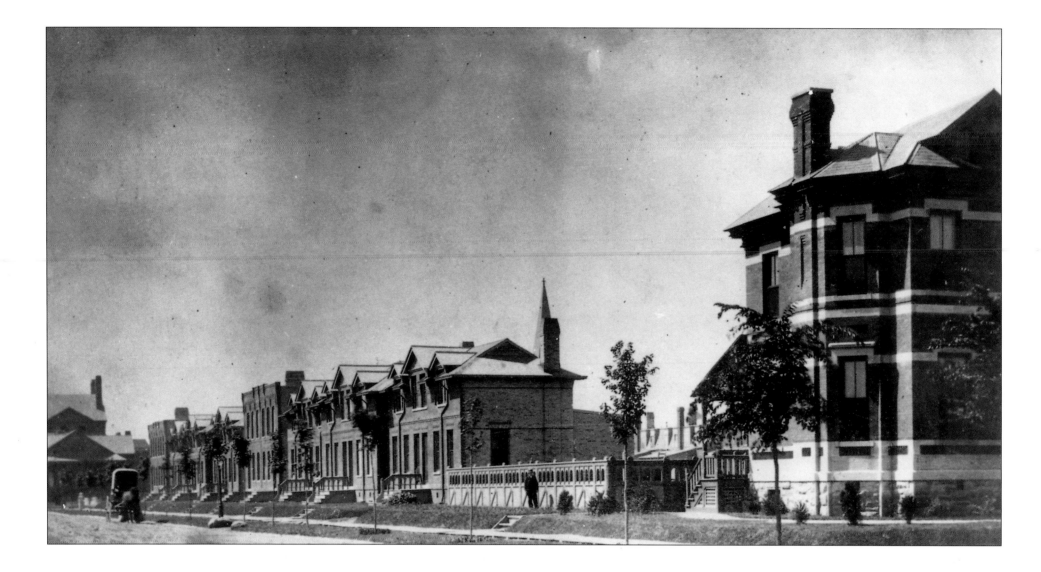

Rather than building a factory in the city amid the workers, railroad sleeping car magnate George Pullman decided to build a city around his factory. The first model industrial (planned) community in the U.S., Pullman on the city's far South Side was designed in the 1880s by renowned Chicago architect Solon Beman. The town included everything the worker might need—school, library, theater, church, bank, post office, etc. Taverns, however, were banned. Pullman's workers (all 20,000) were required to live in the tidy little brick row houses, with expensive modern conveniences (such as indoor plumbing and gas) provided at reasonable rents (and an annual six percent profit for Pullman).

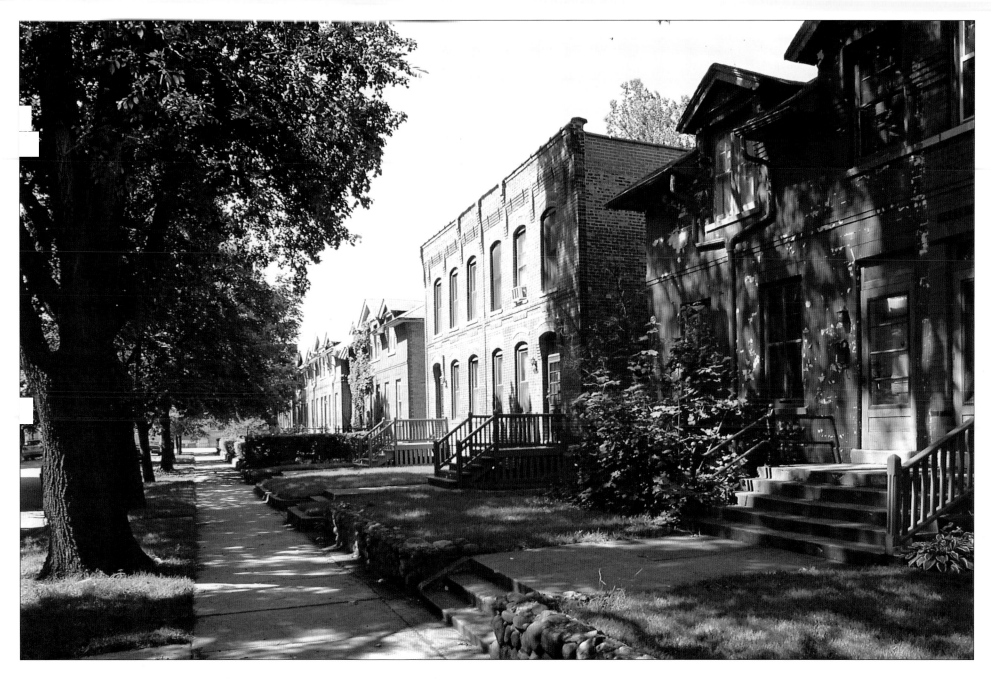

Business plummeted in the depression of 1893, so Pullman fired thousands of workers and sliced wages 25 percent for those remaining. However, he refused to lower rents, resulting in near-starvation conditions. The workers went on strike, and in spring of 1894, the American Railway Union led by Eugene V. Debs voted to support the Pullman strike. After a few episodes of violence, President Cleveland sent in federal troops. Pullman died in 1897, and the town was sold to its residents in 1907. The entire district was declared a National Historic Landmark in 1971, but its isolated position ten miles out from downtown has made a complete renaissance difficult.

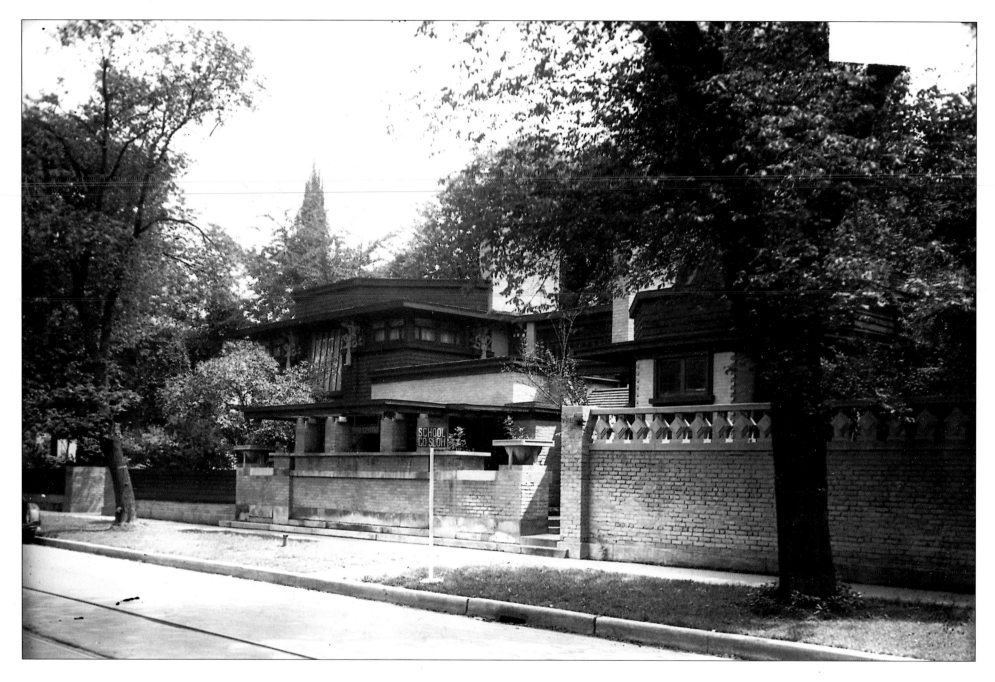

Oak Park, 951 Chicago Avenue. Seen here somewhat overgrown in 1926 after being divided up into multiple apartments is the original Frank Lloyd Wright home and studio. Wright's great passion was residential design; during his career he created over 270 homes, but this was his first. Wright used the home as a laboratory, constantly revising, rebuilding, and adding on. Some kernels of his later theories can be seen here in the stark geometric shapes, horizontal banding, and organic, flowing interior.

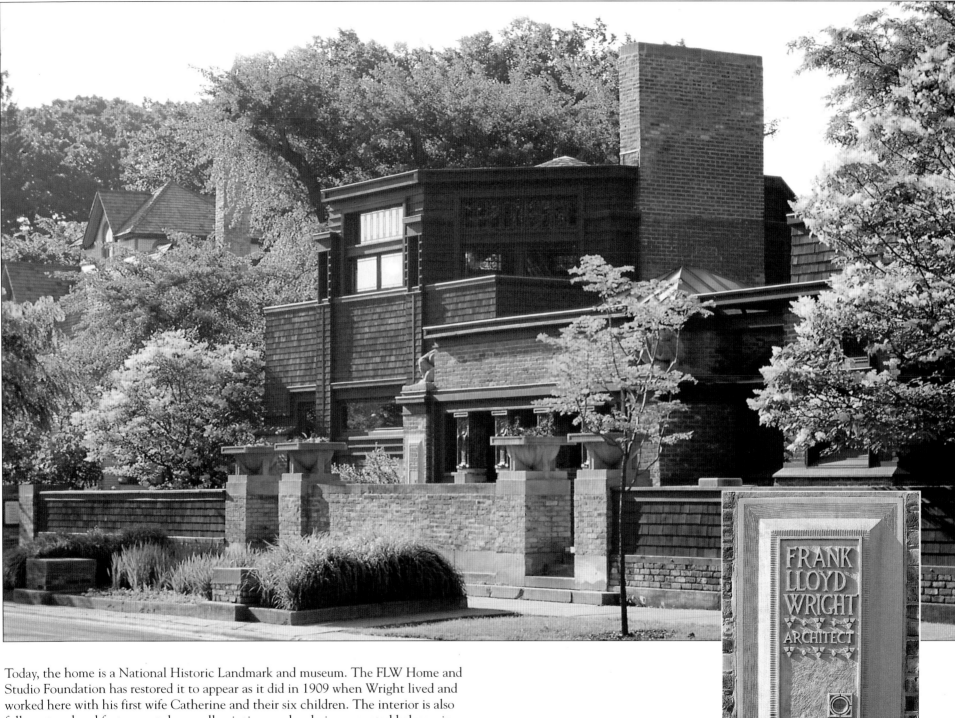

Today, the home is a National Historic Landmark and museum. The FLW Home and Studio Foundation has restored it to appear as it did in 1909 when Wright lived and worked here with his first wife Catherine and their six children. The interior is also fully restored and features art deco wall paintings and a chain-supported balcony in the architecture studio. Technically a suburb of Chicago, Oak Park boasts the world's largest collection of Wright-designed buildings. Wright lived in the streetcar suburb from 1889 until he fled to Europe with his lover, Mamah Borthwick Cheney, in 1909.

# INDEX